W9-BDU-276

DATE DUE	RETURNED
SEP 2 2 2008	SEP 1 3 2008
OCT 0 9 2008	
FEB 0 6 2009	OCT 0 9 2008
	FEB 0 2 2009
FEB 1 7 2009	MAR 0 7 2009
	JUN 0 3 2009
MAY 2 8 2009	
OCT 0 1 2009	OCT 1 3 2009

DISCARD

HUMBER COLLEGE
LAKESHORE CAMPUS
LEARNING RESOURCE CENTRE
3199 LAKESHORE BLVD. WEST
TORONTO, ONTARIO M8V 1K8

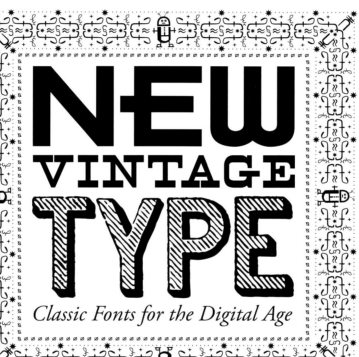

NEW VINTAGE TYPE

Classic Fonts for the Digital Age

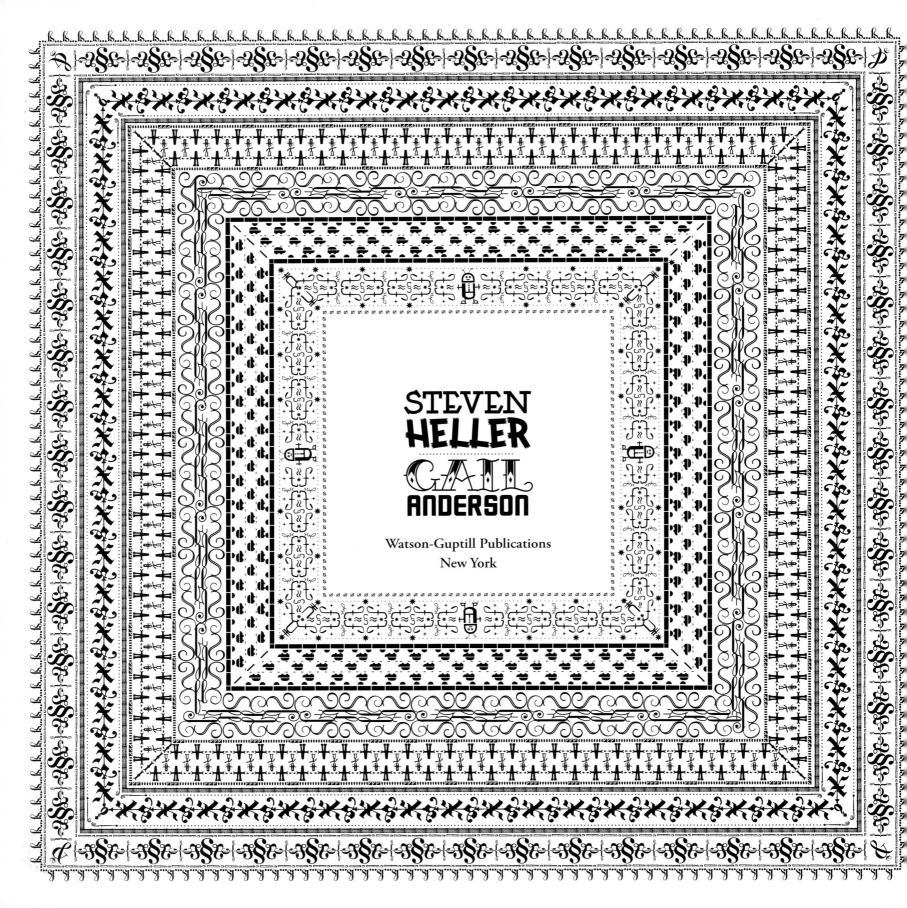

STEVEN HELLER
GAIL ANDERSON

Watson-Guptill Publications
New York

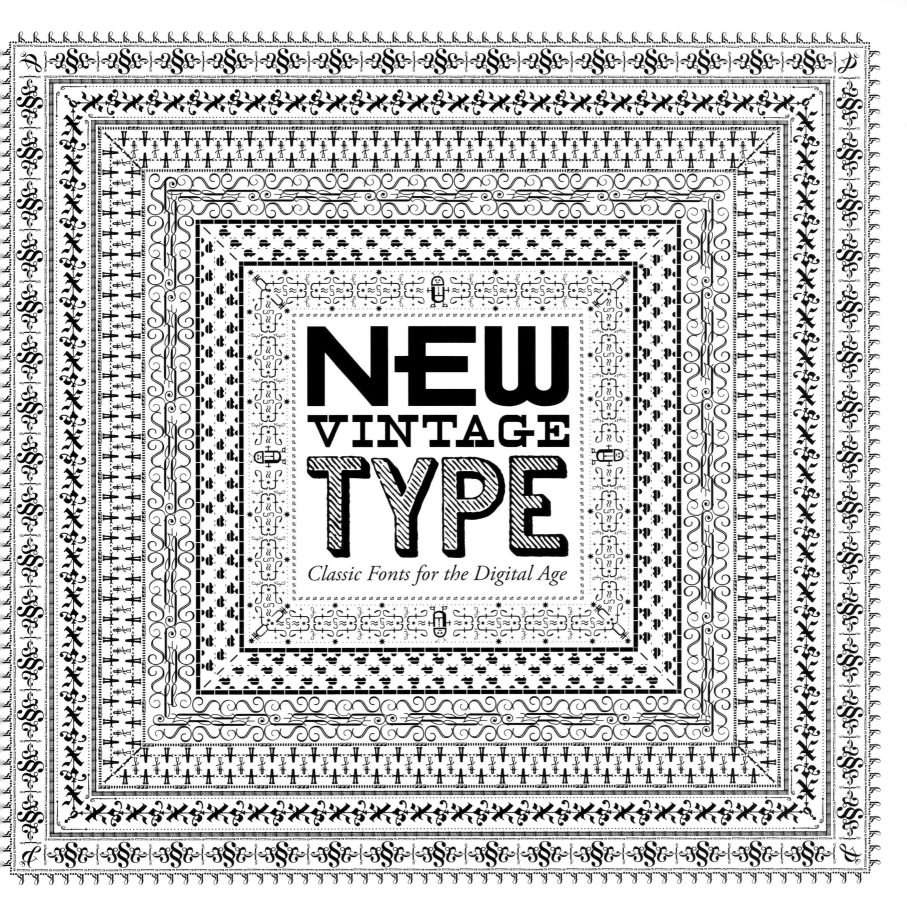

NEW VINTAGE TYPE

Classic Fonts for the Digital Age

For Nicholas Heller – S. H.

For Jake, Megan, Courtney,
Nicolas, Evelyn and Louie – G. A.

ACKNOWLEDGMENTS

*The authors' deep gratitude is extended to our editors at Thames &
Hudson, Lucas Dietrich and Cat Green, whose patience, good humor
and encouragement made missing the East Coast fall foliage to finish
this book almost bearable.*

*We are most indebted to Christine Thompson Maichin and Gary
Montalvo for their invaluable assistance in researching this book
through a pregnancy (Christine's not Gary's), job and life changes.
Without them, there would be only a series of pretty page borders
and openers.*

*And to that end, we are indebted to Jessica Disbrow for her love of
letterforms and above and beyond help with the design of this book.
Without her, there would only be picture boxes without a series of
pretty page borders and openers.*

*Special thanks must be extended to the following people for research,
scans, phone calls, e-mails, faxes, and copying and pasting in all the
right places: Darren Cox, Sarah Foley, Jamie Prokell, Dan Savage,
Jeff Walters, and Mike Everett.*

Finally, to the incredibly talented contributors to New Vintage Type,
*our thanks for returning our calls and e-mailing those hi-res files.
Without you, there'd be no book.*

– SH & GA

© 2007 Steven Heller and Gail Anderson

First published in the United States in 2007 by
Watson-Guptill Publications, Nielsen Business Media, a division
of the Nielsen Company, 770 Broadway, New York, NY 10003

www.watsonguptill.com

First published in the United Kingdom in 2007 by
Thames & Hudson Ltd, 181A High Holborn,
London WC1V 7QX

www.thamesandhudson.com

All Rights Reserved.
No part of this publication may be reproduced or transmitted
in any form or by any means, electronic or mechanical, including
photocopy, recording or any other information storage and retrieval
system, without prior permission in writing from the publisher.

CIP data is available from the Library of Congress.
Library of Congress Control Number: 2007924868

ISBN-13 978-0-8230-9959-7
ISBN-10 0-8230-9959-8

Printed and bound in China by C&C Offset Printing Co., Ltd.

DESIGNED BY *Gail Anderson & Jessica Disbrow*

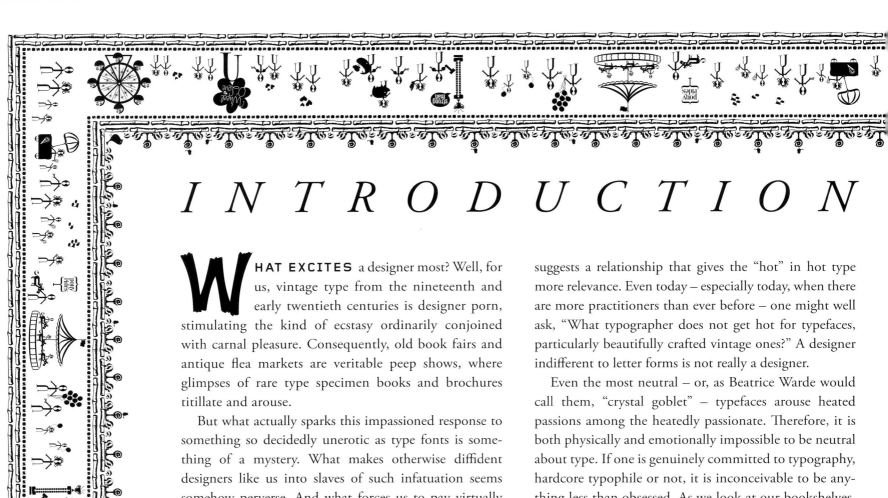

I N T R O D U C T I O N

WHAT EXCITES a designer most? Well, for us, vintage type from the nineteenth and early twentieth centuries is designer porn, stimulating the kind of ecstasy ordinarily conjoined with carnal pleasure. Consequently, old book fairs and antique flea markets are veritable peep shows, where glimpses of rare type specimen books and brochures titillate and arouse.

But what actually sparks this impassioned response to something so decidedly unerotic as type fonts is something of a mystery. What makes otherwise diffident designers like us into slaves of such infatuation seems somehow perverse. And what forces us to pay virtually any price and go to such great lengths to possess the object of our desires is curious at best.

Nonetheless, sensuality has had a long entanglement with type, and sex is, surprisingly, the principal metaphor for many things typographic. In the hot metal eras, dating back to the sixteenth century, type production was routinely described in terms of human reproduction. Matrices (or mothers) were impregnated by patrices (or fathers), producing exact offspring (or children). Although this tale of the typographic birds and bees may seem more mechanical than sexual, it nonetheless

suggests a relationship that gives the "hot" in hot type more relevance. Even today – especially today, when there are more practitioners than ever before – one might well ask, "What typographer does not get hot for typefaces, particularly beautifully crafted vintage ones?" A designer indifferent to letter forms is not really a designer.

Even the most neutral – or, as Beatrice Warde would call them, "crystal goblet" – typefaces arouse heated passions among the heatedly passionate. Therefore, it is both physically and emotionally impossible to be neutral about type. If one is genuinely committed to typography, hardcore typophile or not, it is inconceivable to be anything less than obsessed. As we look at our bookshelves, lined as they are with luscious type catalogs dating back to the late nineteenth century, with reproductions so pristine that they might have been composed and printed yesterday, we cannot but feel a seductive gravitational pull to use and reuse them in current designs.

Type is not merely the lingua franca of the designer's craft, it is the *sina qua non* of our art – the paint on our canvas, the clay of our sculpture, the symbolism in our poetry, the film in our camera, the wool of our sweater, the shrimp in our cocktail and the ricotta in our cannoli. While this might sound excessively florid, most designers

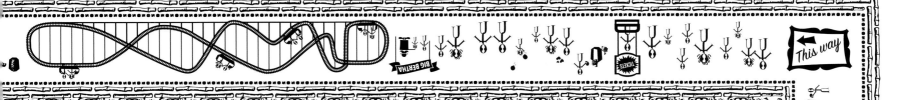

and all typographers worthy of their professional standing must be fluent in the language of type and fanatically fixated on the look, shape, and kiss of letter forms. (The term kiss is a common, physical reference describing the delicate impression made when the hot metal type touches paper.) The allure of a perfect cut, the quintessential x-height, and the ideal ascender and descender are essential to the aesthetics and function of typefaces. This is why specimen books of old were designed in such fetching ways, enticing users through a kind of typoroticism and enabling them to fantasize about just how beautiful the perfect composition can be when set on the naked page.

Typographic seduction may have come to a head (though not a climax) at the turn of the twentieth century with the advent of free-spirited, feminine Art Nouveau lettering. The eccentrically ornamented faces of Arnold Bocklin, Koloman Moser, Georges Auriol, and Otto Eckmann (among other Art Nouveau, Secessionist, and Stil Liberty designers), with their curvaceously entwined tendrils, exuded a come-hither look and defined the obsessively sensual style of the *fin de siècle*. Conversely, the Victorian era, known for its hard-edged no-nonsense typefaces with heavy slab and block serifs, suggested a kind of stoicism and masculinity. Art Nouveau was the style in which womanly beauty reigned supreme, as if each contour insinuated wanton delights. Victorian type was the rigidly dogmatic preacher who wailed against gaiety.

It is no wonder that designers continue to lust after these and other similar faces from subsequent eras. In each period, types have fulfilled an erotic promise. In the 1920s, Oswald Cooper's Cooper Black was naughty and fleshy, whether he intended it or not. In the 1930s, A. M. Cassandre's Peignot had the innate sensuality fitting for the face that defined (if only for a moment) France. In the 1950s handbook, *Printing Types and How to Use Them*, author Stanley Hlasta casually tosses around adjectives such as "masculine," "handsome," "dashing," "feminine," "beautiful," "graceful," "romantic," and "charming," when describing the typefaces he sampled. Type designers and type critics may not even be conscious of this. Generally speaking, most type designers are themselves more geeky than sexy, yet sex is so totally endemic to type forms that it is surprising the church has not imposed moral codes on its design and composition.

Enough of this fixation on the erotic! Let's face it, sometimes a cigar is just a cigar, as Sigmund Freud has been quoted as saying a million times. A vintage typeface is often just a vintage typeface, perhaps steeped in symbolic relevance but used not to turn back the hands of time but because it is well suited to a particular contemporary layout.

Moreover, a large percentage of all contemporary, even ultra-orthodox Modernist typography, is based on vintage letter forms. Compositionally speaking, designers often pick through the timeworn menus of type for complimentary combinations, regardless of when or why

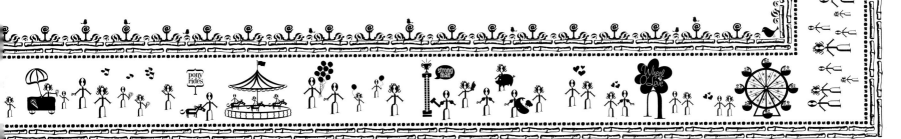

OLD NEW WOOD
During the 1960s, the Morgan Press in New York obtained a huge assortment of original woodtypes, which they offered to graphic and advertising designers at reasonable rates. Although a few eclectic designers were already using wood, this vast resource helped launch the eclectic style at that time.

the typeface was designed. Jan Tschichold, standard-bearer of Bauhaus- and Constructivist-inspired New Typography in the late 1920s, used a few nineteenth-century-looking swash scripts as a counterpoint to Modern, bold sans serifs. Was he playing with contrasts, or did he truly revere the sumptuousness of the curlicues? Probably both. Today many old and young designers are attracted to a slew of nineteenth-century bifurcated Tuscans, slab woodtypes, Art Nouveau and Art Deco letters, and other antiquated faces retrieved from the hellbox of history. Many of these types are redrawn or digitally remastered to make them more adaptable to today's needs; others are used without even slight tweaks or modifications from the original. Some old faces are deliberately employed to underscore appropriate themes and concepts which the types have to historical

or symbolic relationships, for example, the luxury of the Streamline era or the functionality of the wartime years. But many old types are reconfigured into fashionable new design schemes, such as mixing Victorian and Swiss Modern faces together into an eclectic stew, resulting in hybrid neo-modernist grunge or proto-retro techno styles.

Few art forms are completely made from a whole cloth, and more than others, type design is built largely on historical precedents (for what is the alphabet if not an historical precedent?). The ratio of brand-spanking-new typefaces compared to revivals is rather low, and the old is ultimately revered since few faces designed after Garamond, Bembo, Janson and Bodoni, among others, are quintessentially as beautiful or as functional. Revivification is the heart and soul of all type design, and there is hardly a typeface that was conceived decades or centuries ago that will not be retrofitted at some time (take Neue Helvetica, for instance). Look at how many passé types were placed in mothballs, only to be resurrected and appreciated years later. Ed Benguiat's popular Souvenir, dating back to the Art Nouveau period, lost its original currency but returned with vengeance in the 1970s. Prior to Benguiat, Push Pin Studios' Milton Glaser and Seymour Chwast revived Victorian, Art Nouveau and Art Deco faces and ornaments, triggering a so-called "retro" fashion for eccentric faces. It continues to the present day with a regular outpouring from such digital type foundries as P22 and House Industries. Both companies have digitized numerous old-timers: among P22's hit faces, Bauhaus, Constructivist, Dada, Victorian and Arts and Crafts are used when the moment calls for pastiche. Each of these respective revivals has a nostalgic aura, but the cumulative result of blending period styles into an über-aesthetic promotes a curious longevity.

This moment in design history, like this entire period of popular culture we live in, is beyond eclectic. It is post-neo-proto-eclectic. Chronological and aesthetic boundaries have become more fungible today than at any other period during the typographic continuum. Anything goes, and all combinations of what was once jarring and jostling are now acceptable. The result is timeless, and

even styleless, style. Nonetheless, carbon markers measure time and context. Certain traits and tics define particular historical moments. How type is used is indicative of the culture in which it is employed.

For example, there is a fashion in copying vintage typefaces by hand on layouts in their raw, sketched form. This method of "transcribing" typefaces accentuates the basic shapes yet highlights a contemporary rough-hewn character, and playing with old and new allows designers more leeway with typographic tradition and standards. With so many options for computerized perfection, designers now look to tickling types from the past, not to indiscriminately "borrow" but to find alternatives outside computer-imposed perfection. In addition to the hand-writing method, vintage types are also routinely scanned, manipulated and digitally altered to make them even more idiosyncratic. Old faces are being used like illustrations to spell out messages and to visually interpret them. In this diverse stew of applications, types representing one era are often juxtaposed willy-nilly with those from others to deliberately trigger the clash of sensibilities.

The clash of old and new brings about change. And this book – a record of change – aims to reveal, analyze, and discuss the shifts in aesthetics and function through how old typefaces, from classical *tours de force* and mongrel abnormalities, inspire and prompt new typo-graphic languages. It shows how the raw, sensuous and the sensuously raw historical models have directly and indirectly influenced and been appropriated by contemporary designers for a wide range of projects, from magazines to packages, from print to screen, from posters to billboards. This book is a timely guide to typographic practice and possibility, and a lively overview of how decorative, novelty and expressive type can successfully span stylistic periods with aplomb and ease.

– *SH & GA*

ED ROMAN
SIGN PAINTER UPRIGHT
TIKI PALMS
CHALET 1970
Big house
LAS VEGAS NUGGET
FLYER FONTS STRAIGHT

9

GOOFY AND STRANGE House Industries has made a career out of reviving and reinventing historical and novelty types, from Victorian wood to Hawaiian bamboo. House draws from vast resources, like the vintage Photo-Lettering, Inc. catalog, once the foremost purveyor of goofy and old-fashioned type, as well as bits and pieces found on period ephemera. This sampling, used in creating the opening spread for the introduction, reveals the fervently eclectic range of styles and mannerisms. DESIGNERS: Ken Barber, Ed Benguiat, Jeremy Dean, René Albert Chalet, Allen Mercer CLIENT: House Industries

THE VICTORIAN AGE
ORNAMENT

KINGS AND QUEENS, EMPERORS AND EMPRESSES, czars and czarinas always seem to have major design styles named after them, even if they had nothing whatsoever to do with the theoretical or physical design of the objects themselves. Being a monarch has to be one of the most egocentric jobs around, so in addition to cities, boulevards, and lakes, royal name-branding of virtually everything from architecture to furniture remains *de rigueur*.

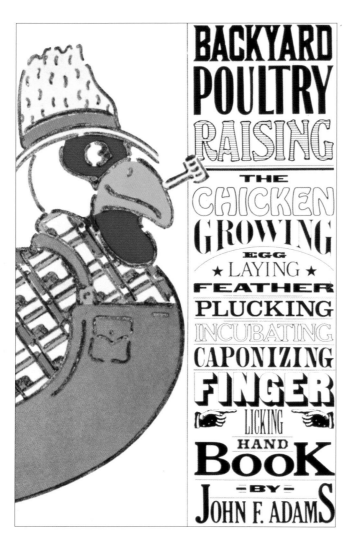

CHICKEN SCRATCHES
The Victorian bill serves as the model for this assemblage of eccentric typography. The drawing is pure Seymour Chwast.
DESIGNER/ ILLUSTRATOR: Seymour Chwast
PRIMARY FONTS: "Backyard" is No. 500, "Poultry" is Modified Gothic XX Condensed

While French kings and Russian czars have been associated with certain typefaces and lettering trends, it was Queen Victoria's reign in England, from 1837 to 1901, that enveloped the largest array of graphic mannerisms, many of which bear her name only by virtue of being created during her lifetime. She was not a designer (although her beloved husband Prince Albert was a great patron of the industrial arts and responsible for the Crystal Palace Exposition of 1851) but she was a trendsetter. Her primary influence on the aesthetics of the period was a kind of lugubrious melancholy triggered by the death of her husband Albert. The significant design of the age, and other cultural manifestations, came under this curious spell.

Indeed, there were various common traits, tropes, and conceits that even now signal an unmistakably Victorian sensibility, for example, the color black, and elaborate funereal marks and symbols incorporated into illustrations and typography. One of the most vivid evocations of this was Edward Gorey's faux Victorian-styled illustration produced from the late 1960s through the early 1990s to accompany his famously sardonic gothic tales. Back in the Queen's day, Gothic or neo-Gothic was the rage in everything from couture to building. Typical Victorian-styled houses were characterized by elaborate scroll-work façades and other eccentric embellishment. As Queen Victoria's epoch coincided with the Industrial Revolution, so the monumental expositions with their cast iron and glass pavilions typify the "Victorian style."

Victoriana was, however, mostly underscored by pomp and ornament. While Queen Victoria was known for her high moralist ideals and her name connotes conservative, if not prissy virtues, she also reigned over the rise of middle-class bourgeois tastes pervasive in all the applied arts. Since this was the longest reign in English history (and the literary, art, and design styles that bear her name even extended a few years beyond her death), Victoriana covered several sub-stylistic periods. During her early reign, England embraced the medieval or Gothic Revival in all aspects of architecture and design. From the 1880s onwards, however, England experienced a series of reactions against this style in the forms of Aestheticism, Art Nouveau, Japonisme, the Arts and Crafts movement, and even a Celtic Revival. Yet these movements were all part of the Victorian era.

John Ruskin was the moralizing philosopher who exercised the most influence over Gothic methodology that gave rise to the lush yet stoic look of the "high Victorian" period. He saw the Gothic as a pathway to enlightenment and moral existence. Ruskin inspired William Morris, the proto-socialist artist-designer-philosopher, who in fostering the Arts and Crafts movement proffered handcrafted design and manufacture as necessary alternatives to the social and aesthetic toxins of the Industrial Revolution. When Victoriana is invoked, Morris's style must be seen as one of the more innovative offshoots, even if his fervent reduction

and simplification of design forms went counter to the prevailing stereotypes. He advanced the idea that all applied arts, including typography, seamlessly fitted into one another, and in this way was a precursor of the Bauhaus philosophy.

In this sense, Victorian typography is harmonious with most of the other artistic endeavors prevalent during the nineteenth century. Its obsessive ornamentation – its serious pomp – echoed England's, and later America's, need to come to grips with the eyesores of industrialization. Ornament was used, in large part, to mask the looming industrial monsters and its dark spreading shadow. It was further a way to mediate between vintage verities and the shock of the new. Modern life was too frightening to accept so Victorian ornamental design, and type in particular, was a kind of bridge between old and new, known and unknown, fashion and folly.

Most type of the era was designed to conform to fashion, but as it grew increasingly eccentric – large slab serifs, elaborate in-line and outline motifs and cartouches, unwieldy bifurcations – it became its own fashion. And since fashion inevitably becomes obsolete, Victoriana, whose duration lasted longer than most, was disposed of without a hint of regret once other forms took hold. Victoriana, like the aged, morose monarch who lent the style her name, came to represent tired, conformist mediocrity, which is why it took so many decades until it was revived as pastiche. It was Push Pin Studios in the late 1950s and early 1960s, and kindred designers in the United States, England and elsewhere, who came to appreciate Victoriana's lost charms. In contrast to the late Modernist simplicity, typified by the contemporary Swiss Style, ornamentation enlivened certain products and concepts. It offered an alternative to the sedate and cold typographic manifestations of the new age.

Today's Victorian revivals are not revolting against anything. Style is a closet from which to draw conceits. An ability to mix and match allows designers to build new styles from old remnants, with the ease of a computer quick-key. The patchquilt of type and image is limitless and ever-changing. But one thing is certain, the pomp and ornament of the Victorian aesthetic is a popular revivified style, if only because there are so many alluring varieties to choose from.

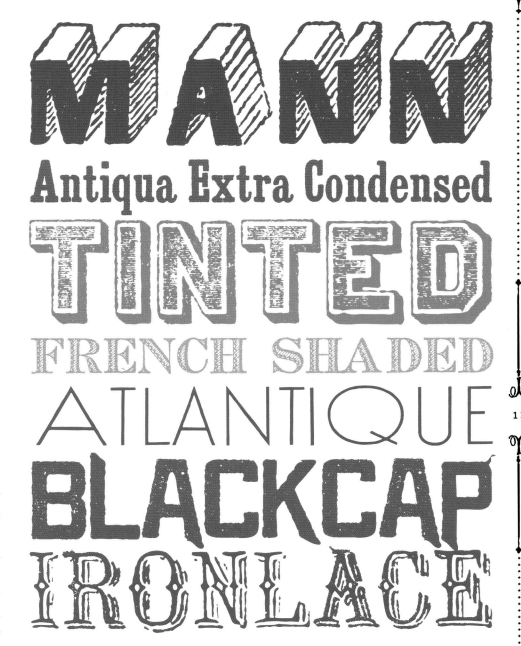

ARCHIVE ON VICTORIAN TYPE There is the common notion that Victorian-era type design is eclectically over-decorated. This image has stuck despite some quite elegant and understated typeface and layout designs from this period. The founders of Archive Type Foundry, who created the type on the section opener (see pages 10–11), insist the Victorian style comprises a combination of different typefaces, ornaments and other typographic elements rather than the typeface design itself. "Some wood and metal engraved typefaces are quite minimalist in their design," they say, "but combine them with baroque penmanship ornaments or late Renaissance fleurons used as wallpaper prints, and you'll get that Victorian style in designs not older than five years." DESIGNER: Unknown PUBLISHER: Archive Type Foundry

13

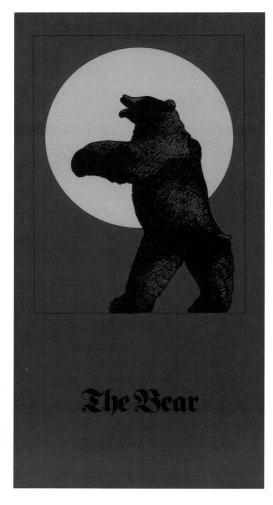

The Bear

14

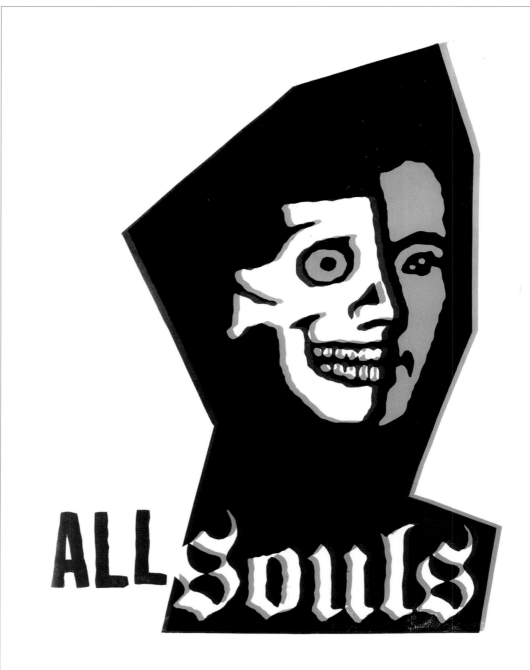

MODERNIZING SPIKY Ever since Milton Glaser was cofounder of Push Pin Studios in the mid-1950s, he has maintained an interest in passé type and lettering. The Push Pin logo alternately shifted from Art Deco to Art Nouveau, but the primary face used was German Fraktur, or blackletter. DESIGN FIRM: Milton Glaser, Inc. ART DIRECTOR/ DESIGNER: Milton Glaser

HORROR FANCIERS "The inspiration for this image," explains Dirk Fowler, "comes from an instructional diagram of a human body model. The type is hand-cut and takes its inspiration from old blackletter specimen sheets." It is also a face embraced by Gothic horror fanciers and thus is symbolically endemic to Halloween festivities. DESIGN FIRM: f2 Design DESIGNER: Dirk Fowler CLIENT: onQ Gallery PRIMARY FONT: Hand-cut blackletter

GANG COLORS This novel is about a boy growing up in a rough neighborhood in San Pedro, California. "The blackletter with the added texture," says Rodrigo Corral, "is a nod to inner-city gang lettering used in their tattoos."
ART DIRECTOR: John Fontana DESIGNER: Rodrigo Corral PUBLISHER: Doubleday PRIMARY FONTS: Trade Gothic, blackletter (unknown)

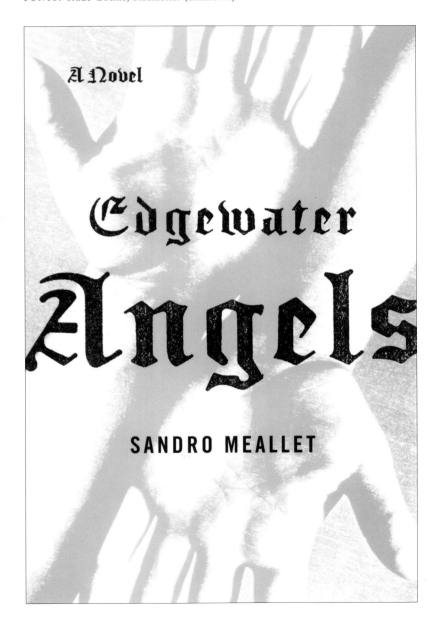

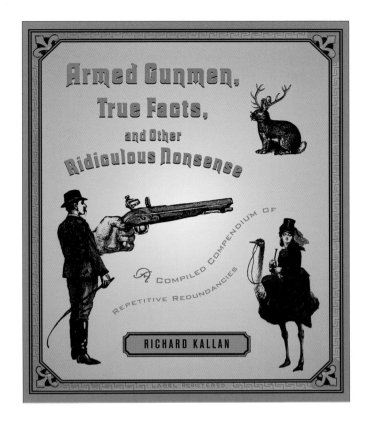

15

LABOR INTENSIVE Turn-of-the-century type catalogs are rare but obtainable. Many faces that were laboriously cut in heavy metal were used frequently for bills and posters. The lettering for this book cover derives from some late Art Nouveau experiments.
ART DIRECTOR/DESIGNER: Archie Ferguson PUBLISHER: Pantheon Books PRIMARY FONTS: Mac Beta Old Style, Liberty Regular, Bank Gothic Medium, Akzidenz Medium Condensed

Images of Robin Hood

The fifth biennial meeting of the
International Association for Robin Hood Studies

September 29 to October 2, 2005
University of Delaware • Newark, Delaware

e welcome 20-minute talks on all aspects of the Robin Hood legend and its characters, especially those dealing with images

Illustration from Howard Pyle's
The Merry Adventures of Robin Hood

of the outlaw in early printed books, broadsides, chapbooks, children's books, comic books, and film. In addition, we are interested in talks on other outlaw tales; on the work of Howard Pyle, whose 1883 adaptation of the Robin Hood stories (illustrated by himself) introduced generations of American children to the merry outlaw; and on his pupil N.C. Wyeth, another great illustrator of Robin Hood.

or information about the meeting, contact one of the members of the organizing committee:

Lois Potter <lpotter@udel.edu>, University of Delaware
Sayre Greenfield <eng6@pitt.edu>, University of Pittsburgh at Greensburg
Linda Troost <ltroost@washjeff.edu>, Washington and Jefferson College

The deadline for 250-word abstracts or completed papers is 15 January to Lois Potter.

Link to www.washjeff.edu/users/ltroost/robinhood.html for information on Robin Hood, nearby points of interest, and travel options.

he University of Delaware is a short ride from Chadds Ford, Pennsylvania, the home of the "Brandywine School" that included Pyle and Wyeth. Also within easy reach are Longwood Gardens and Winterthur Museum & Library, former estates of the DuPont family.

Past biennial meetings have been in Rochester, New York (1997); Nottingham, England (1999); London, Ontario (2001); and York, England (2003).

Printed at Raven Press at the University of Delaware

16

MORRIS AND HIS CIRCLE Raymond Nichols reports that William Morris and the Kelmscott Press were the prime influences here, particularly in the illuminated initials. The main typeface, Troy, named after *The Recuyell of the Historyes of Troye*, was designed by Morris in the Arts and Crafts aesthetic of the mid-nineteenth century. DESIGN FIRM: Raven Press/Designers ART DIRECTORS/DESIGNERS: Raymond Nichols, Jill Cypher CLIENT: International Association of Robin Hood Studies PUBLISHER: Raven Press at the University of Delaware PRIMARY FONT: Troy

STEP RIGHT UP Rodrigo Sanchez cites the long history of Victorian prints with their eclectic displays of type as inspiration. But this Spanish magazine cover also appears to have been influenced by the classic American circus poster. DESIGN FIRM: Unidad Editorial S.A. ART DIRECTOR/ DESIGNER: Rodrigo Sanchez CLIENT: *El Mundo Métropoli* PUBLISHER: Unidad Editorial PRIMARY FONTS: Champion, Giza, old font brochure

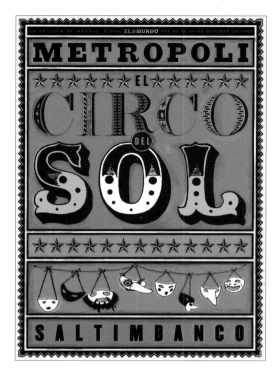

WAGES OF SIN Nineteenth-century engravings of Roman Catholic icons and imagery of the prodigal son pervade this unsubtle ode to religion's biggest bugaboo. Making the snake out of a blackletter "S" seems like the most natural decision in the world. DESIGN FIRM: Scorsone/Drueding ART DIRECTORS: Scorsone/Drueding DESIGNERS/ILLUSTRATORS: Joe Scorsone, Alice Drueding CLIENT: sdposters.com PUBLISHER: Scorsone/Drueding PRIMARY FONTS: Bank Gothic, Kunstler Script, various nineteenth-century decorative initials

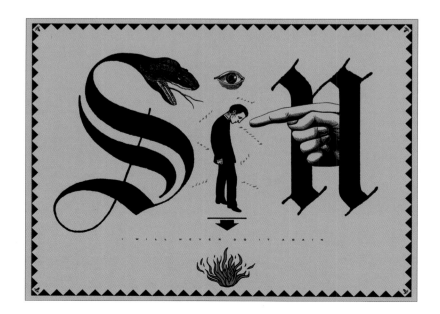

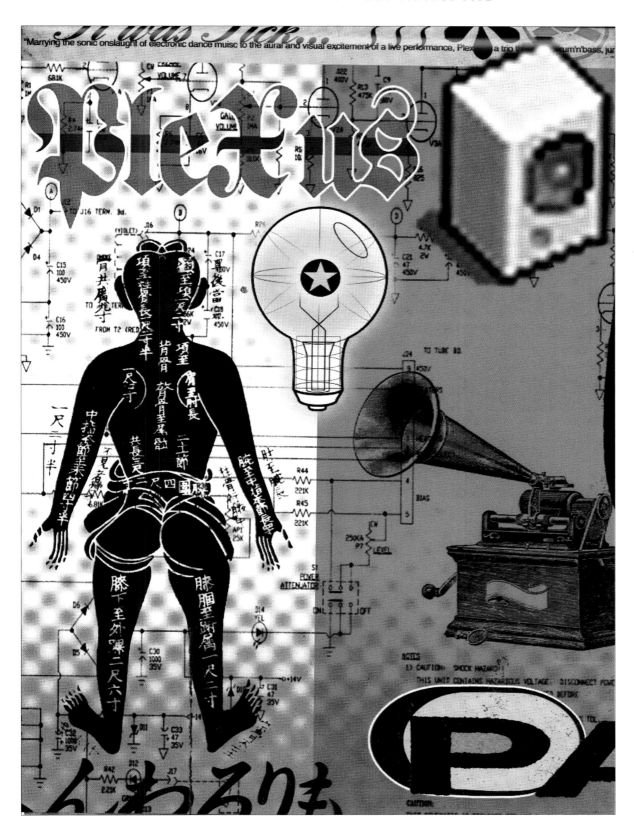

FROM NAZIS TO SNEAKERS

"When and how did blackletter type become associated with American street culture?" Peter Mendelsund asks, indicating the ubiquitous nature of these letterforms, from Nike sneaker campaigns to Urban Outfitters catalogs. Blackletter type now connotes motorcycle gangs, Barrio tattoos, punk rock counterculture and seemingly anything else anti-authoritarian. "Of course for many years, this kind of type represented authoritarianism of a Germanic ilk," he continues, "it was – despite its ban in 1941 – indelibly associated with Nazism. How did we bridge the chasm between Hitler and LeBron James? God only knows."

DESIGN FIRM: Peter Mendelsund Design DESIGNER: Peter Mendelsund CLIENT: Motherwost Records PRIMARY FONT: Fraktur (modified)

17

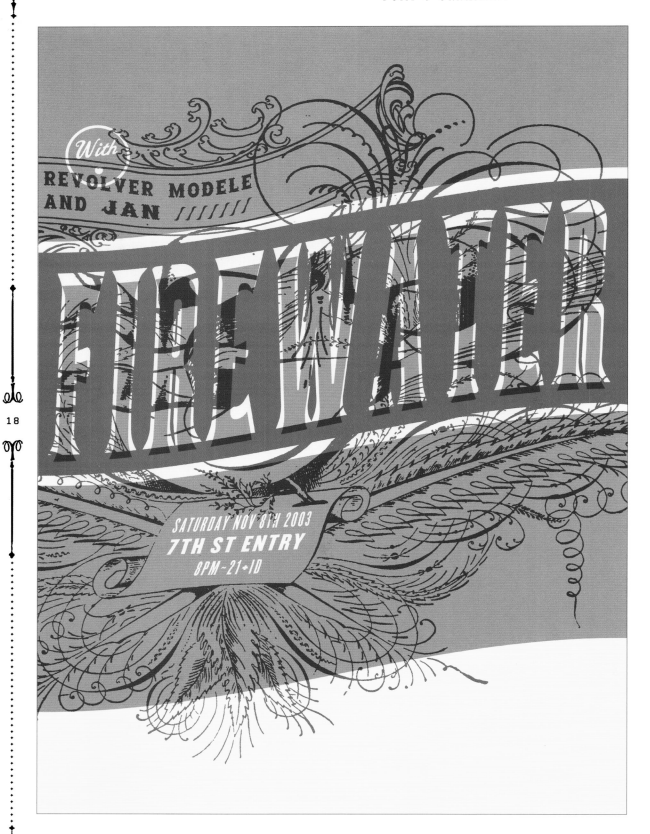

CIRCUS INSPIRED "Since the band was touring in support of an album called *The Man on the Burning Tightrope*, which had somewhat of a calliope meets punk sound," explains Dan Ibarra and Micheal Byzewski, "we wanted something somewhat circus-inspired." Their idea for this piece came from some of the early test prints that they had seen come out of Hatch Show Print. "We wanted a circus-gone-wrong/drunken production quality to the whole poster but still have it be legible." And so they did.

DESIGN FIRM: Aesthetic Apparatus
DESIGNERS: Dan Ibarra, Michael Byzewski CLIENT: The 7th St. Entry
PRIMARY FONT: Cinderella Regular

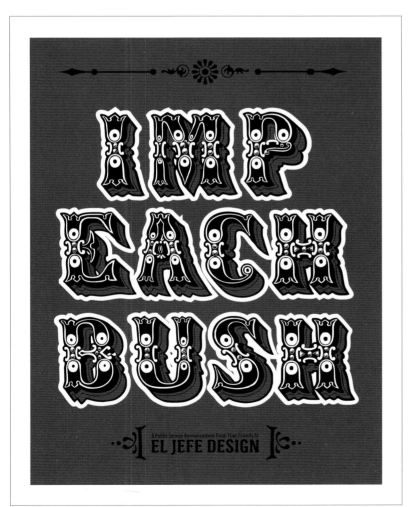

HANDWROUGHT INITIALS Illustrated, decorative woodcut letter forms are common. These handwrought initials derive from this tradition and combine various symbols of life (flowers), death (the devil), and the human spirit (the heart).
ILLUSTRATOR: Joel Rendon CLIENT: Alberto Ruy Sanchez PRIMARY FONT: La Mano

POLITICAL STATEMENT Jeffrey Everett claims he wanted to bring a certain level of "over-classiness and fun" to a protest poster. He was inspired by an interview with a Republican lobbyist, who lived in an ornately styled Rococo house but complained that Democrats were not in touch with the "common man."
DESIGN FIRM: El Jefe Design DESIGNER/ ILLUSTRATOR: Jeffrey Everett CLIENT: El Jefe Design PRIMARY FONT: Azteak

19

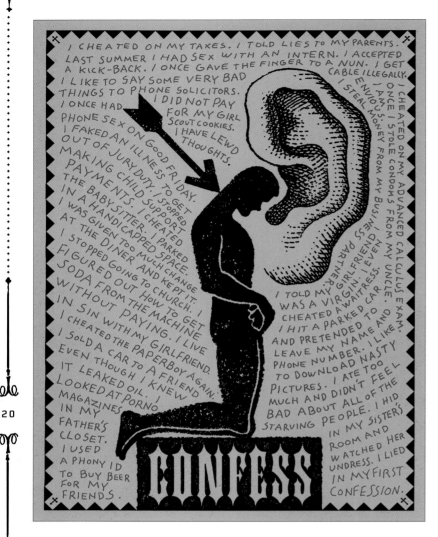

CONFESSIONAL DESIGN Catholicism rears its head in this poster through nineteenth-century engravings of religious icons as well as referencing the Stations of the Cross. The surrealism of this piece owes a debt to Christian votives and Salvador Dalí (who may have found his revelations in the same source).
DESIGN FIRM: Scorsone/Drueding ART DIRECTOR: Scorsone/Drueding DESIGNERS/ILLUSTRATORS: Joe Scorsone, Alice Drueding CLIENT: sdposters.com PRIMARY FONTS: Ironwood, handwriting

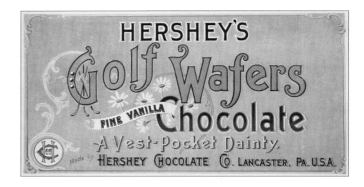

CANDY TYPE Elizabeth Morrow McKenzie was given the rare opportunity to sift through materials from Hershey's archive, including labels and advertisements, to create a collectible nostalgic collection of labels and packages.
DESIGN FIRM: Morrow McKenzie Design ART DIRECTOR: Brian Collins DESIGNER: Elizabeth Morrow McKenzie CLIENT: Ogilvy & Mather Brand Integration Group PRIMARY FONTS: Drawn, Courier (scanned from a woodtype book), Miehle, Typo Upright

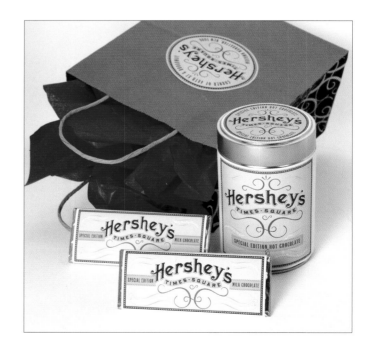

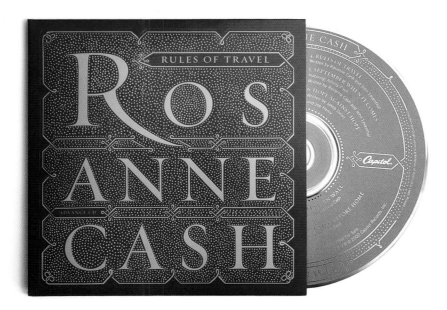

CASH CROP A well-known cover of *A Book of Scripts*, published in 1949 by King Penguin Books, was the direct inspiration for this CD cover. The classic lettering and Arts and Crafts ornament are almost identical, though the colors have been changed to make this version more vibrant.
DESIGN FIRM: Doyle Partners ART DIRECTOR: Stephen Doyle DESIGNER: Staci Mackenzie CLIENT: Capitol Records PRIMARY FONT: Requiem

JOYFUL LETTERING Daniel Pelavin's penchant for Victorian and Art Deco ornaments and lettering are fused in this cross-stylistic manifestation. With the addition of bright yellow and red, this salary guide looks like a million bucks.
DESIGN FIRM: Daniel Pelavin ART DIRECTOR: Mark Zisk DESIGNER/ ILLUSTRATOR: Daniel Pelavin PUBLISHER: Institute of Management Accountants PRIMARY FONT: Custom lettering

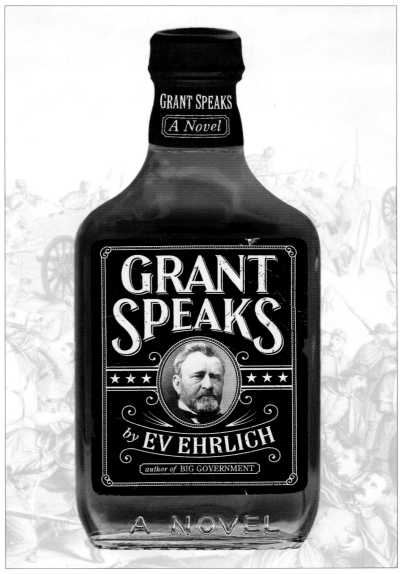

21

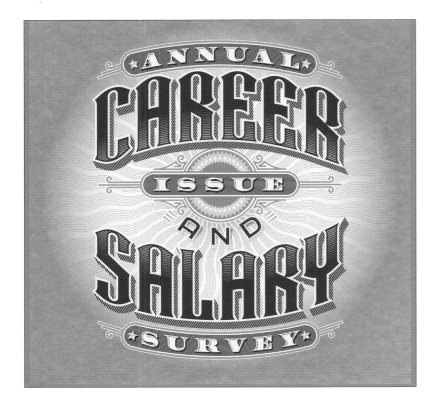

CHOICE BOURBON There can be no mistaking the Jack Daniels bourbon label and bottle as the primary referent here.
DESIGN FIRM: Jon Valk Design ART DIRECTOR: Jackie Merri Meyer DESIGNER: Jon Valk PHOTOGRAPHER: Corbis (background) PUBLISHER: Warner Books PRIMARY FONT: Handdrawn, based on a few old Photo Lettering fonts.

BLOUNT PARK

TWIGS AND TREES The "B" is meant to reference the rustic fences used at, and typical of, the popular Shakespearean theater at this public park. It was extracted and redrawn from an illuminated medieval initial.
DESIGN FIRM: Louise Fili Ltd ART DIRECTOR/ DESIGNER: Louise Fili CLIENT: Blount Park PRIMARY FONT: Handlettering

22

CALLING CARDS The elegant engraving type and illustration style has a clear lineage back to formal calling cards of the late nineteenth century. Gabriele Wilson further says she was drawn to old woodtype signage of the same period. It is notable that in this context, even the old looks new again.
DESIGN FIRM: Gabriele Wilson Design DESIGNER: Gabriele Wilson CLIENT: Anne Gibbs PRIMARY FONTS: AT Sackers family (Roman, Italian script), Bank Gothic

DADA SENSIBILITY While this composition suggests a Dada sensibility more than a nineteenth century one, the type is nonetheless derived, if not also lifted, from an old type catalog.
DESIGN FIRM: Pleasure DESIGNERS/ ILLUSTRATORS: Kevin Brainard, Matt McGuiness PRIMARY FONTS: Scanned woodtype, Clarendon (modified), Vitrina

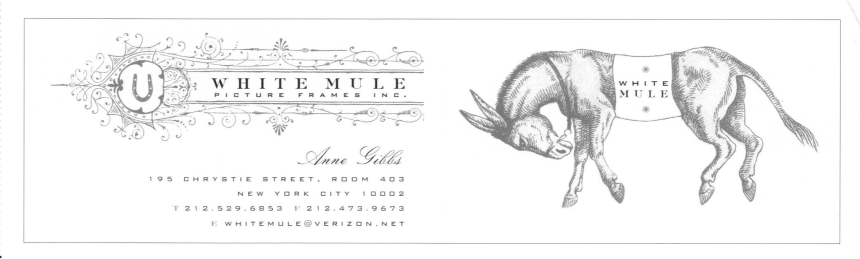

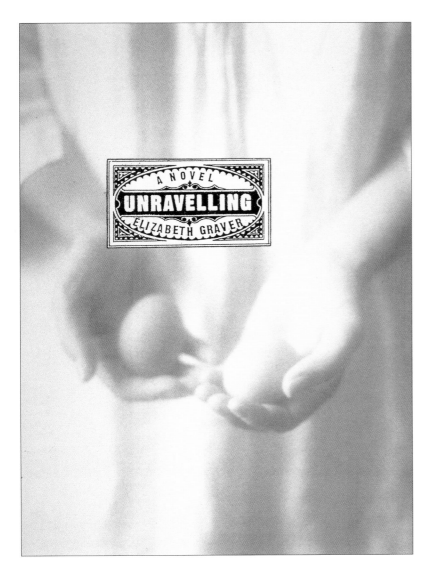

SKIN DEEP Photographs of old tattoos served as the inspiration here, but the type is too pristine for that painful method. Here, type from nineteenth-century engraving catalogs was lovingly copied and applied to the skin in a less painful fashion.
DESIGN DIRECTOR/DESIGNER: Roberto de Vicq de Cumptich
PHOTOGRAPHER: Frans Jansen PUBLISHER: HarperCollins
PRIMARY FONT: Blackletter

FOOD FOR TYPE Carin Goldberg notes her interest in nineteenth-century Victorian-styled American food packaging for the title panel of this jacket. Set against the contemporary photograph, it appears as a stamp or engraving.
DESIGN FIRM: Carin Goldberg Design
ART DIRECTORS: Victor Weaver, Carin Goldberg
DESIGNER: Carin Goldberg PHOTOGRAPHER:
Christine Rodin PUBLISHER: Hyperion PRIMARY
FONT: Woodtype (distressed using a photocopier)

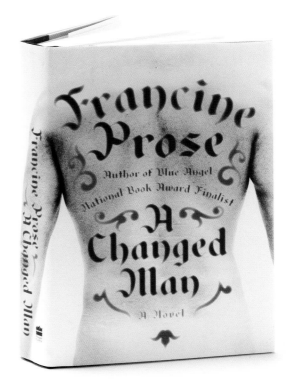

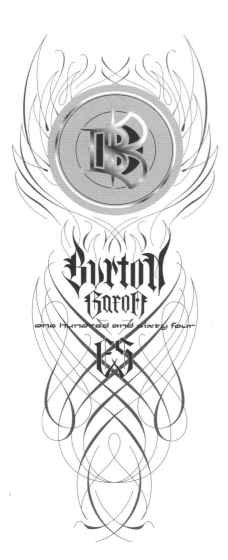

GOTHIC CALLIGRAPHY

Ironically, this logo for the leading American snowboard company has the look of a motorcyclist's tattoo. A marriage of Fraktur type styles and gothic calligraphy produces an ersatz satanic swirl and flourish that is common in much contemporary body art.

DESIGN FIRM: Jager Di Paola Kemp ART DIRECTOR: Michael Dabbs DESIGNER/ ILLUSTRATOR: Anthony Bloch CLIENT: Burton Snowboards PRIMARY FONT: Handlettering

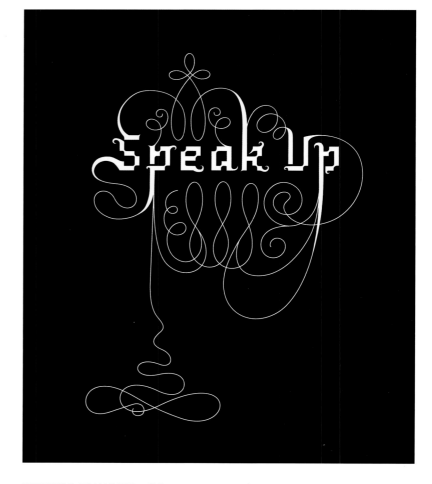

STRING THEORY If there were a string theory in graphic design, this logo would be part of it. The swirly swashes emanating from this scribe-inspired, ornate handlettering curls and swerves as though from a ball of thread.
DESIGNER: Marian Bantjes ILLUSTRATOR: Marian Bantjes (custom type)
CLIENT: Armin Vit/UnderConsideration

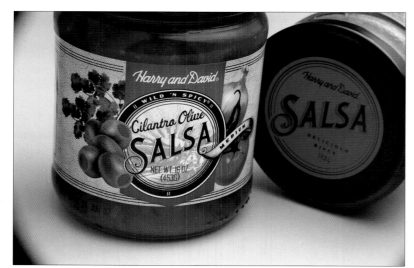

SALSA TYPE Type samples from letterheads, vintage seed packets and a specimen of typographic borders and ornaments from the Enschede type foundry combine to give these labels a distinctive period look.
DESIGN FIRM: Morrow McKenzie Design ART DIRECTOR: Elizabeth Morrow McKenzie ILLUSTRATOR: Jennifer Sbragia DESIGNERS: Mette Hornung Rankin, Elizabeth Morrow McKenzie CLIENT: Harry and David PRIMARY FONTS: Thick and thin serif, Billhead, Fenway Park, Agency Gothic

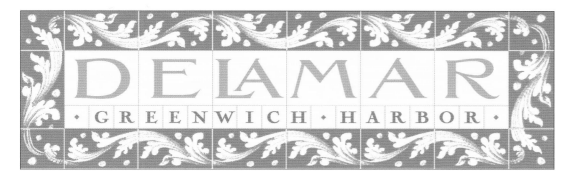

SICILIAN TILES Louise Fili, an orthodox Italo-phile says, "This motif comes from my collection of sign photos from Sicily." The motif's tiles may not be the orange, green and white of Sicily, but are adapted to a waterfront palate for a seaside restaurant.
DESIGN FIRM: Louise Fili Ltd ART DIRECTOR/DESIGNER: Louise Fili
CLIENT: Delamar at Greenwich Harbor PRIMARY FONT: Handlettering

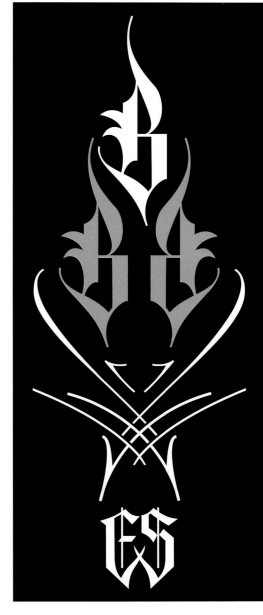

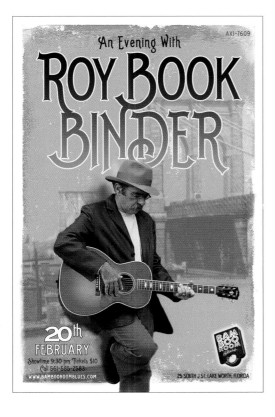

TYPE MUSIC Mike Rivamonte notes that this tribute to Roy Book Binder's humble beginnings with Blind Reverend Gary Davis started in Jamaica, Queens, New York. The type and image suggest the tenor of old New York.
DESIGNER: Mike Rivamonte PHOTOGRAPHER: Peston Poe CLIENT: Bamboo Room PRIMARY FONT: Billhead

25

FLAMING BLACK LETTERS "Gothic and Fraktur styles of type and earlier calligraphic traditions," says Anthony Bloch, are the key inspirations for a snowboard logo that give the illusion of a typographic flame.
DESIGN FIRM: Jager Di Paola Kemp ART DIRECTOR: Michael Dabbs DESIGNER/ILLUSTRATOR: Anthony Bloch CLIENT: Burton Snowboards PRIMARY FONT: Handlettering

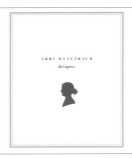
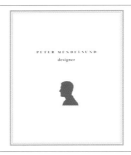
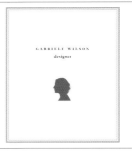

JOHN STEINBECK

No. of Shots
Distance
Score
Name

The **MURDER**

CALLING CARDS Interpretations of the classic silhouette portraits made during the Victorian era and before. Rather than being nostalgic for a time that is long gone, the design evokes a literary sensibility that is appropriate for all periods.
DESIGNER: Gabriele Wilson PHOTOGRAPHER: Peter Mendersund PUBLISHER: Alfred A. Knopf PRIMARY FONT: Eldorado

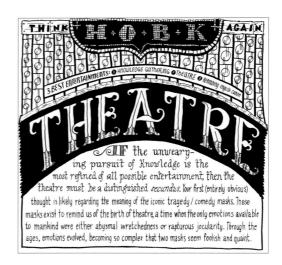

HYBRID ADS The nineteenth-century is written all over this hybrid of Victorian and Art Nouveau typography. The stark black-and-white image is reminiscent of the small space print advertisements found in newspapers of those eras.
DESIGN FIRM: Co. & Co. DESIGNER/ ILLUSTRATOR: Ray Fenwick PUBLISHER: The Coast Weekly PRIMARY FONT: Handdrawn

BULLS EYES Jonathan Gray borrowed the motif of vintage animal shooting targets to evoke a low-key, though ironic, sense of mayhem in this murder mystery by one of America's greatest novelists.
DESIGN FIRM: Gray318 ART DIRECTOR: John Hamilton/Penguin Books, UK DESIGNER/ ILLUSTRATOR: Jonathan Gray PUBLISHER: Penguin Books PRIMARY FONTS: Handlettering

THE SCENT OF TYPE The elegant swash script comes directly from vintage perfume and sundry labels dated between the eighteenth and nineteenth centuries. As with all adaptations, the centuries are bridged for stylistic license.
ART DIRECTOR: John Gall DESIGNER: Gabriele Wilson PHOTOGRAPHER: Erwin Von Dessauer PUBLISHER: Vintage Books PRIMARY FONTS: Brickham Script, Vineta, Clarendon BT, AT Sackers English Script

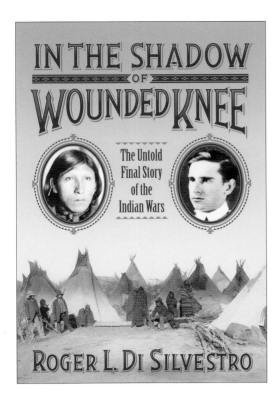

ELECTRIC ELECTROTYPE Daniel Pelavin is a master of lettering as image. These derivations of late-nineteenth-century decorative wood and electrotypes complement the classic American Indian images borrowed from the Library of Congress historical photography collection.
DESIGN FIRM: Daniel Pelavin ART DIRECTOR: Krystyna Skalski DESIGNER: Daniel Pelavin PHOTOGRAPHERS: John C. Grabill, L. T. Butterfield PUBLISHER: Bloomsbury/Walker PRIMARY FONTS: Custom lettering, Birch

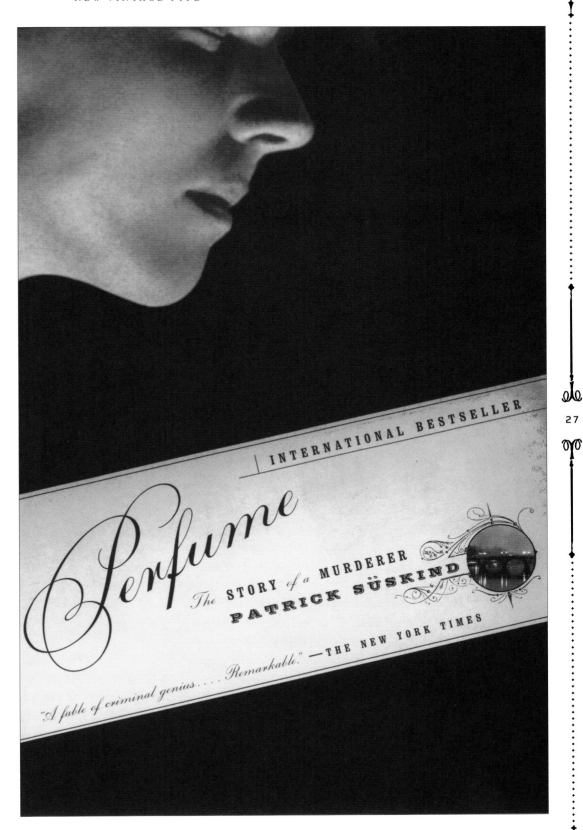

ABCDEFGHI
JKLMNOPQ
RSTUVWXYZ
abcdefghijklm
nopqrstuvwxyz

ABCDEFGHI
JKLMNOPQ
RSTUVWXYZ
abcdefghijklm
nopqrstuvwxyz

28

ABCDEFGHI
JKLMNOPQ
RSTUVWXYZ
abcdefghijklm
nopqrstuvwxyz

BLACK IS BEAUTIFUL Blackletter type springs from northern European roots, the traditional or "volk" style of Germany. It comes in various forms, some more spiky than others. In this example, Fakir weds Art Nouveau and Fraktur into a curious hybrid that is at once authoritarian and lyrical.
DESIGN FIRM: Underware ART DIRECTORS/ DESIGNERS/CLIENT: Underware PRIMARY FONT: Fakir – a blackletter with a holy kiss

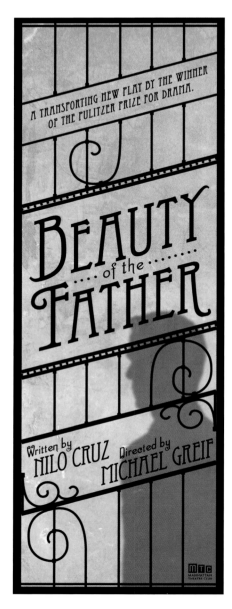

A TRANSPORTING NEW PLAY BY THE WINNER OF THE PULITZER PRIZE FOR DRAMA.

BEAUTY
of the
FATHER

Written by
NILO CRUZ
Directed by
MICHAEL GREIF

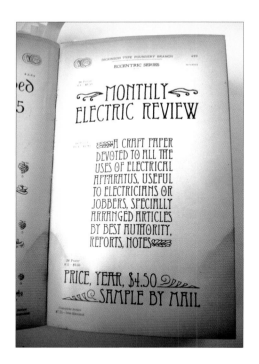

DICKINSON TYPE FOUNDRY BRANCH
ECCENTRIC SERIES

MONTHLY
ELECTRIC REVIEW

A CRAFT PAPER DEVOTED TO ALL THE USES OF ELECTRICAL APPARATUS, USEFUL TO ELECTRICIANS OR JOBBERS, SPECIALLY ARRANGED ARTICLES BY BEST AUTHORITY, REPORTS, NOTES

PRICE, YEAR, $4.50
SAMPLE BY MAIL

MVSEO D LAS CASAS REAIES

NOUVEAU VICTORIAN This mixed-up type, a cross between Victorian and Art Nouveau stylization, evokes the ornate sensibility of the *fin de siècle*.
DESIGN FIRM: SpotCo ART DIRECTOR: Gail Anderson DESIGNER: Jessica Disbrow CLIENT: Manhattan Theatre Club PRIMARY FONT: Eccentric Std.

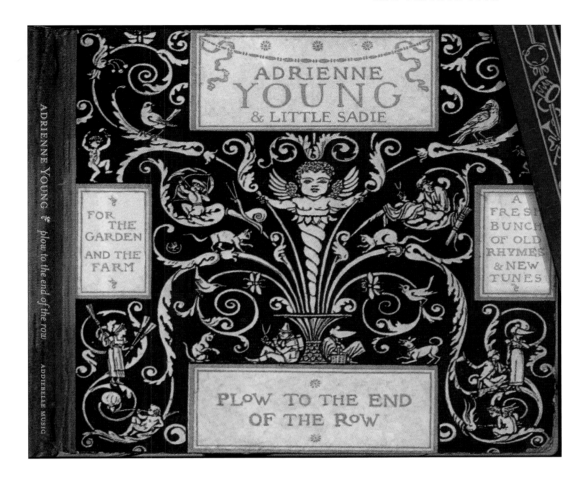

REMIX ROCOCO The CD recalls a book of early-twentieth-century children's stories designed in a rococo manner common to eighteenth-century book title page design, and revived in American advertising around the mid-1910s and early 1920s. In addition to handwriting, the fundamental letter forms are an eclectic mix of ornamented Victorian metal and woodtype faces.
DESIGN FIRM: Jami Design ART DIRECTOR/DESIGNER/PHOTOGRAPHER: Jami Anderson ILLUSTRATOR: Unknown/found CLIENT: AddieBelle Music PRIMARY FONTS: Reconstructed type, Palatino, Mrs Eaves

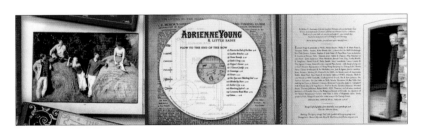

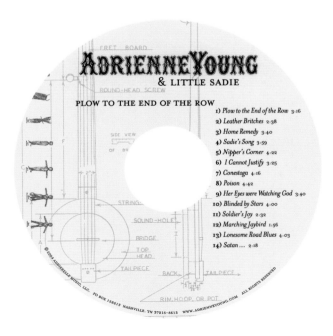

MODERNISME The Rayo imprint of HarperCollins publishes fiction and non-fiction by Latino writers. Mucca Design found the inspiration for the logo in Modernisme, Spain's turn-of-the-century brand of Art Nouveau. The spiral motif was inspired by wrought-iron architectural details, and the curled shapes serve nicely as a metaphor for unfurling – perfect for a publisher. The letter forms are organically contoured as a counterpoint to the geometry of the spirals.

DESIGN FIRM: Mucca Design ART DIRECTOR: Matteo Bologna DESIGNER: Andrea Brown PUBLISHER: HarperCollins PRIMARY FONT: Rayo

ORNAMENTAL TENDENCIES

30

With both a Spanish and Art Deco accent, this ornamental typeface is adapted in such a way that it echoes two past stylistic eras while finding a place in the present.

DESIGN FIRM: Mucca Design

ART DIRECTOR/ DESIGNER: Matteo Bologna

PRIMARY FONT: Decora

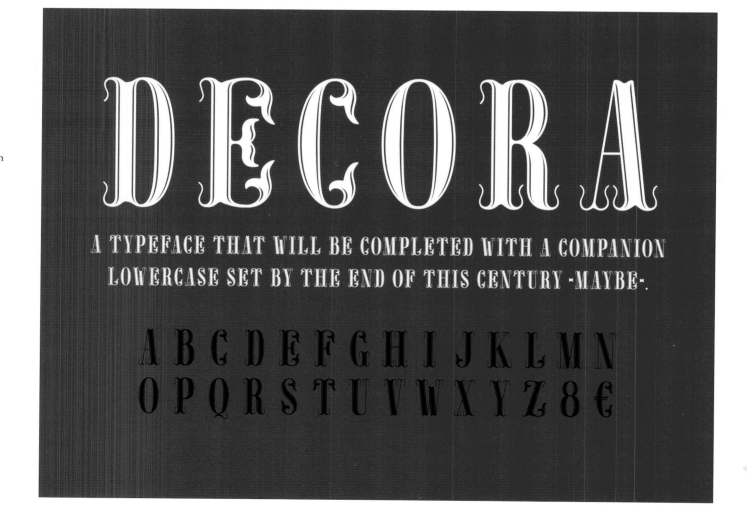

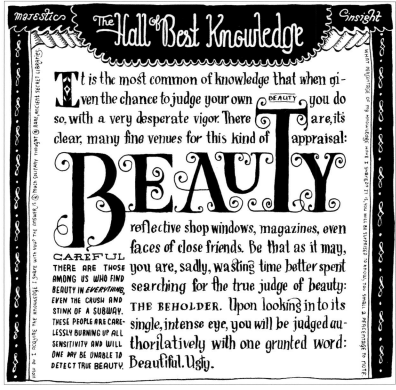

PARALLEL TYPE WORLDS Drawing (literally) from various past styles, Ray Fenwick has produced a uniquely parallel typographic world. His faces defy exact historical categorization, but derive from the fonts that job printers used to make type advertisements jump out of small spaces on the printed page.
DESIGN FIRM: Co. & Co. DESIGNER/ILLUSTRATOR: Ray Fenwick PUBLISHER: The Coast Weekly
PRIMARY FONT: Handdrawn

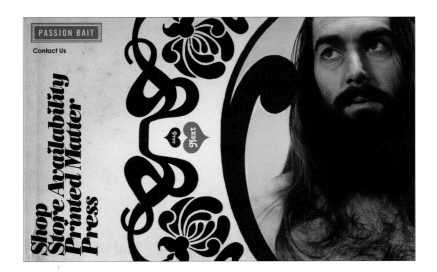

SQUIGGLES AND ZINES The Art Deco ornament dominates this odd concoction of curvilinear squiggles and what Rob Alexander describes as, "vintage handmade adult zines from the sixties and seventies."
DESIGN FIRM: Tank ART DIRECTOR: Ben Segal DESIGNER: Rob Alexander
PHOTOGRAPHER: Stephen Rose CLIENT: Passion Bait PRIMARY FONTS:
Bodoni, Tango

31

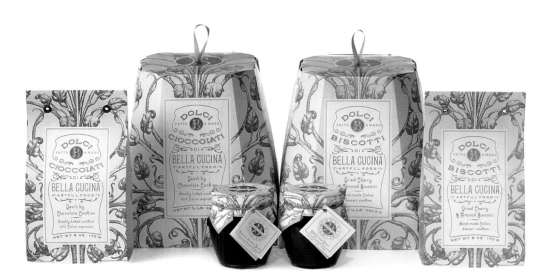

FROM THE ARCHIVE For this spirited nineteenth-century aesthetic, lettering was drawn from bits and pieces of type specimens collected from Louise Fili's extensive archive, then pieced together into a new font.
DESIGN FIRM: Louise Fili Ltd ART DIRECTOR: Louise Fili DESIGNERS: Louise Fili, Mary Jane Callister CLIENT: Bella Cucina PRIMARY FONT: From personal archive

PASTICCERIA INSPIRED This decorative composition is based on 1930s designs from Italian *pasticceria* papers, which often repeat the basic logo or trademark. The lettering comes from a collection of eclectic sources and are juxtaposed to give the logo a period air.
DESIGN FIRM: Louise Fili Ltd ART DIRECTOR: Louise Fili DESIGNERS: Louise Fili, Mary Jane Callister CLIENT: Pink Door PRIMARY FONT: Handlettering

FROM GERMANY The main typeface and accompanying decorations derived from a specimen from Ehmcke Rustica by Schriffgiesserei D. Stempel/AG/Frankfurt am Main, dated 1914, which was redrawn and cleaned up for this jacket.
DESIGN DIRECTOR/DESIGNER: Roberto de Vicq de Cumptich
PHOTOGRAPHER: Photo, courtesy of the author PUBLISHER: HarperCollins
PRIMARY FONTS: Tekon, Moal Gothic

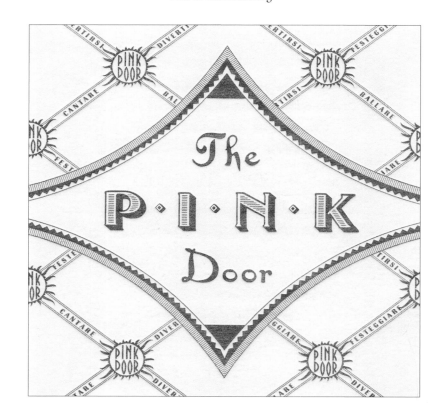

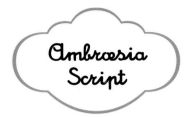

Ambroesia Script

Aa Bb Cc Dd Ee Ff Gg Hh Ii Ll Mm Nn
Oo Pp Qq Rr Ss Tt Uu Vv Ww Xx Yy Zz
1234567890,.-

PATRON SAINT Mucca Design was commissioned to update the logo for Sant Ambroeus, a traditional Milanese restaurant. The original logo, drawn in 1936 when the restaurant was established, is in an irregular script – a style typical of the time. When the logo was redrawn, the aim was to preserve its distinct style and warmth. Mucca created two companion typefaces, basing one on the unusual script printing on Sant Ambroeus's illustrated wrapping paper, and one based on a sans serif face found on packaging from the Art Deco era. "By incorporating elements from their existing materials, such as a cloud motif that evokes Saint Amboeus, the patron saint of Milan and the restaurant's namesake, a modern identity was built that is contemporary while still celebrating the restaurant's history," explains Matteo Bologna.
DESIGN FIRM: Mucca Design ART DIRECTOR: Matteo Bologna DESIGNER: Andrea Brown CLIENT: Sant Ambroeus PRIMARY FONTS: Ambroesia Script, Ambroesia Text

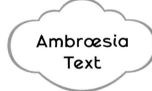

Ambroesia
Text

Aa Bb Cc Dd Ee Ff Gg Hh Ii Ll Mm Nn
Oo Pp Qq Rr Ss Tt Uu Vv Ww Xx Yy Zz
1234567890,.-

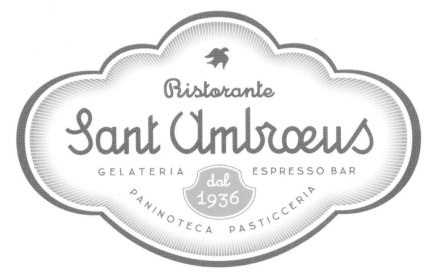

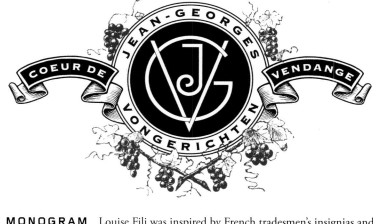

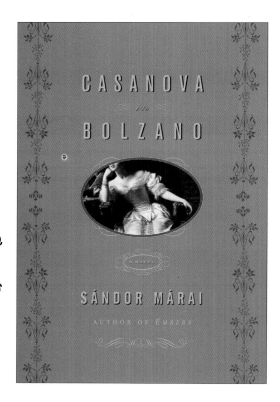

34

VINTNER'S MONOGRAM Louise Fili was inspired by French tradesmen's insignias and monograms from the late nineteenth century, used to identify different vintners and wineries. She combined it with modern Gothic initials to create the Jean-Georges Vongerichten marque.
DESIGN FIRM: Louise Fili Ltd ART DIRECTOR/DESIGNER: Louise Fili CLIENT: Jean-Georges Vongerichten
PRIMARY FONT: Handlettering

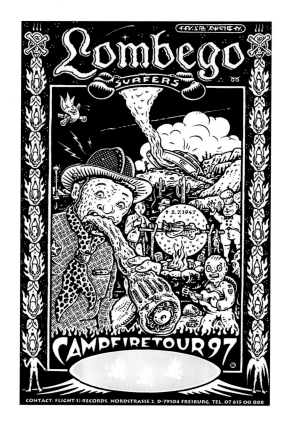

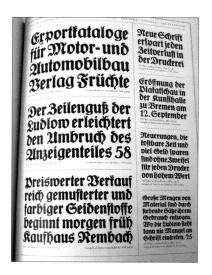

TYPE FOR LOVERS The look of sheet music from mid-nineteenth-century Europe imbues the jacket for this period novel with a sense of history. Though more simplified than the rococo iterations of the original time period, this suggests a time when Casanova was a mythical figure, as a lover.
DESIGN FIRM: Peter Mendelsund Design ART DIRECTOR: Carol Carson DESIGNER: Peter Mendelsund PUBLISHER: Alfred A. Knopf PRIMARY FONTS: Trade Gothic, AT Sackers, English Script

ALIEN TYPE The ornamental lettering suggests a nineteenth-century interest in blackletter, but illustrates mid-twentieth-century obsession with Roswell – the presumed sight of an alien landing from outer space.
ILLUSTRATOR: Dirk Bonsma
CLIENT: Lombego Surfer, Flight 13

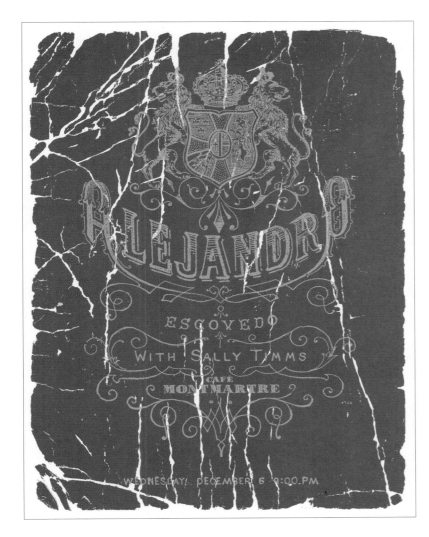

GOLD LEAF This flyer combines the look of those leather-bound tomes with the extravagant gold leaf typographic embossing so common in fine drawing rooms and the typography of early-nineteenth-century sheet music. It is also weathered enough – or too much – to give it the allure of a real artifact.

DESIGN FIRM: Planet Propaganda ART DIRECTOR: Kevin Wade DESIGNERS: Dan Ibarra, Michael Byzewski CLIENT: Café Montmartre PRIMARY FONT: Found type

THE CONSERVATORY LOOK "We'd recently gotten our hands on old *Avant Garde* magazines and this motivated us to do some research on Herb Lubalin, Ed Benguiat and the ITC in general," explains Seripop. "The handlettered text – made out of a combination of Bookman, Souvenir, Tiffany and Century – seemed appropriate for a poster that was going to represent two shows with a very varied line-up. We based the main theme of the design on the 'official' name of the venue since we were not working with a headliner in particular, leading us to create our idea of what The Conservatory would look like as the main image. The poster was for two separate shows: one was a more heavy metal, hardcore show and the other, an indie pop show. We tried to find mutual ground by basing our design theme around the venue and the location of the show."

DESIGN FIRM: Seripop CLIENT: The Conservatory PRIMARY FONTS: Handlettering, Perspective – a Solotype novelty type from Dover books.

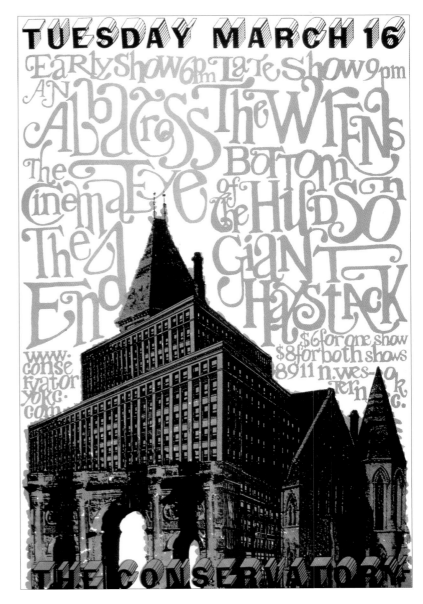

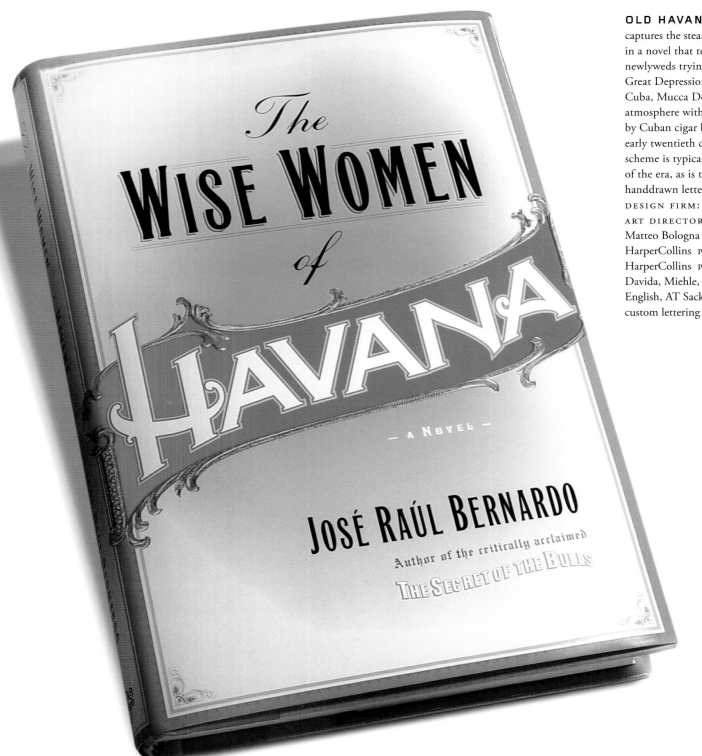

OLD HAVANA Just as the author captures the steamy climate of Havana in a novel that tells the story of two newlyweds trying to survive the Great Depression as it affects pre-war Cuba, Mucca Design captures the atmosphere with a cover inspired by Cuban cigar box design from the early twentieth century. The color scheme is typical of Cuban packaging of the era, as is the typography and handdrawn lettering and filigree. DESIGN FIRM: Mucca Design ART DIRECTOR/DESIGNER: Matteo Bologna CLIENT: HarperCollins PUBLISHER: HarperCollins PRIMARY FONTS: Davida, Miehle, Engravers Old English, AT Sackers English Script, custom lettering

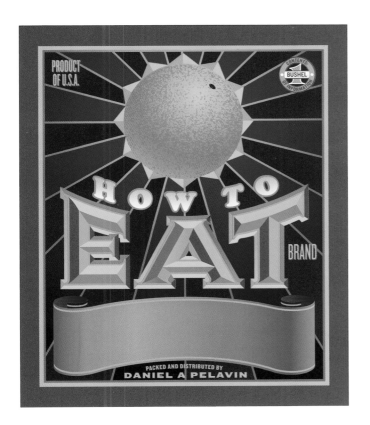

37

LAVISH LETTERING Daniel Pelavin collects the detritus of graphic culture for the raw material for his lavish lettering compositions. This typographic scheme is based entirely on American orange crate labels, an indigenous art produced by scores of anonymous artists and designers.
DESIGN FIRM: Daniel Pelavin ART DIRECTOR: Kristen Fitzpatrick
DESIGNER/ILLUSTRATOR: Daniel Pelavin PUBLISHER: *O, The Oprah Magazine*/Hearst PRIMARY FONTS: Custom lettering, Copperplate

SCROLLWORKS The pixelated scrollwork that has become a signature of Marian Bantjes's designs derive from both a Medieval metallurgy (signs and gates) and illuminated manuscripts.
DESIGNER/ILLUSTRATOR: Marian Bantjes CLIENT: Rick Valicenti/Playground Project 2004 PUBLISHER: Thirst PRIMARY FONT: Pixelle (almost)

CIGAR BANDS Cigar bands – the ring of die-cut paper that surrounds the top of most cigars – come in many forms but usually follow the same basic style. Daniel Pelavin borrowed the form and exaggerated the typography for this book cover with attitude.
DESIGN FIRM: Daniel Pelavin ART DIRECTOR: Matt Strelecki DESIGNER: Daniel Pelavin PUBLISHER: Meredith Corporation PRIMARY FONT: Custom lettering

38

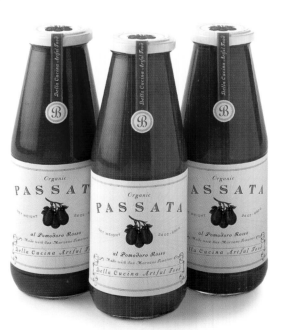

PACKAGES AND LABELS Although the bottles are contemporary, the label is inspired by French and Italian packaging design from the early twentieth century. The typeface is a composite of various display faces used on packages and labels, though composed without the typical ornamentation of the era.
DESIGN FIRM: Louise Fili Ltd ART DIRECTOR/ DESIGNER: Louise Fili CLIENT: Bella Cucina PRIMARY FONT: From personal archive

COMMEDIA DEL ARTE "I have no idea what the provenance of the Bujardet font is, but it looks (to my eye, anyway) like the old French typeface, Par Excellence," admits Peter Mendelsund. He adds that this theater poster was meant to evoke the French *commedia del arte* and street-performing culture of the nineteenth century.
DESIGN FIRM: Peter Mendelsund Design DESIGNER: Peter Mendelsund CLIENT: Company of Strangers PRIMARY FONT: Bujardet

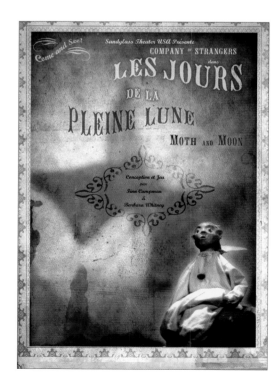

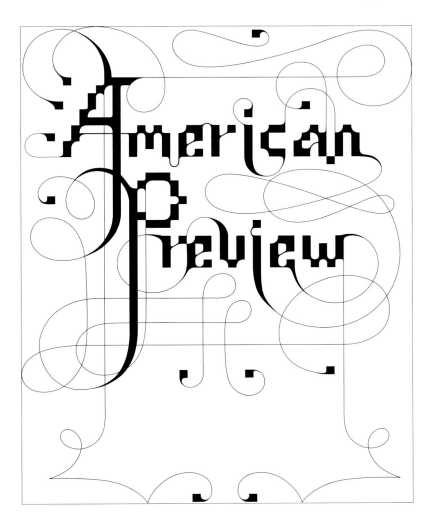

OSTENTATIOUS FLOURISHES Marian Bantjes combines various references in this curiously contemporary return to the ornamental past. The calligraphic line draws on nineteenth-century handiwork. The bitmapped style suggests early computer typography but also the woven samplers so common in eighteenth- and nineteenth-century homes. The ostentatious flourishes further suggest a homage to the curvilinear eccentricities of Art Nouveau.
DESIGNER/ILLUSTRATOR: Marian Bantjes
PUBLISHER: *Details* magazine/Fairchild Publications
PRIMARY FONT: Handlettering

EXOTIC EXPRESSION "This is a potpourri of exotic influences," says Peter Mendelsund, such as Muslim (Persian) miniatures, Chagall paintings, and vintage advertising posters.
DESIGN FIRM: Peter Mendelsund Design ART DIRECTOR: Carol Carson DESIGNER: Peter Mendelsund ILLUSTRATOR: Brian Cronin PUBLISHER: Alfred A. Knopf PRIMARY FONTS: Alparma, AT Sackers Script, Bujardet

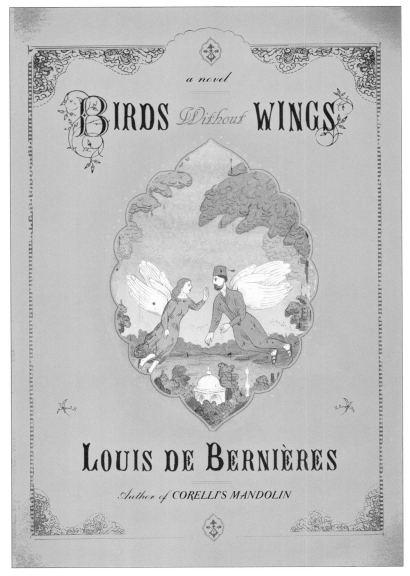

39

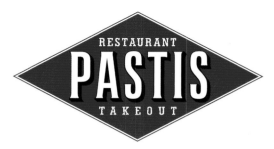

ENAMEL DESIGN Pastis is a Parisian-styled café/restaurant with menus painted on the mirrors and vintage rattan chairs. The logo is rooted in the aesthetics of the trade where enameled signs have been affixed to French restaurant façades since the early twentieth century.
DESIGN FIRM: Mucca Design ART DIRECTOR/DESIGNER: Matteo Bologna CLIENT: Keith McNally PRIMARY FONT: Handlettering

STREET JEWELRY Enamel sign lettering was the favored form of identification and advertising at the turn of the nineteenth century and a sizable industry for lettering craftsman and fabricators of outdoor signs, or "street jewelry." The type for this sign interprets the vintage lettering common to all sign makers.
DESIGN FIRM: Daniel Pelavin ART DIRECTOR: Jane McCampbell DESIGNER: Daniel Pelavin PUBLISHER: DFS Group PRIMARY FONT: Custom lettering

MUSICAL SCORES "I tried to emulate the typography one would find in the frontispieces of musical scores dating from the early nineteenth century," says Peter Mendelsund. The scripts and ornament were taken from electrotype catalogs of the same era.
DESIGN FIRM: Peter Mendelsund Design ART DIRECTOR: Carol Carson DESIGNER: Peter Mendelsund PUBLISHER: Alfred A. Knopf PRIMARY FONTS: Opti Leon, Bickham Script

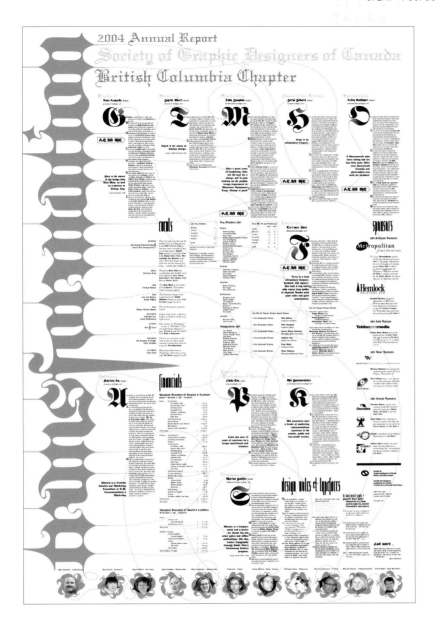

INDELIBLE MODELS The spiky blackletter produced in countless iterations by German type foundries during the early to late nineteenth century, provides indelible models for Marian Bantjes to follow.
DESIGNER/ILLUSTRATOR: Marian Bantjes CLIENT: Society of Graphic Designers of Canada, British Columbia Chapter PRIMARY FONTS: Wittenberger Fraktur, Monarchia, Plagwitz-Gotisch, Fette Fraktur, Brea, Auferstehung, Deutsch-Gotisch, Sebaldus-Gotisch, Bastard

LABEL VERISIMILITUDE When the pastiche works, it is difficult to tell the inspired from the inspiration. Jon Valk's sampling of the classic Levis label is a perfect example, from the lettering to the patina on the leather label.
DESIGN FIRM: Jon Valk Design ART DIRECTOR: Kathleen Lynch DESIGNER/ILLUSTRATOR/PHOTOGRAPHER: Jon Valk PUBLISHER: Oxford University Press PRIMARY FONTS: Newtext, Trade

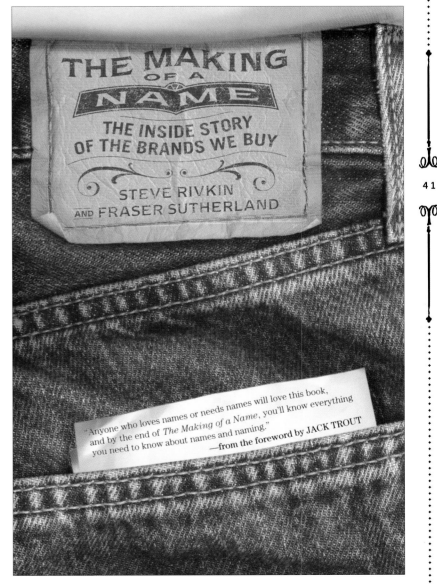

41

GERMANIC SWASHES This display title is derived directly from a rare type specimen sheet for Kleukens–Antiqua, printed by the leading German foundry, Bauersche Giesserei. With its swashes and curlicues, this decidedly feminine face evokes the lyrical essence of the word "Nectar."
DESIGN DIRECTOR/DESIGNER: Roberto de Vicq de Cumptich ILLUSTRATOR: Alexander Marshal
PUBLISHER: HarperCollins PRIMARY FONT: Bulmer MT

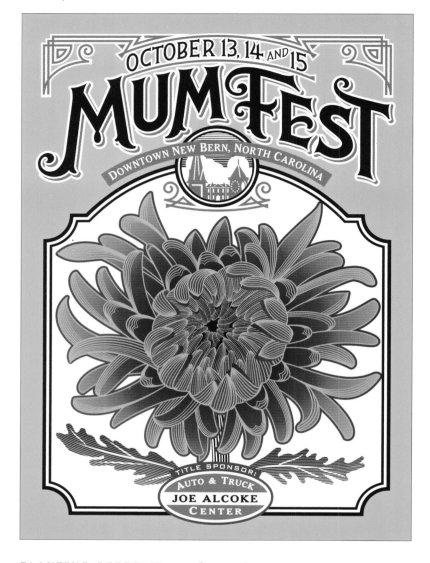

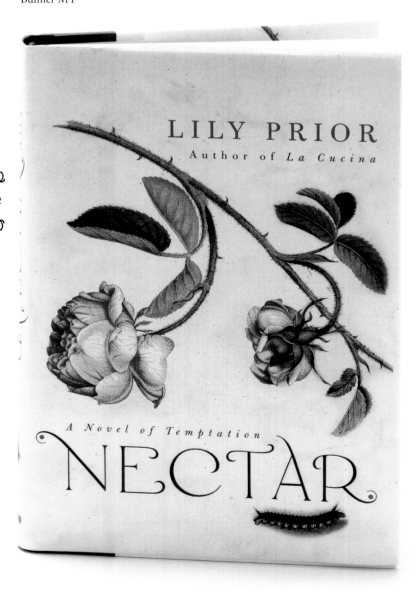

PLANTING SEEDS Victorian flower seed packets all conformed to a distinctive typographic style with a stark, colorful chromolithographic image of the flower in a decorative frame. Daniel Pelavin draws on the Victorian obsession for ornament in this pastiche of the times.
DESIGN FIRM: Daniel Pelavin ART DIRECTOR: Chris Rhyne DESIGNER/ILLUSTRATOR: Daniel Pelavin CLIENT: Littleton Advertising
PUBLISHER: New Bern, NC Chamber of Commerce
PRIMARY FONTS: Custom lettering, Cheltenham

42

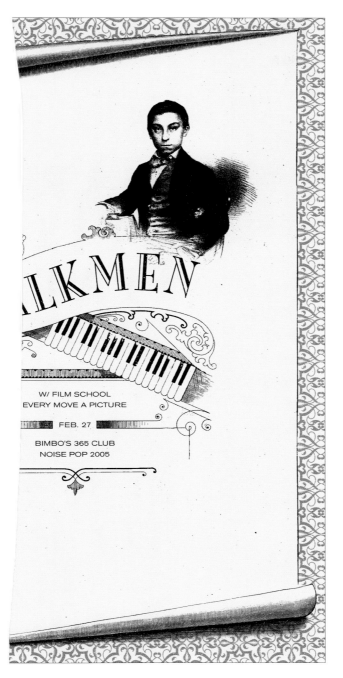

SHEET Californi... the rest o... DESIGN ...is poster was overtly inspired by a collection of sheet music from the 1800s found at the Oakland Public Library in ...nts from different covers to make a new image. He notes that the "W" was a found original typeface of the period, while ...d in the updated Bursten.

DIRECTOR/DESIGNER: Jason Munn CLIENT: Noise Pop PRIMARY FONT: Bursten

FRIEDRICH NIETZSCHE WHY I AM SO WISE

I know my fate. One day there will be associated with my name the recollection of something frightful—of a crisis like no other before on earth, of the profoundest collision of conscience.

Penguin Books **Great Ideas**

44

FROM ECCE HOMO The Art Nouveau handlettering is based on the title page by Henry Van der Velde, first director of the Bauhaus, for Nietzsche's *Ecce Homo* (*c*.1908), which Fredrik Marns found in the book by Nicolette Grey, *Lettering as drawing* (Taplinger, 1971).
DESIGN FIRM: Phil Baines for Penguin Books ART DIRECTORS: David Pearson, Jim Stoddart DESIGNER: Phil Baines LETTERING: Fredrik Marns PUBLISHER: Penguin Books PRIMARY FONTS: Handlettering with Imprint (Monotype)

NOT TRAJAN "I wanted to suggest Roman inscriptions without using the predictable Trajan typeface," exclaims Phil Baines. And Mantinia, a revival of fifteenth-century reinterpretations of classical Roman letter forms, had much more life.
DESIGN FIRM: Phil Baines for Penguin Books ART DIRECTORS: David Pearson, Jim Stoddart DESIGNER: Phil Baines PUBLISHER: Penguin Books PRIMARY FONT: Mantinia (Matthew Carter/Carter & Cone)

MARCUS AURELIUS · MEDITATIONS · A LITTLE FLESH, A LITTLE BREATH, AND A REASON TO RULE ALL—THAT IS MYSELF · PENGUIN BOOKS GREAT IDEAS

FROM THE BIBLE "I used early printed bibles as my main influence," says David Pearson, "linking Browne in terms of his position as both scientist, philosopher, Christian, politician, and social being. The inclusion of the skull alludes to the fact that knowledge is transient and that our perception is simply a collection of 'isolated lights in the abyss of ignorance.'" The thin, high setting is intended to make the skull look as if it has fallen. As the period determines, a "long S" is used within the word and a "Roman S" ends the word.

DESIGN FIRM: David Pearson at Penguin Books ART DIRECTORS: David Pearson, Jim Stoddart DESIGNER: David Pearson PUBLISHER: Penguin Books PRIMARY FONT: FF (FontFont) Johannes G.

Sir Thomas
Browne
Urne-Burial
Penguin Books ◆
Great Ideas
Life is a pure flame,
and we live by an
invisible Sun
within us

API
Chri
on fi
was
histo
DES
Pear
PRI

es notes, "There is no early
ine, but Vere Dignum (based
e crudeness and simplicity that
words more than the

ks ART DIRECTORS: David
BLISHER: Penguin Books
ype)

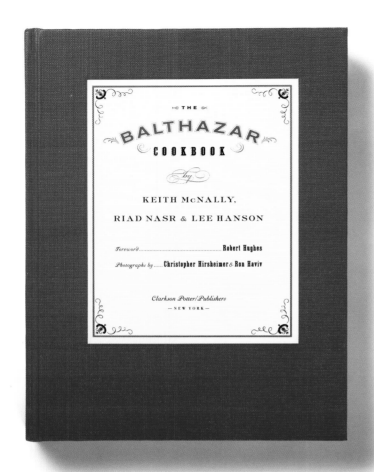

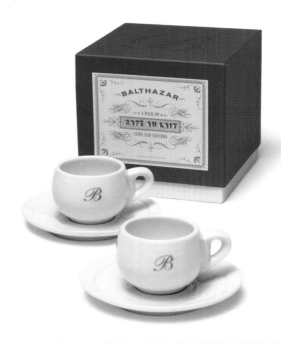

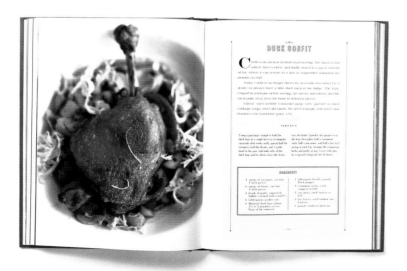

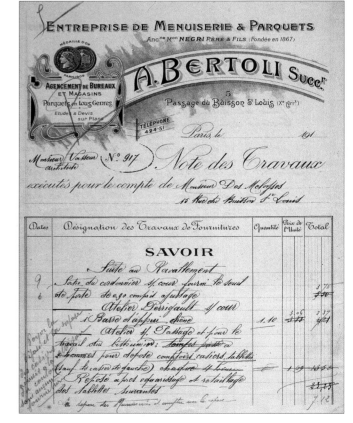

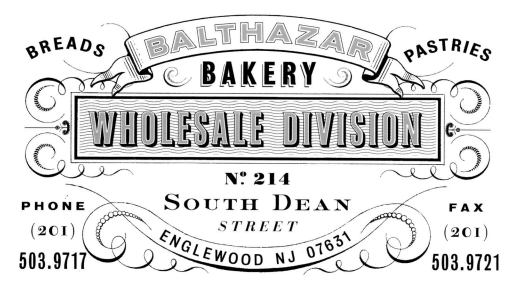

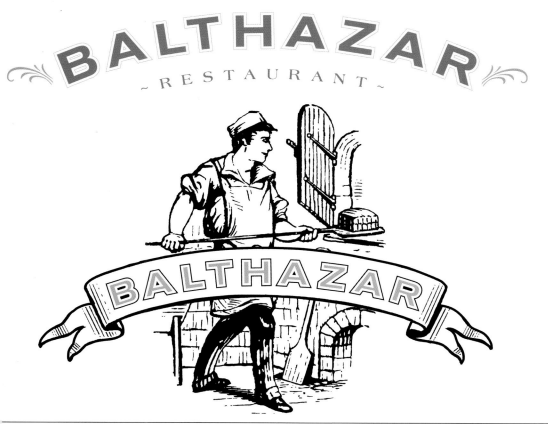

SO FRENCH This overall typographic identity was for Keith McNally's Balthazar restaurant based on signage typical of early-nineteenth-century French brasseries and an historic style that is still very much alive in Paris today. "After researching Victorian typography," says Matteo Bologna, "we organized a cohesive group of typefaces to create a weathered, romantic, turn-of-the-century mood that adapts well to various applications. The various designs are unified by Balthazar's bold signature colors – a rich carmine red which is embellished with metallic copper accents." For the packaging of Balthazar's *café au lait* cups, a new typeface was created based on samples found in a Charles Derriey-type catalog from the mid-nineteenth century. The ornate Victorian letter forms create a new addition to the identity system and marry well with the standing Balthazar style.

DESIGN FIRM: Mucca Design ART DIRECTOR: Matteo Bologna DESIGNERS: Christine Celic Strohl (cup box), Matteo Bologna (logo), Matteo Bologna, Victor Mingovits (book) CLIENT: Keith McNally PUBLISHER: Clarkson Potter (book) PRIMARY FONTS: Decora (Matteo Bologna); Sackers Gothic, Rockwell, custom (cup); Akzidenz-Grotesk (logo); Miehle, FF Bodoni Classic, Engravers MT, Americana, Modern 20, Bickham Script, Bureau Grotesque (book)

47

SLABS

WOODTYPE WAS POPULARIZED DURING THE late nineteenth century, but its antecedent dates back to around the fifth, when the Chinese invented printing using wood blocks (a process known as Xylography) to copy sacred texts. This involved engraving fixed characters into a single piece of wood that was then printed on treated paper. Xylography came to Europe around the fourteenth century but was superseded by Gutenberg's development of moveable type in the mid-1450s. This revolution led to the advent of metal typefaces, which made typesetting individual characters, words, sentences, and paragraphs easier and more elegant. It has been the printing and

typographic standard since the respective photographic and digital type revolutions of the late twentieth century.

During the early nineteenth century, however, as an alternative to hot metal type founding, woodtype came into fashion, especially in large sizes for advertisements and posters. To make woodtype, engravers carved individual letters from wood cut perpendicular to the grain. This technique lost those fine and ultra thin lines achievable with metal type, but it gained a slew of bold, highly contrasting faces available at sizes

GOTHICS

THE WOODTYPE ERA

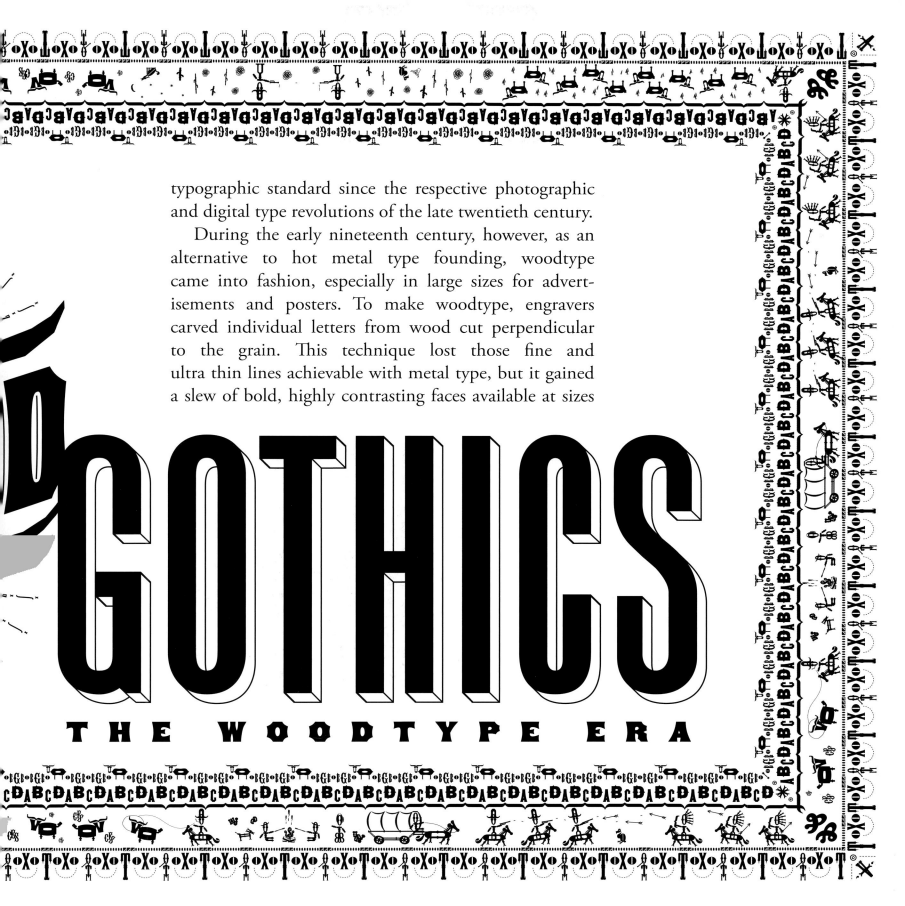

OLD TYPE CAMP
Ross MacDonald is one of a growing number of hot metal and woodtype archeologists who keep the presses running and make sure students (like these from the School of Visual Arts MFA Design program) keep their hands in the ink pots.

50

larger than with metal. Dark gothics and slab serifs were well suited for wood, and certain shadowed, in-lined, and outlined letters were also concocted to add dimension to the printed page.

The primary users were commercial craftsmen known as "job printers," who produced posters and handbills for the businesses of their day. Depending on the availability of complete fonts, job printers combined various size and style of letters together in one composition. Since woodtype fonts were fairly large, cumbersome, and degraded after repeated use, the smaller print shops could not always warehouse or maintain a complete set of fonts. Out of necessity, a distinct graphic mannerism developed, characterized by multiple dissonant type styles and sizes.

Woodtype is best known today as the letter form of choice during the late nineteenth century for theater bills, patent medicine advertisements, and circus posters. They remain such emblems of these genres that faux woodtype faces are still used, sometimes nostalgically but also without pretense, for contemporary bills advertising state fairs and carnivals. They were also commonly used on Western "wanted" posters, and to this day woodtype evokes the Wild West – or at least the Disneyfied "Frontierland" version. By the early nineteenth century, woodtype styles were decidedly out of vogue, initially replaced by eccentric, curvilinear Art Nouveau faces, sober Arts and Crafts styles, and finally by more elegant letter forms, although quirky handlettered approaches were always in use.

With the advent of early-twentieth-century Modernism, woodtype was revived by radical artists and typographers as an alternative to the bourgeois or archaic design mannerisms. Trade, News, and Railroad gothics and slab serifs were considered brutal compared to the finer, pristine cuts of Bembo, Jenson, and Garamond, and so were more appealing to the radical art and design movements such as Futurism, Dadaism, and Surrealism, whose designers used woodtype because it was cheap, but also to fly in the face of aesthetic propriety. These artists deliberately, and often randomly, scattered woodtypes (or woodtype-derived faces) throughout their ad hoc manifestoes and broadsides, turning a blind eye to the nuances of finessed type.

"Brut Modernism" was replaced, in turn, by the more refined, minimalist, asymmetric "New Typography," which was influenced by Constructivism and the Bauhaus. Woodtype was, once again, sent to the hellbox for a few decades. Its renaissance took until the late 1950s, when Push Pin Studios began reviving all sorts of passé forms, such as Victorian, Art Nouveau, and Art Deco. Soon various mainstream and small magazines started using slab serif faces, most notably *Monocle*, a satiric journal published in a long narrow format akin to old handbills. The influential New York type house Photo-Lettering, Inc., began issuing an extensive assortment of redrawn woodtypes, and the smaller, though popular Morgan Press, Inc., sold original woodtype cuts to advertising agencies and others.

By the mid-1960s, alternative "underground" newspapers introduced old typefaces (the *East Village Other* logo was based on an exaggerated slab serif cut), and psychedelic poster artists liberally drew from vintage woodtype specimen books, although they made the type vibrate and shimmy using fluorescent inks and optically challenging color combinations.

Bold gothics and slab serifs are among today's most popular rediscovered and revamped typefaces. Their eccentricity seems to appeal to designers who are bored with modernist purity and early digital anarchy. Representing a pre-modern era of type design, this style is provocative for its sheer antediluvian-ness in the Digital Age. Using it does not, however, make the designer a Luddite (most of what is shown in this section was done on computer) but it does reveal an interest in defying proscribed fashions.

Yet while some designers do it to be contrary, others work with woodtype out of appreciation for antique methods. Design schools are increasingly adding print or type shops supplied with original woodtypes (purchased from a growing number of collectors or closed job printers). This may not indicate a full-fledged revival, but the growth in woodtype fanciers does reflect the desire, in the face of digital perfection, to return to a curiously refreshing, messy period of typographic history.

ANTIQUE TUSCAN CONDENSED
EGYPTIAN BOLD
CONCAVE TUSCAN X CONDENSED
GOTHIC TUSCAN 9 NARROW
MANSARD EXTRA BOLD
FRENCH ANTIQUE CONDENSED
SKELETON ANTIQUE LIGHT
WILLIAM PAGE 506 MEDIUM
PACEJOR BOLD
GOTHIC SPECIAL

LONG LIVE WOOD Jordan Davies has been interested in woodtype design for many years. While he dreams of designing an original text face, he prefers to work on revivals of the quirky American woodtype designs of the nineteenth century. "The originality inherent in these typefaces, as seen in large broadsides from the period, is interesting to me because the choice of wood as a material in which to create is very American."

DESIGNERS: William Page Company, Hamilton Company, Vanderburgh, Wells & Company, Steven Shanks CLIENT: woodentypefonts.com.

51

[A B C D E F G H I J K L M
52
N O P Q R S T U V W X Y Z]

MIXING AND MATCHING Alexander Isley explains that he was influenced by handbills from the early days of printing, and by how printers would mix and match fonts to emphasize thoughts or passages. "We took this to an extreme by creating a tall, narrow format," he says. While the vintage references are exact, there is also a contemporary sensibility at play, showing that not everything drawn from the past is pure nostalgia.

DESIGN FIRM: Alexander Isley Inc. ART DIRECTOR: Alexander Isley DESIGNER: Carrie Leeds CLIENT: Brooklyn Academy of Music PRIMARY FONTS: Various

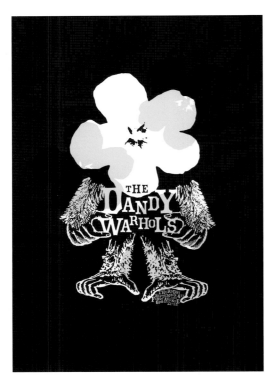

GOING CIRCUS "Circus type," or what might also be termed, "bifurcated Tuscan," has been the inspiration for many a rock'n'roll poster for its ornate theatrical aesthetic. "The Dandy Warhols were touring on a record called 'Welcome to the Monkey House,'" says Michael Byzewski. "We wanted to mimic the feel of the disembodied monkey limbs and this old circus typeface did just the trick."

DESIGN FIRM: Aesthetic Apparatus DESIGNERS: Michael Byzewski, Dan Ibarra CLIENT: First Avenue PRIMARY FONT: Hometown

A THOUSAND BITS OF TYPE 6 Pence None the Richer is a Christian band from Nashville, the wellspring of old woodtype concert and county fair posters, from which this poster drew its inspiration. Yee-Haw Industries, in effect, channels this vernacular tradition. Kevin Bradley, who savors these original sources, notes, "This was an assembled piece culled from many thousands of bits of type in our collection."

DESIGN FIRM: Yee-Haw Industries DESIGNER: Kevin Bradley CLIENT: 6 Pence None the Richer PRIMARY FONTS: Various woodtype/cuts

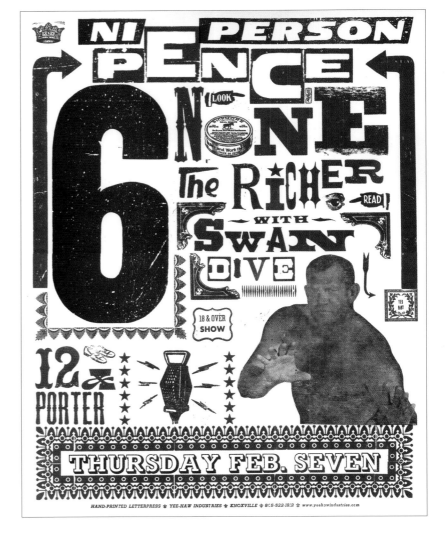

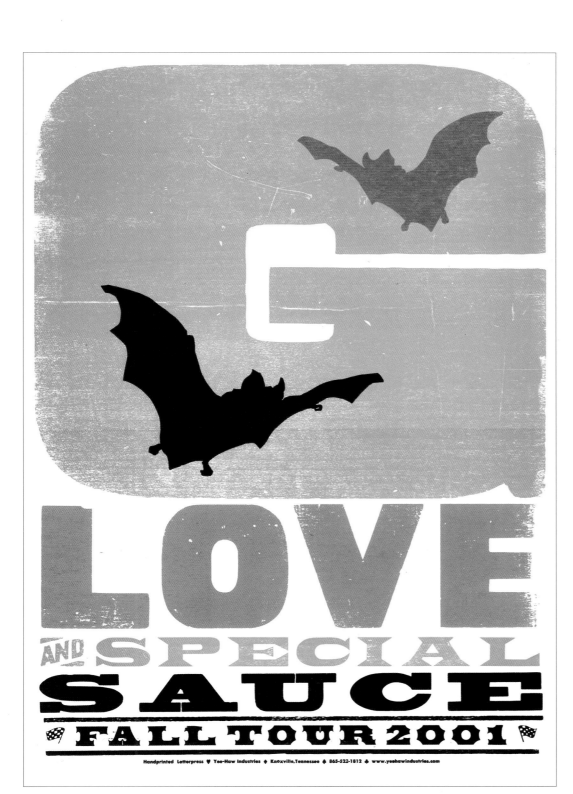

A CLASH OF FACES Each band on this poster is known for a somewhat "heavy" sound, so Michael Byzewski and Dan Ibarra chose the newly digitized Poster Bodoni to suggest heaviness. "We also liked how varying the size of the type made it seem as if each band name was fighting for attention, which lends itself well to the aggressive nature of the poster," says Byzewski about the clash of faces that overlap each other.

DESIGN FIRM: Aesthetic Apparatus DESIGNERS: Michael Byzewski, Dan Ibarra CLIENT: 7th St. Entry PRIMARY FONT: Poster Bodoni

NASHVILLE TYPES All these types come from huge woodtypes designed for poster use only. But the color palette, which gives it a contemporaneous aura, was based on the current weather and season in Nashville. "At the time this poster was printed," recalls Julie Belcher, "the largest print we could produce was 18" x 28". We had acquired this large type and would seize any opportunity to use it. The large 'G' is 90 picas tall." And it fits perfectly.

DESIGN FIRM: Yee-Haw Industries ART DIRECTOR: Julie Belcher DESIGNER/ILLUSTRATOR: Adam Hickman Ewing CLIENT: G Love & Special Sauce PRIMARY FONTS: Gothic woodtype of many heights, widths and ages. The other face used is a sort of expander Latin. The word "Sauce" was carved into linoleum and based upon the smaller face above.

[A][B][C][D][E][F][G][H][I][J][K][L][M] 54 [N][O][P][Q][R][S][T][U][V][W][X][Y][Z]

YE OLDE BROADSIDE If this book cover resembles a Western "wanted" poster, it is because Jon Valk drew inspiration from nineteenth-century broadsides – the early forms of advertising that relied almost exclusively on woodtypes and were composed by everyday job printers.
DESIGN FIRM: Jon Valk Design ART DIRECTOR: Kathleen Lynch DESIGNER: John Valk CLIENT: Oxford University Press PUBLISHER: Alfred A. Knopf
PRIMARY FONTS: Tapeworm, Rosewood, Carimbo

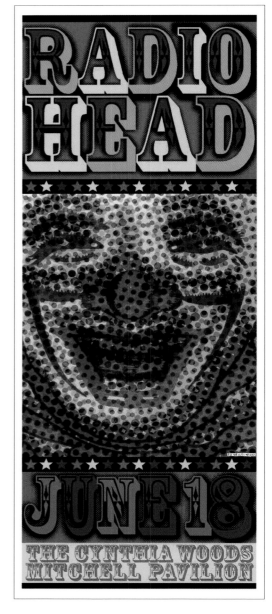

THREE RING TYPE CIRCUS Charlie Hardwick admits that old Western and circus posters are what nourishes his typographic eclecticism. Here, the promotion for this Radiohead concert delves deep into vintage troves to produce a thoroughly modern graphic artifact.
DESIGN FIRM: Uncle Charlie ART DIRECTOR/DESIGNER: Charlie Hardwick CLIENT: Pace Concerts PRIMARY FONT: Rosewood

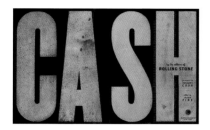

SCULPTURAL CASH There is nothing more sculptural than a case of variously sized and differently colored woodtype. Gail Anderson purchased a disk containing scans of woodtype blocks years back, and was thrilled to finally get a chance to show them off. "They were just gorgeous," she recalls fondly. DESIGN FIRM: SpotCo ART DIRECTOR: Gail Anderson DESIGNERS: Jessica Disbrow, Sam Eckersley CLIENT: Random House PRIMARY FONT: John Housley's woodtype

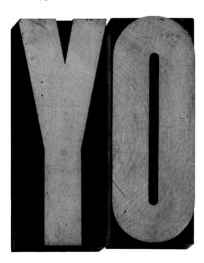

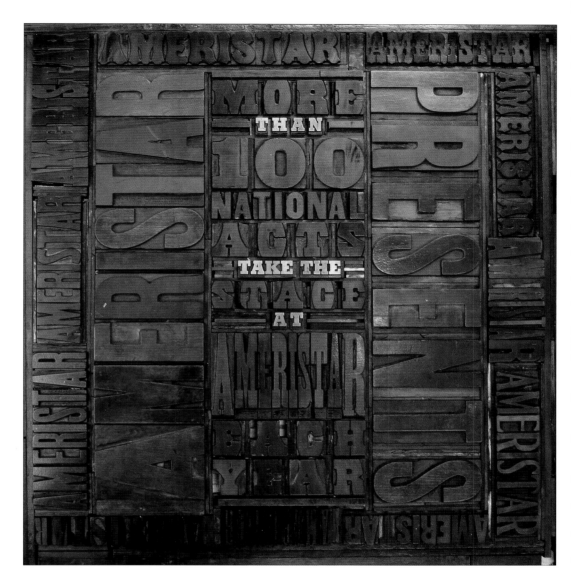

IN THE TYPE CASE The 127-year-old history of Hatch Show Print is based entirely on its huge and varied collection of vintage wood. For this tightly layered composition, the actual letters fill a case that dramatically spells out the message. DESIGN FIRM: Hatch Show Print/Relay Station ART DIRECTORS: Josh Baker, Hillary DuMoulin/Eleven Incorporated DESIGNER: Jim Sherradan PHOTOGRAPHER: Bob Delevante CLIENT: Ameristar Casinos PRIMARY FONT: Rock-Grain Maple from the archive at Hatch Show Print.

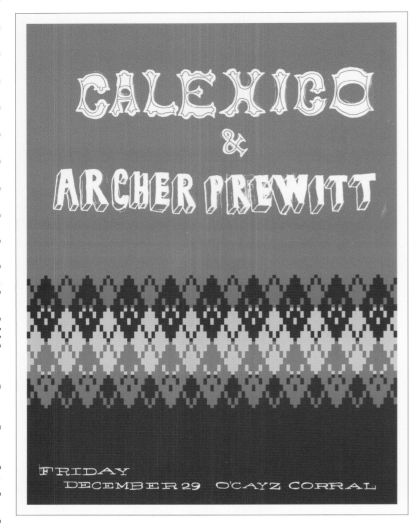

JUMBLED SERIFS Alexander Isley notes that this contemporary slab serif assemblage is a marriage of nineteenth-century broadsides and *Rolling Stone* magazine layouts. The overlapping Egiziano was also a design trope of the late 1980s and early 1990s.

DESIGN FIRM: Alexander Isley Inc. ART DIRECTOR/DESIGNER: Alexander Isley CLIENT: Columbus Society of Communicating Arts PRIMARY FONT: Egiziano

ARGYLE TYPE "Mainly we wanted to create type on the poster that felt like the music that Calexico played," says Dan Ibarra and Michael Byzewski about the quirky band that is, "somewhat country, somewhat ranchero or mariachi but dirty and ragged around the edges." They drew type inspired from woodtype catalogs that they say they had lying around as, "We thought it felt like that emotion."

DESIGN FIRM: Aesthetic Apparatus DESIGNERS: Dan Ibarra, Michael Byzewski CLIENT: O'Cayz Corral PRIMARY FONTS: Hand-rendered type inspired by the found woodtype faces, Balderdash and Helenic.

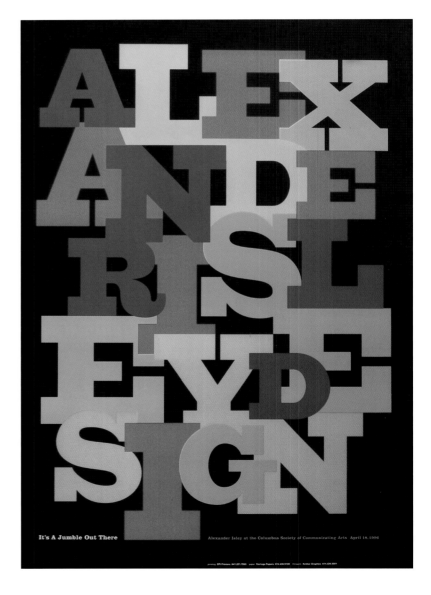

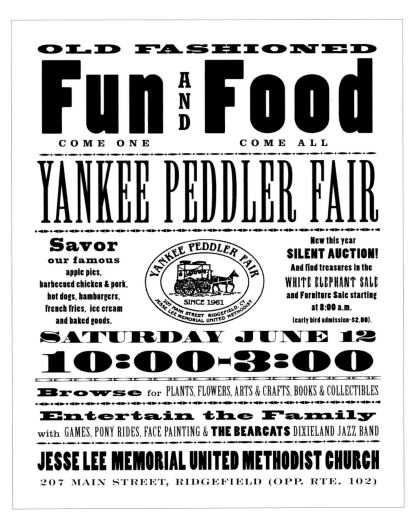

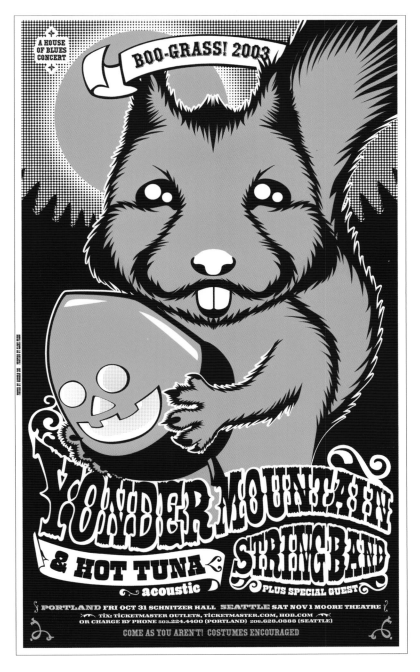

BIG AND BOLD How many fonts can a designer fit on a page? When Alexander Isley is the designer, the answer is an infinite number. For the bold display selected here, he says, "we were inspired by old handbills that mixed a variety of typefaces for emphasis and effect."
DESIGN FIRM: Alexander Isley Inc. ART DIRECTOR/DESIGNER: Alexander Isley CLIENT: Jesse Lee Memorial U.M.C. PRIMARY FONTS: Black Oak, Willow, Birch, Rockwell, Clarendon, Engravers Roman, Ironwood, Madrone, Popular

NUTS AND BOLTS Although the demonic squirrel could have come from any naturalist tome, Junichi Tsuneoka insists the overall poster owes a debt to the heavily-ornamented product labels and packages so common in nineteenth-century emporia.
DESIGN FIRM: Modern Dog ART DIRECTOR/DESIGNER/ILLUSTRATOR: Junichi Tsuneoka CLIENT: House of Blues PRIMARY FONTS: Handlettering, customized woodtype

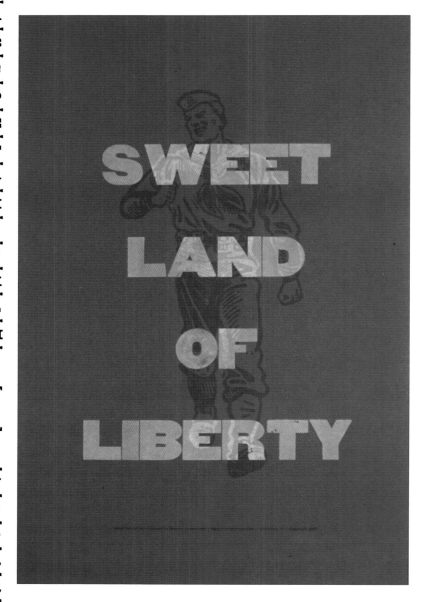

A
B
C
D
E
F
G
H
I
J
K
L
M

58

N
O
P
Q
R
S
T
U
V
W
X
Y
Z

PATRIOT GAMES The inspiration for this poster came from those patriotic wartime posters of the 1940s and 1950s. "The phrase was important and the subtle soldier in the background always working hard is everything we stand for and who [the soldier] keeps us safe," says Casey McGarr. "It's sort of a whisper that reminds us of our freedom."
DESIGN FIRM: Bargarr Letterpress DESIGNER/ILLUSTRATOR: Casey McGarr PRIMARY FONTS: Gothic Extended woodtype, hand-carved linoleum figure

HANDBILL REDUX Three influences converge in this fairly true copy of a nineteenth-century handbill: American woodtype introduced in the book by the same name authored by Rob Roy Kelly; American circus posters, so common during the mid-1800s; and those dubious American slave broadsides advertising new shipments of human stock.
DESIGN FIRM: Art Chantry Design Co. ART DIRECTOR/DESIGNER: Art Chantry CLIENT: Freemont Theater PRIMARY FONTS: Historical woodtype faces

STORE WINDOW CHIC Edwin Vollebergh explains that this truly loving facsimile of a chromolithographic bill was based on an old "letterfont/printer/specimen/samplebook," designed for nineteenth-century store window and sign painters to copy from.
DESIGN FIRM: Studio Boot ART DIRECTOR/
DESIGNERS: Petra Janssen, Edwin Vollebergh
CLIENT: Helga Voets & Paulo Van Vliet PRIMARY
FONTS: Folio, Clarendon

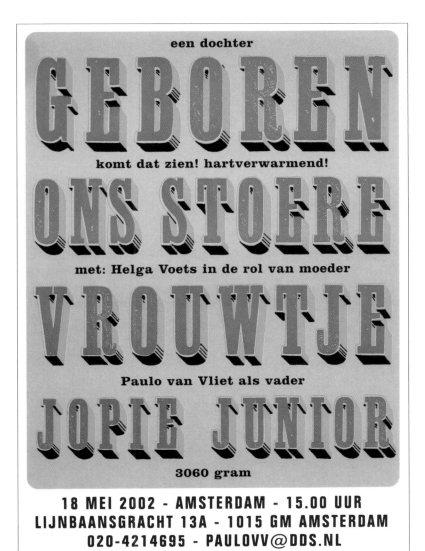

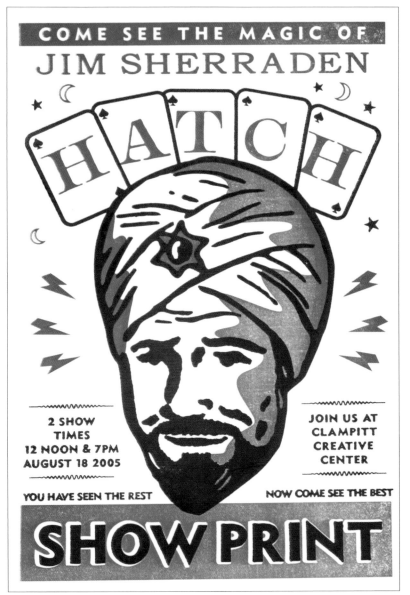

MAGICAL TYPE The type used here was as similar to old handbills or broadsides as Casey McGarr could find. "The magic of letterpress was the metaphor," he says about the poster honoring the proprietor of Hatch Show Prints. "Capture the mystical powers of Jim Sherraden and what he does, like the mystic of the magicians eighty years ago."
DESIGN FIRM: Bargarr Letterpress DESIGNER/ILLUSTRATOR: Casey McGarr
PRIMARY FONTS: Mercantile, sans serif black

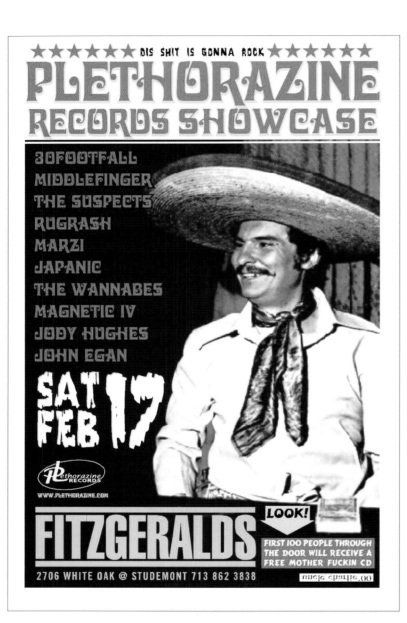

BUNDLE OF JOY "Once again, Jim Sherraden, the Hatch Show manager and chief designer, allowed me to wander around the type drawers of Hatch asking nothing (but to bring a large coffee – light, no sugar – when you come)," explains Bob Delevante about this printed announcement celebrating the birth of his son. In fact, he says the arrival of Ben "Knockerboy" Delevante was a perfect opportunity to use contrasting Heavy Gothic and Script typefaces, without anybody telling him not to. DESIGN FIRM: Relaystation DESIGNER/PRINTMAKER: Bob Delevante CLIENT: Self PRIMARY FONTS: Gothic No 2., Styles Script courtesy of Hatch Show Print

ORGANIZED ORNAMENTATION For this re-creation of an old piano roll label, Christian Helms was inspired by Victorian packaging. The type was printed on actual old piano scrolls of the kind once used to run vintage piano players. DESIGN FIRM: The Decoder Ring DESIGNER: Christian Helms CLIENTS: The Decemberist & PMC Presents PRIMARY FONT: Opti Emporium Ten

TYPOGRAPHICA MEXICANA Certain vernaculars become popular graphic conceits and in recent years, Mexican type and ornaments have captured designers' imagination. Here, Uncle Charlie references vintage Mexican movie posters as the primary source. DESIGN FIRM: Uncle Charlie ART DIRECTOR/DESIGNER: Charlie Hardwick CLIENT: Fitzgerald's PRIMARY FONT: Davida

NUMBERS AND STARS Carin Goldberg found some pages at a Barcelona flea market from a 1930s newsprint wall calendar, and wanted to design something similar. She had her chance with this concert poster that uses old numerals and comparatively new starburst dingbats.
DESIGN FIRM: Carin Goldberg Design DESIGNER: Carin Goldberg CLIENT: Gabriella Kiss PRIMARY FONTS: Woodtype, Poster Bodoni

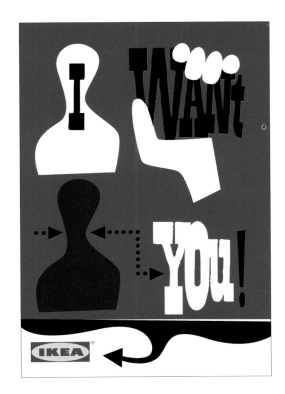

MODERNIST FOLLY This blending of mini-malist, though humorous, graphic elements derives in large part from posters by "Saul Bass, Paul Rand, and Jean Arp," says Laurie Rosenwald, as they routinely combined a little old and a little new in their typo-graphic compositions.
DESIGN FIRM: Rosenworld.com ART DIRECTOR: Steve Kulp DESIGNER/ILLUSTRATOR: Laurie Rosenwald CLIENT: IKEA North America PRIMARY FONT: Italienne

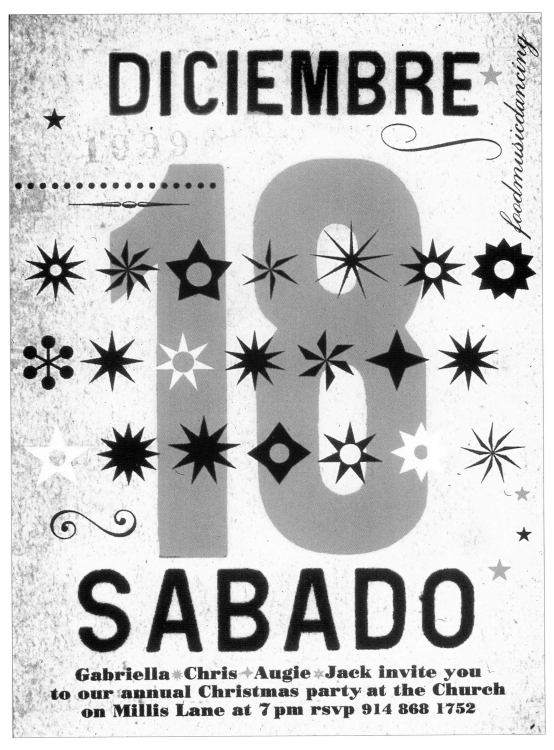

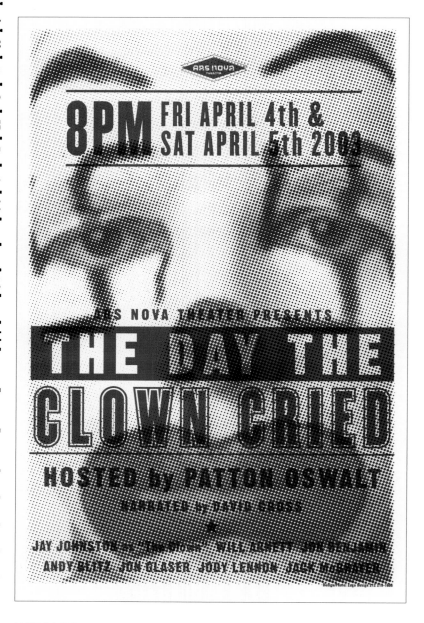

TYPE AND LANGUAGE Carin Goldberg's penchant for re-creating English and American vintage woodtype posters was given a little twist in this topsy-turvy composition that resembles a printer's make-ready proof.
DESIGN FIRM: Carin Goldberg Design ART DIRECTOR: Suzanne Noli
DESIGNER: Carin Goldberg CLIENT: Harper Perennial PUBLISHER: Harper-Collins PRIMARY FONTS: Various woodtype (distressed using a photocopier)

SERIOUS CLOWNING This play concerns an unhappy German circus clown who's sent to a concentration camp and forced to become a sort of genocidal Pied Piper, entertaining the Jewish children as he leads them to the gas chambers. "Willing to rely on the incorporation of swastikas in the clown makeup, I purposely avoided using what might be considered Nazi typography or using blackletter," says Kevin Brainard. "I decided instead, to reference a less ornate version of the types normally associated with circuses and county fairs. Overprinting this type solution not only helped create a sense of imprisonment but purposely pushed the Nazi factor to a more secondary level."
DESIGN FIRM: Pleasure v. Zago Design ART DIRECTOR: Kevin Brainard
DESIGNERS: Kevin Brainard, Nereo Zago PHOTOGRAPHER: Manuel Toscano
PRIMARY FONTS: E Ten, E Seventeen, E Twenty-five

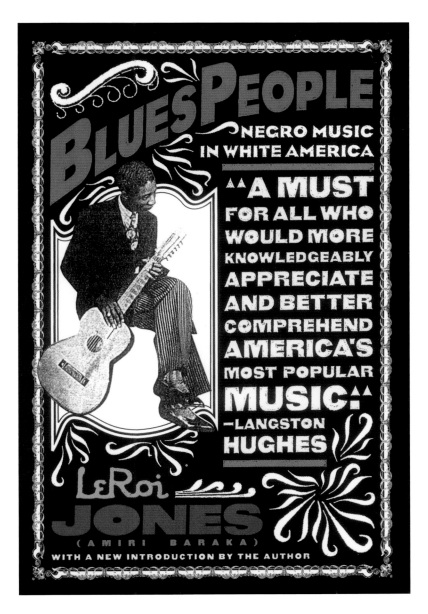

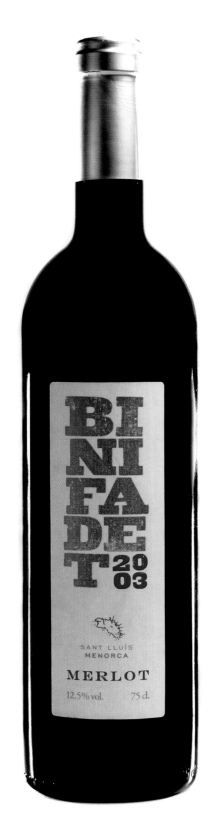

STACKED WOOD

Woodtype style has its own built-in clichés, most notably, the old-fashioned quality. But for this wine label, Estudi Duró has transcended the clichés by composing the type in a decidedly contemporary manner – stacked, centered, and against white.
DESIGN FIRM: Estudi Duró
ART DIRECTOR: Jordi Duró
DESIGNER: Lucrecia Olano
CLIENT: Bodegas Binifadet
PRIMARY FONTS: Hand-printed Egyptian woodtype, Engravers Gothic BT–MT

SELLING THE BLUES Music posters and promotional flyers from the turn of the century serve the theme of American blues. The type is not all from this period, but it's made to look passé and distressed by being put through a photocopier a number of times.
DESIGN FIRM: Carin Goldberg Design DESIGNER: Carin Goldberg PUBLISHER: William Morrow
PRIMARY FONTS: Various woodtype (distressed using a photocopier)

A B C D E F G H I J K L M
N O P Q R S T U V W X Y Z

GOTHIC ON FIRE Dirk Fowler notes that this is, "A homage to the Cadillac Ranch just outside Amarillo, Texas. The large type is Gothic Triple Condensed – a great old display from William Page." It was printed on a three-color letterpress.
DESIGN FIRM: f2 Design DESIGNER: Dirk Fowler CLIENT: Jake's Back Room
PRIMARY FONT: Gothic Triple Condensed (wood)

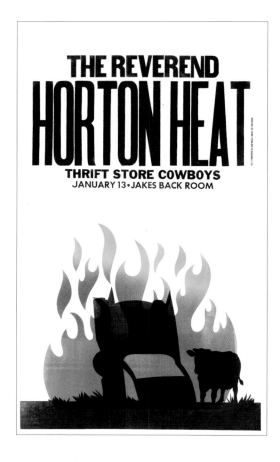

THEATRICAL TYPE "This spread from our book, *Peace: 100 Ideas*, was inspired by the visual history of war and violence in America," explains Joshua C. Chen. "There is a frenetic, addictive quality to such imagery that draws us in, even as it repulses. The carnival typography is intended to tease out the subtle yet undeniable sense of lunacy always present in images of war.
DESIGN FIRM: Chen Design Associates ART DIRECTOR: Joshua C. Chen DESIGNER/ILLUSTRATOR: Max Spector CLIENT: CDA Press PRIMARY FONTS: Rosewood, Shelley

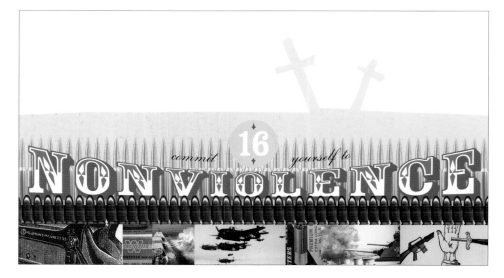

COWBOYS AND FRUITS Dirk Fowler reports that this image found on a Mexican fruit crate label had numerous charms and pairing it with a bold, geometric Gothic gave it the ability to be both old and modern. The large type is a hand-cut version of the Eagle typeface from Morris Fuller Benton's National Recovery Association (NRA) logo.
DESIGN FIRM: f2 Design DESIGNER: Dirk Fowler CLIENT: Thrift Store Cowboys
PRIMARY FONT: Eagle (hand-cut letterpress)

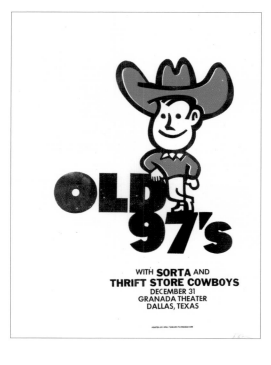

A B C D E F G H I J K L M N O P Q R S T U V W X Y Z

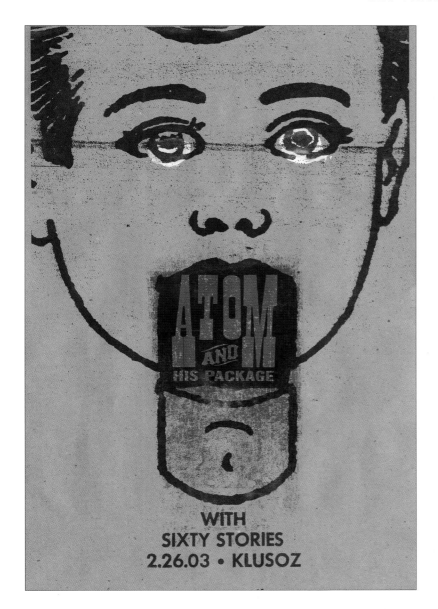

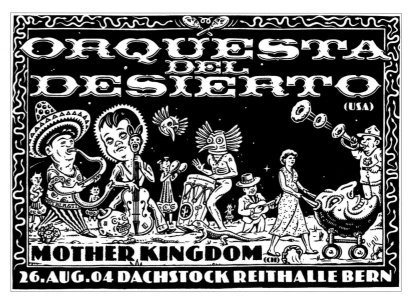

DUMMY TYPE The main pictorial element comes from an old manual diagraming how to make your own ventriloquist dummy. The white color is made from a pair of quarters mounted type high and inked. The red plate was hand-brayered on a sheet of plexi and then printed using a proof press. The type is a mix of a very condensed old Italienne wood face, similar to Linotype's Ponderosa, and various lead foundry type. The entire job was printed on a three-color letterpress with a hint of photocopy.
DESIGN FIRM: f2 Design DESIGNER: Dirk Fowler CLIENT: Klusoz
PRIMARY FONT: Ponderosa

SOUTH OF THE BORDER The Estampa Populaire produced in Mexico makes its influence known in this ornate and clever *Day of the Dead*-styled poster.
ILLUSTRATOR: Dirk Bonsma CLIENT: Reitschule Bern PRIMARY FONT: Inspired by Thunderbird and Koloss.

MIRROR IMAGES
Klangfarger is a Norwegian word that vaguely refers to the phenomenon of echo. "We chose a font with descenders that would become key elements in the design," says Bob Delevante. "The choice seemed obvious to create the echo of color and typeface."
DESIGN FIRM: Hatch Show Print/Relay Station ART DIRECTOR: Bob Delevante PRINT-MAKER: Jim Sherraden CLIENT: Norsk Noteservices AS, Oslo PRIMARY FONT: Unknown (6th drawer from the top)

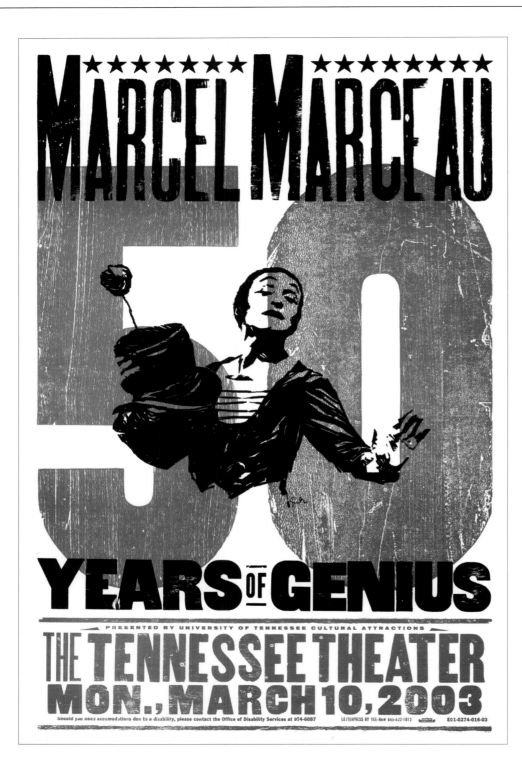

MIMING IT Kevin Bradley recalls, "A friend of mine said, 'you know you've hit the big time when you're making posters for mimes.' That made me laugh. I wanted to do something that connected Marcel Marceau to the past in a classical sense through the use of typography." His poster was inspired by wood and metal type from the turn of the nineteenth century such as the gothic specimen above, and although this poster looks more American than French, it nonetheless has the circus sensibility that Marceau fits into.

DESIGN FIRM: Yee-Haw Industries ART DIRECTOR/DESIGNER: Kevin Bradley ILLUSTRATOR: Eric Smith CLIENT: V. T. Cultural Attractions/TN, Theater PRIMARY FONTS: American Gothics woodtype (30 picas/25 picas/90 picas/10 picas/6 picas)/ Hamilton Wood Type Factory, *c.* 1870

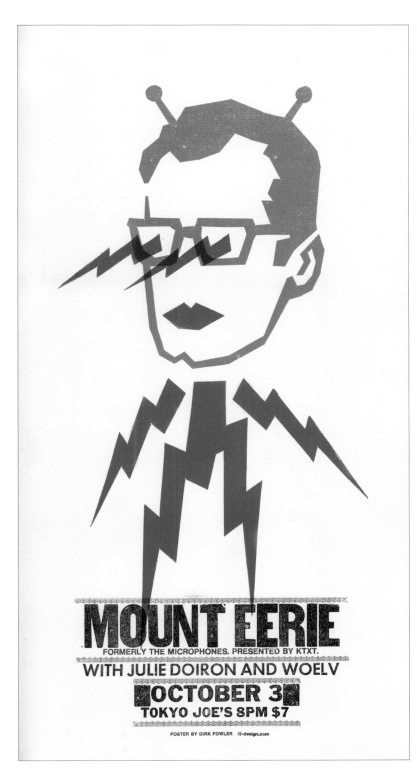

KILLOWATT TYPE "A friend described this poster as, 'Ready Killowatt meets *My Favorite Martian*, meets Buddy Holly,'" says Dirk Fowler. "I guess that about covers it. The type is simple, bold, Gothic woodface and Neon Helvetica metal type combined with an ornate lead border. And it was printed on a two-color letterpress."
DESIGN FIRM: f2 Design DESIGNER: Dirk Fowler CLIENT: KTXT Radio
PRIMARY FONTS: Gothic (wood), Neon Helvetica (metal)

THUNDERBIRD STYLE Thomas Scott reverentially refers to a 1960s kids television show, *The Thunderbirds*, as the primary inspiration for this pastiche that includes a cacophony of nostalgic woodtypes and scripts.
DESIGN FIRM: Eye Noise DESIGNER: Thomas Scott
CLIENT: Foundation PRIMARY FONTS: Playbill, Blackoak, Dom Casual, Monteray

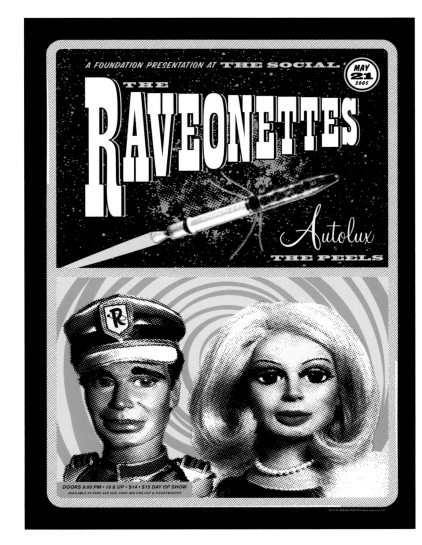

BLUE GRASS BOXING This poster references the classic boxing card style accented with excruciating kerning and tight letter spacing.
DESIGN FIRM: Yee-Haw Industries DESIGNER: Kevin Bradley CLIENT: Clinch Mountain Bluegrass Festival
PRIMARY FONTS: Various woodtype, hand-carved woodtype Gothic

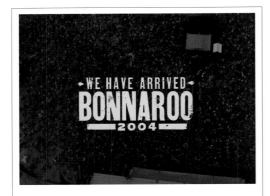

HATCH IN MOTION "When my friend Danny Cunch, the director of the *Bannaroo* documentary, asked me to design the running titles for the film," explains Bob Delevante, "Hatch immediately came to mind." The woodtype fit perfectly with the tenor of the music festival. "What's more, it was the first time Hatch letterpress was used in film."
DESIGN FIRM: Relaystation ART DIRECTOR/ DESIGNER: Bob Delevante CLIENT: 3 Tree Productions PRIMARY FONTS: Assorted Gothics, courtesy of Hatch Show Print

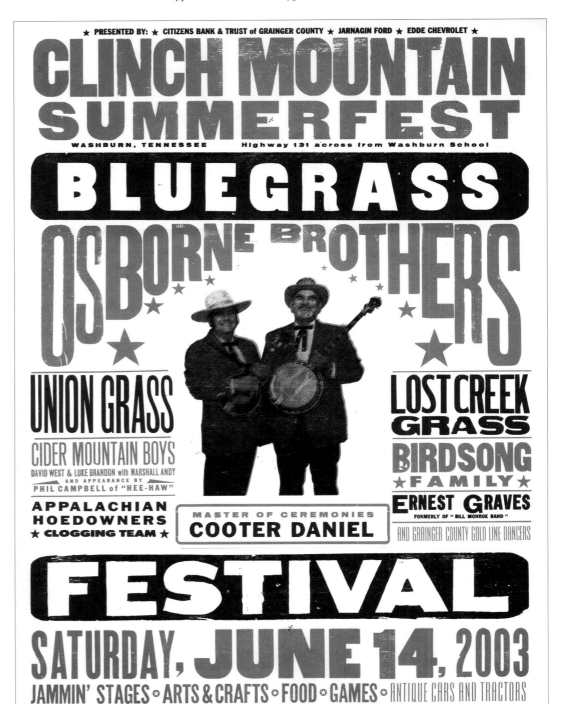

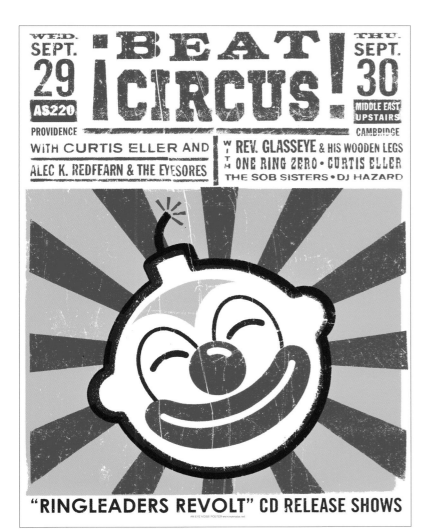

UNDER THE BIG TYPE Thomas Scott proudly notes that this is a replica of, "The carnival and the circus posters still in use today: usually screen-printed blanks, with space left at the top for specific information to be added with letterpress later." DESIGN FIRM: Eye Noise DESIGNER/ILLUSTRATOR: Thomas Scott CLIENT: Beat Circus PRIMARY FONTS: Cheapjack, Clown Alley, Blackoak, Franklin Gothic, Akzidenz Grotesk, Century Gothic

MAGIC REALISM "The primary reference for this poster was Gabriel Garcia Marquez's magical realism writing," explains Pablo A. Medina. He adds that it was, "also inspired by movie posters for Fellini films like *La Dolce Vita* and *8½*. The handlettering is my own." DESIGN FIRM: Cubanica ART DIRECTOR/DESIGNER/ILLUSTRATOR: Pablo A. Medina CLIENT: Cartagena Film Festival PRIMARY FONTS: All fonts were handdrawn. The sans serif type was based on Berthold Akzidenz-Grotesk.

69

A B C D E F G H I J K L M N O P Q R S T U V W X Y Z

[[A]|B|C|D|E|F|G|H|I|J|K|L|M] ◉ ◉ 70 ◉ ◉ [N|O|P|Q|R|S|T|U|V|W|X|Y|Z]]

ONGOING EXPERIMENTS This is Denis Y. Ichiyama's playing with overprinting large letter forms in transparent inks. The process was a mistake in the days of woodtype printing, but became an art form in the avant-garde 1930s, notably with H. N. Werkman's printing technique applied to his experimental magazine, *The Next Call*.
DESIGN FIRM: Dennis Y. Ichiyama DESIGNER: Dennis Y. Ichiyama PRIMARY FONT: Historic American woodtype/Hamilton Wood Type & Printing Museum, Wisconsin.

FLUORESCENT TRANSPARENT More of Denis Y. Ichiyama's experiments with oversized, poster typefaces and transparent inks, and in this case, psychedelic fluorescent inks.

DESIGN FIRM: Dennis Y. Ichiyama DESIGNERS: Dennis Y. Ichiyama, Laurie Caird CLIENT: Dennis Y. Ichiyama PRIMARY FONTS: Historic American woodtype/Hamilton Wood Type & Printing Museum, Wisconsin.

71

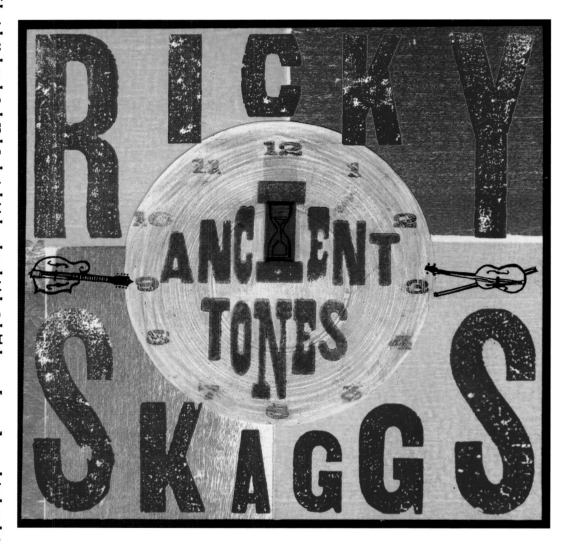

THAT AD HOC FEELING The country and
bluegrass singer, Ricky Skaggs, wanted the visual look
of an old vinyl record as the primary image. Bob
Delevante recalls, "A roll of electrical tape was pasted
on its side to create the look of the grooves. We used
the numbers to create a clock face to suggest the
passing of time." The varied sized display type gives
the entire piece an ad hoc feeling.
DESIGN FIRM: Hatch Show Print/Relay Station
ART DIRECTOR: Bob Delevante PRINTMAKER:
Jim Sherraden CLIENT: Skaggs Family Records
PRIMARY FONTS: Gothic No 2., Tuscan Antique

LOTS OF WOOD Actual vintage woodtypes are
at the core of Raven Press's design activity. If an entire
alphabet is not available in the same point size, then
they mix and match to get an aesthetically pleasing
result. This is one of the many small jobs the Press
handles for the University of Delaware. While it uses
types of the past, the design is of the present.
DESIGN FIRM: Raven Press/Designers ART
DIRECTORS: Raymond Nichols, Jill Cypher
DESIGNERS: Raymond Nichols, David Huynh
CLIENT: Department of Fine Arts and Visual
Communications PUBLISHER: Raven Press at the
University of Delaware PRIMARY FONT: Extra
Condensed Antique

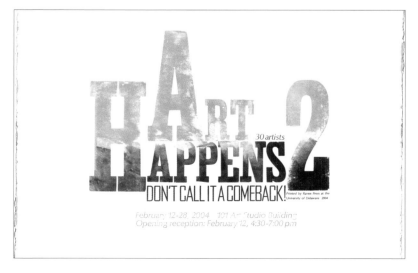

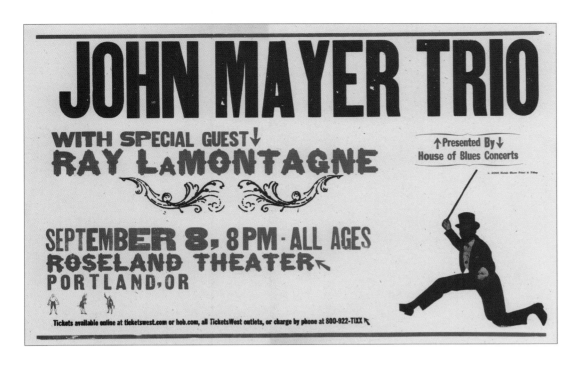

THE HATCH COLLECTION "I really wanted to use the old typeface Mahoney on this project after finding it in the Hatch collection," says Sarah Foley. It had that circus-like air but also served as a kind of contempo logo, too. The image on the poster is truly vintage. "I had to print the image so that the man's face was unrecognizable," adds Foley – just in case he or his ancestors felt like suing.
DESIGN FIRM: Hatch Show Print DESIGNER: Sarah Foley ILLUSTRATOR: Leslie Cabarga CLIENT: House of Blues Concerts PRIMARY FONTS: Mahoney, Franklin Gothic, Gothic

MIDWAY TYPOGRAPHY
Once again, Keith Bradley has created a, "throwback ode to carnivals and sideshow days juxtaposed with good-old-rock'n'roll."
DESIGN FIRM: Yee-Haw Industries
DESIGNERS: Kevin Bradley CLIENT: Bassholes & Labiators
PRIMARY FONTS: Woodtype, American Gothics, c. 1865/ Hamilton Wood Type & Printing Museum, Wisconsin.

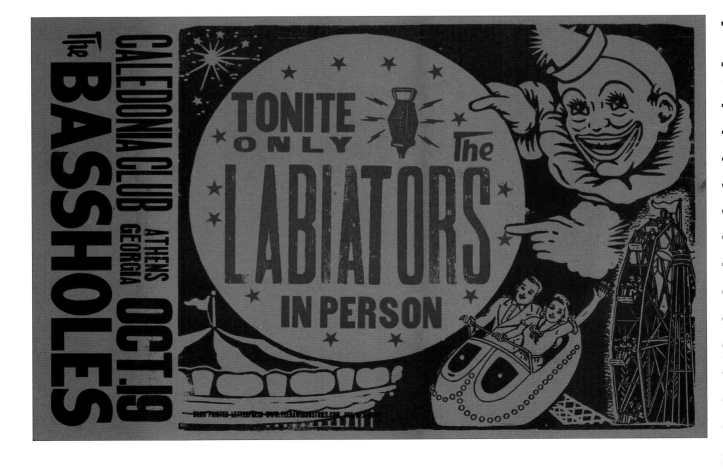

SALSA AND SWING Day of Music is a free 24-hour outdoor musical event that features all genres of music, from bluegrass to swing to salsa. The type selected was inspired by classic album designs from past decades, and the campaign's look is an eclectic mix of contemporary concert poster design and naive pseudo-nostalgic album cover art, rooted in floral and fauna imagery, and sheet music.
DESIGN FIRM: Wink, Incorporated CREATIVE DIRECTORS: Scott Thares, Richard Boynton DESIGNER/ILLUSTRATOR: Scott Thares CLIENT: Marshall Field's PRIMARY FONTS: Stereodelic, Trade Gothic, Egyptian

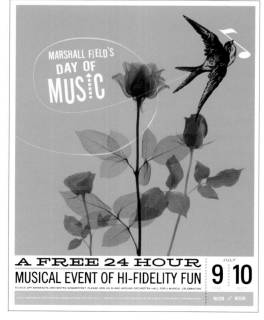

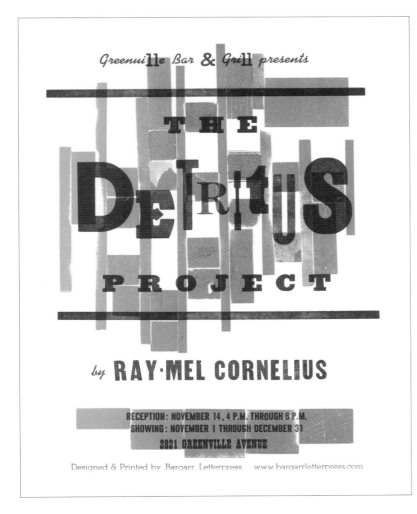

SNAKE OIL FONTS "This was one of a series of four prints for this funky band and the goal," says Kevin Bradley, "was to sell magic 'snake-oil' that each band member had 'hawked' on stage." Heavy on concept, these Yee-Haw Industries's prints demand viewers give their full attention, for the pay off, says Bradley, is "a punch in the gut, Vaudeville style."
DESIGN FIRM: Yee-Haw Industries DESIGNER: Kevin Bradley PHOTOGRAPHER: Ron Keith CLIENT: Southern Culture on the Skids COPYWRITERS: Kevin Bradley, Rick Miller PRIMARY FONTS: Handdrawn/carved typography, woodtype, various lead type

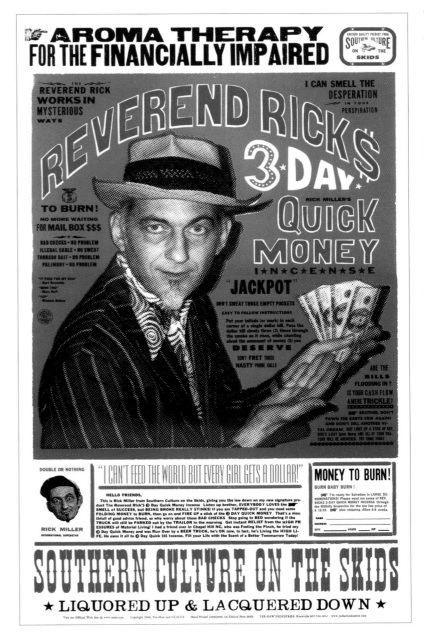

DETRITUS MADE LITERAL "We took the meaning of the word (eroded or accumulated matter) and created a poster using a mix of stray and unrelated typefaces," explains the letterpress printer and designer, Jeff Barfoot. "The affect of the mix of faces and the mix of colored blocks in the background gives it a nice rhythm and supports the idea for the collection."
DESIGN FIRM: Bargarr Letterpress DESIGNER: Jeff Barfoot CLIENT: Ray-Mel Cornelius PRIMARY FONTS: Gothic Special Condensed, No. 154, Antique Bold, Gothic Bold, Clarendon, Kaufman, Antique Condensed, Stymie

[A][B][C][D][E][F][G][H][I][J][K][L][M] ◎◎◎

76

◎◎◎ [N][O][P][Q][R][S][T][U][V][W][X][Y][Z]

Celebrating Dia de los Muertos

DAY OF THE DEAD "We were inspired by traditional Mexican *Dia de los Muertos* [*Day of the Dead*] imagery seen throughout San Antonio and South Texas and turned to Jose Guadalupe Posada's satirical *calaveras* characters as our primary source for this logo," says Jill Giles. "We distressed the chiseled, angular font Latin Bold, to make it more compatible with the woodcut *calavera* that illustrates the logo. Similarly chunky typefaces were used on Posada's popular letterpress handbills of the early nineteenth century."
DESIGN FIRM: Giles Design, Inc. ART DIRECTOR: Jill Giles DESIGNERS/ ILLUSTRATORS: Cindy Greenwood, Warren Borror CLIENT: Blue Star Contemporary Art Space PRIMARY FONT: Latin Bold

PAUL RAND RETRO Jonathan Gray claims Paul Rand as the inspiration for this cover, but arguably it goes further back to Rand's own roots in Dada and Surrealism. The type is more distressed than Rand might use, but the humor inherent in the typography and image are spiritually linked to his graphic proclivities.
DESIGN FIRM: Gray 318 ART DIRECTOR: Duncan Spilling DESIGNER: Jonathan Gray ILLUSTRATORS: Jonathan Gray, Mel Croft CLIENT: Time Warner Books, UK PUBLISHER: Little Brown

EARLY DADA The archive at Hatch Show Print with its wealth of old wood and letterpress faces is drawn upon for this poster that almost seems like a precursor to 1920s Dada typography.
DESIGN FIRM: Hatch Show Print DESIGNER: Agnes Barton-Sabo CLIENT: Ryman Auditorium PRIMARY FONTS: Multiple letterpress typefaces from the Hatch Show Print archive.

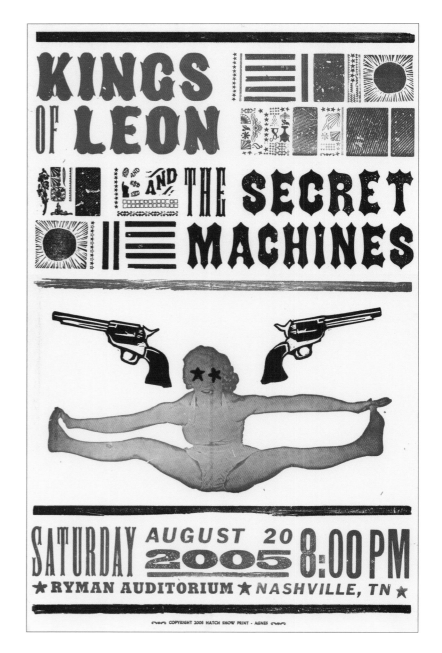

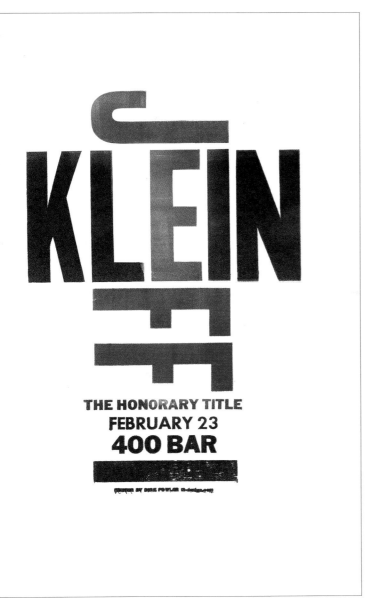

COMPOSITION IN WOOD "In my opinion," Dirk Fowler announces, "there is nothing more beautiful than large wooden type. This poster is simply a composition made with woodtype in which two words happen to share a common character. I never tire of studying all the 'isms' – Dada, Constructivism, Futurism, etcetera. Perhaps all my work is somehow influenced by that time period." DESIGN FIRM: f2 Design DESIGNER: Dirk Fowler CLIENT: Jeff Klein PRIMARY FONT: Unknown (wood)

LUSH AND PRETTY Blonde Redhead makes music that is simultaneously delicate, yet kind of harsh. "It has a very somber dramaticism to it," says Brady Vest, "so we wanted the poster to be lush and pretty." The confluence of woodtypes and ornaments give it an exuberance that fits the tunes.
DESIGN FIRM: Hammerpress DESIGNER: Brady Vest CLIENT: Eleven Productions PRIMARY FONTS: Assorted lead and woodtype, rule, and ornaments

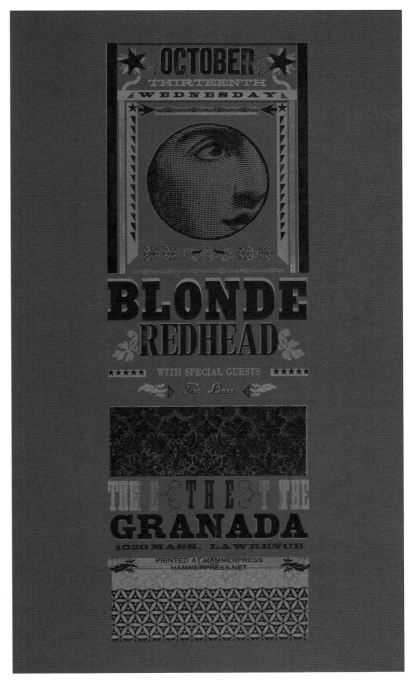

77

[A][B][C][D][E][F][G][H][I][J][K][L][M] ⊚ ⊚ ⊚

78

⊚ ⊚ ⊚ [N][O][P][Q][R][S][T][U][V][W][X][Y][Z]

WAR PROPAGANDA The vintage advertising cut of Boy Scouts was firstly combined with arrows, as well as a mixture of various degraded wood and lead typefaces, then printed one-color letterpress on chip board. "Anytime I see a design using arrows," explains Dirk Fowler, "I think of the work of Lester Beall [American Modernist designer who designed for the Works Progress Administration (WPA), among other things.]" The marching scouts look military in nature, hence the war propaganda sensibility of this poster.
DESIGN FIRM: f2 Design DESIGNER: Dirk Fowler CLIENT: Thrift Store Cowboys PRIMARY FONT: Unknown (wood)

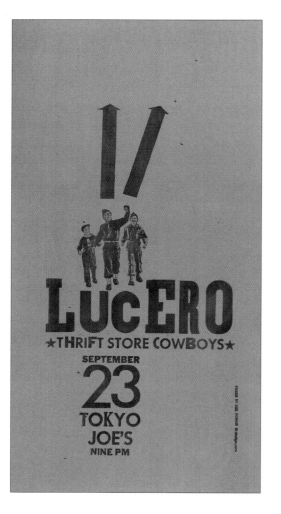

OPENING NIGHT This poster was for a fundraising event that took place on the opening night of *The Wizard of Oz* production for the Children's Theatre. The main headline type was found in an old typeface catalog Wink, Incorporated have in their office. "The particular type that was used gave the poster historical reference as well as visual grounding," explains Scott Thares.
DESIGN FIRM: Wink, Incorporated CREATIVE DIRECTORS: Scott Thares, Richard Boynton DESIGNER/ILLUSTRATOR: Scott Thares PRIMARY FONTS: Trade Gothic, Grand B (found typeface)

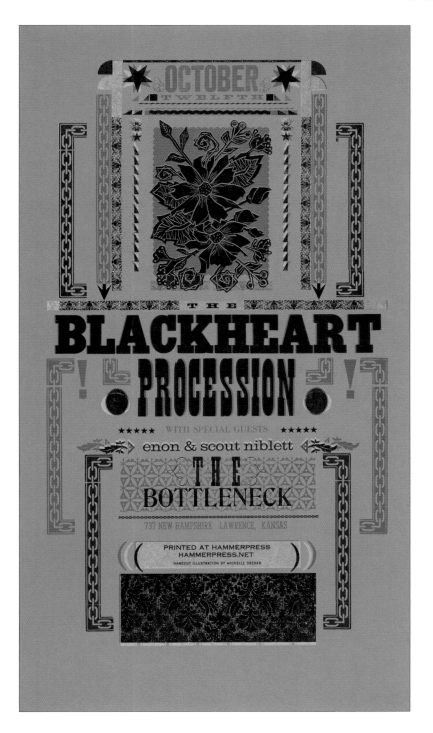

SMALL PRESS IMPRINT "The reference for this poster was actually another poster [Blonde Redhead (see p.77)] we did the same week," says Brady Vest. "The client was the same and the music is in a similar vein. We printed the Blackheart poster using the same press set up but we just rearranged and deconstructed the type and border material. Basically, the second layer of the Blonde poster turned into the first layer of the Blackheart procession poster, saving a bit of money and some effort too."
DESIGN FIRM: Hammerpress DESIGNER: Brady Vest CLIENT: Eleven Productions PRIMARY FONTS: Assorted ornaments, wood and lead type, Linocut

FANATIC COLLECTOR Ross MacDonald is a fanatic collector of early-nineteenth-century job printing materials like posters, flyers, lottery notices, street literature, etc. He is also an avid printer and typesetter. This job, produced for *Print* magazine, is a combination of all these inspirations as well as metal and lead typefaces, resulting in a real blast from the past.
DESIGN FIRM: Bright Work Press ART DIRECTOR: Steve Brower DESIGNER/PHOTOGRAPHER: Ross MacDonald CLIENT/PUBLISHER: *Print* PRIMARY FONTS: Wood and lead type, nineteenth-century fonts: Fatface Roman, Fatface Roman XXX Condensed, Antique Extended, Times Gothic, Doric, Clarendon, Blair

TYPECASE EXTRAVAGANZA Delve into the bottomless Hatch Show Print archive and the number of eclectic typeface combinations are virtually infinite. This series promoting Appleton Papers just scratches the surface. DESIGN FIRM: Hatch Show Print ART DIRECTOR: Ferko Goldinger DESIGNERS: Brad Vetter (Glam Slam!), Agnes Barton Sabo (Blinding White Willie), Lori Walters (Honky Talkin') CLIENT: Appleton Paper PRIMARY FONTS: Multiple letterpress typefaces found at Hatch Show Print archive, one typeface supplied by Appleton Paper.

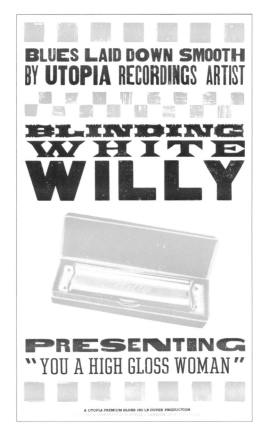

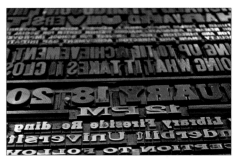

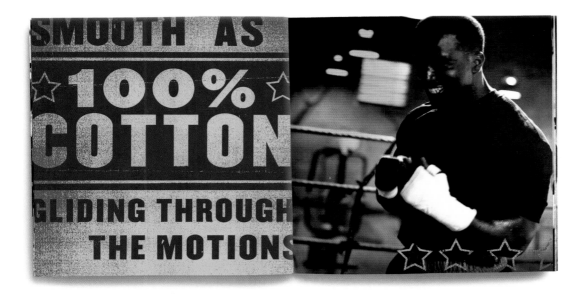

TRANSPARENT OVERPRINTS The rationale for this piece was found in the woodtype and imagery donated to the Hamilton Wood Type & Printing Museum by the Malley Printing Co, Two Rivers, Wisconsin. This is a homage to them. ART DIRECTOR/LETTERPRESS PRINTER: David Wolske CLIENT: Hamilton Wood Type & Printing Museum, Wisconsin. PRIMARY FONTS: Various woodtype

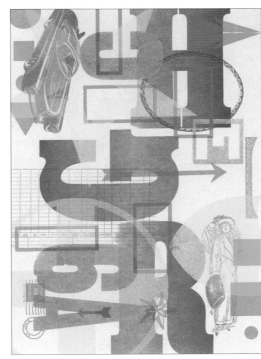

KNOCKOUT TYPE For this brochure for Hanes Printables, Christine Celic modeled the text pages after the traditional black-and-white style of boxing posters, the garishness of prizefighter belts, tough-guy photography, and carnival-barker language from inside the world of boxing. "Sweaty stuff," she comments.
DESIGN FIRM: HendersonBromsteadArt ART DIRECTORS: Hayes Henderson, Christine Celic DESIGNER: Christine Celic ILLUSTRATOR: Hayes Henderson (logo) PHOTOGRAPHER: Lon Murdick CLIENT: Hanes Printables PRIMARY FONTS: HTF Ziggeraut, HTF Champion

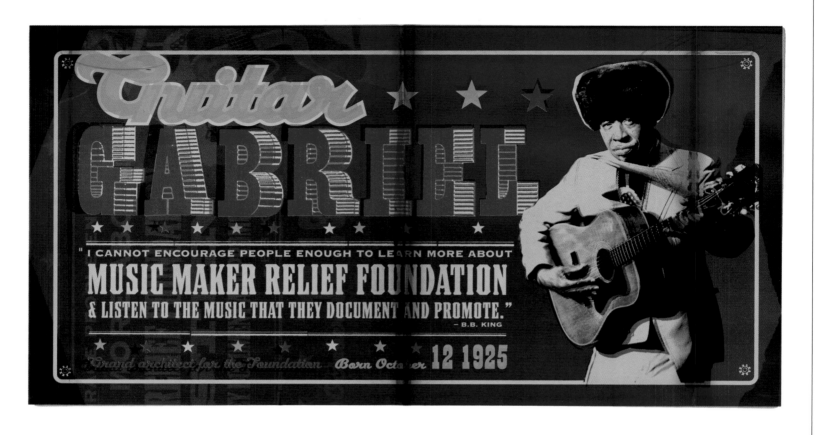

A B C D E F G H I J K L M
82
N O P Q R S T U V W X Y Z

FONDERIES DEBERNY ET PEIGNOT PARIS

LETTRES OMBRÉES

11969 - 56

A B C D E F G H I J
K L M N O P Q R
S T U V W X
. , : Y Z - !
1 2 3 4 5 6 7 8 9 0

SLABS AND SHADOWS The initial inspiration, notes Billington Hackley, were poorly printed fair and concert posters composed with ornamental slab and shadow fonts, and then left out in the rain. "I liked the way they used multiple fonts to over-emphasize every point."
DESIGN FIRM: HendersonBromsteadArt ART DIRECTOR: Hayes Henderson DESIGNER: Billington Hackley PHOTOGRAPHER: Tim Duffy CLIENT: Music Maker Relief Foundation PRIMARY FONTS: HTF Champion, Council, Copperplate, Radio, *Lettres Ombrées* (scanned from old font book)

SALTY TYPE Carrie Hamilton notes that she was intoxicated by, "the many types of tequila labels I found that used filigree and gold leaf," for this otherwise minimalist book jacket.
DESIGN FIRM: Empire Design Studio ART DIRECTOR: Gary Tooth DESIGNER: Carrie Hamilton PHOTOGRAPHER: Clare Parker/Alamy CLIENT: Smithsonian Institution PUBLISHER: Smithsonian Books PRIMARY FONTS: Historical font, Belizio

ADVERTISING INSPIRATION Emilie Burnham went directly to the big closet of nineteenth- and early-twentieth-century vintage advertising for the crude but alluring letter forms, which she slapped together in a melody of visual discord.
DESIGN FIRM: Burnham Design ART DIRECTOR/ DESIGNER: Emilie Burnham CLIENT: Self PRIMARY FONT: Hand-carved woodtype

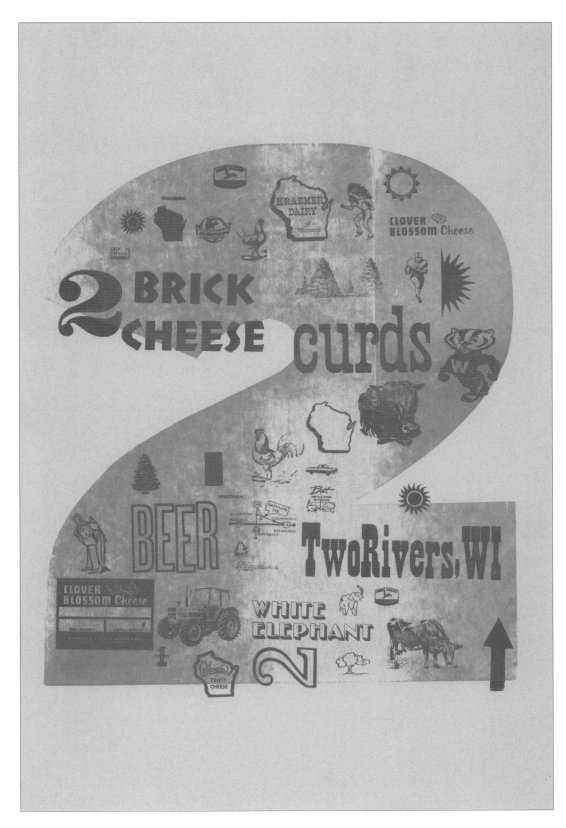

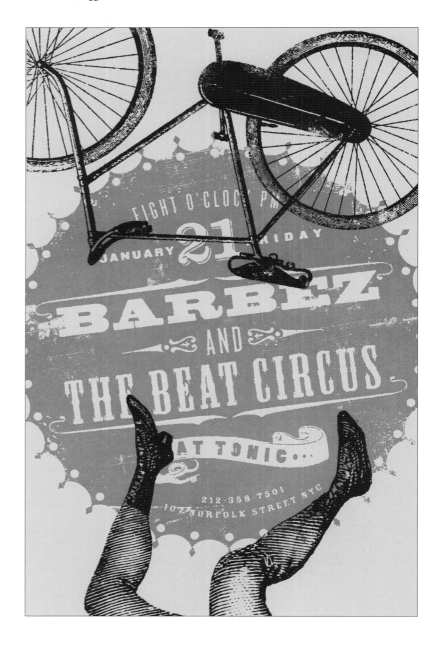

TOPSY-TURVY TYPOGRAPHY Jeff Matz explains, "The posters I've done for Beat Circus are all inspired by turn-of-the-century advertising graphics." This one is a limited edition, hand-pulled screenprint.
DESIGN FIRM: Lure Design DESIGNER: Jeff Matz CLIENT: Beat Circus
PUBLISHER: Lure Design PRIMARY FONTS: Helenic Wide, Mesquite, Knockout, Ziggurat

WOODTYPES GALORE Andrew Rogers designed this poster, "to explore printing and fonts," and so its inspiration was woodtype in all its variations.
DESIGN FIRM: Joslin Lake Design Co., Chicago, IL ART DIRECTOR/DESIGNER: Andrew Rogers CLIENT: Self, to explore printing and fonts PRIMARY FONTS: Referencing Rob Roy Kelly, American woodtype, Edges, French Clarendon No. 2

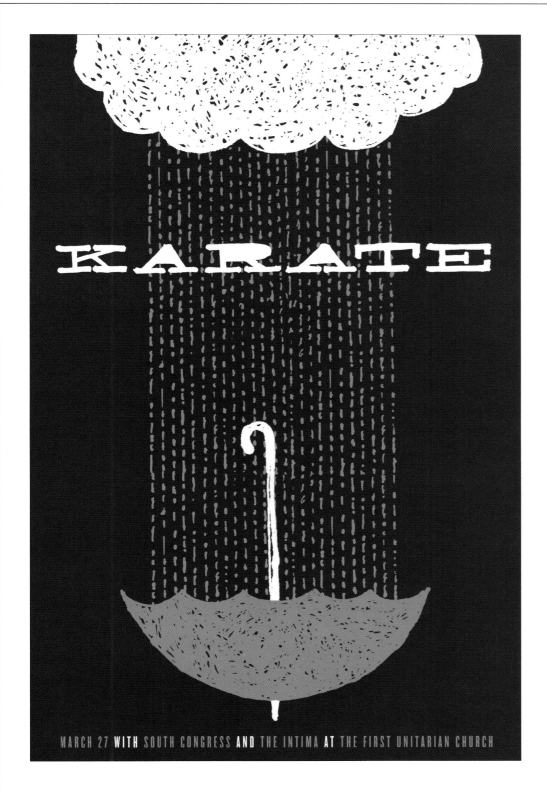

OLD-TIME SIMPLICITY This poster, claims Dustin Summers, was influenced by the 1940s record album pioneer Alex Steinweiss and his eclectic use of simple hand and typeset letters. The type choice stemmed from his cover for *Mozart: Quintet for Clarinet and Strings in A major*, a Columbia release dated 1947.
DESIGN FIRM: The Heads of State ART DIRECTORS: Jason Kernevich, Dustin Summers DESIGNER: Dustin Summers PUBLISHER: First Unitarian Church PRIMARY FONT: Helenic (redrawn)

A B C D E F G H I J K L M N O P Q R S T U V W X Y Z

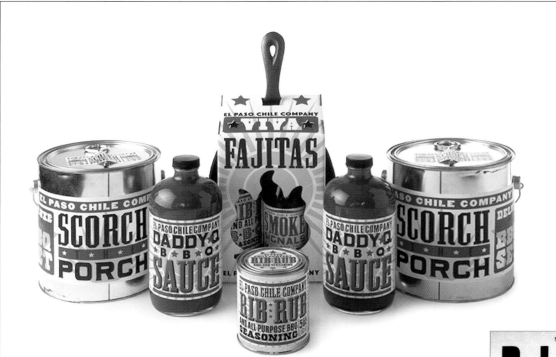

HOT STUFF This quirky slab serif typeface was, "chosen to complement the commissioned woodcut illustration," says Louise Fili. The face itself is torn from the pages of mammoth old type books produced by long-defunct woodtype foundries.
DESIGN FIRM: Louise Fili Ltd ART DIRECTOR/DESIGNER: Louise Fili ILLUSTRATOR: James Grashow CLIENT: El Paso Chile Company PRIMARY FONT: Pabst

HOMAGE TO CHANTRY "This poster is kind of an homage to Art Chantry," admits Jeff Matz. "The album Yo La Tengo was touring with was *Summer Sun*. So I scanned some small space travel ads out of the back of a 1968 *Venture* magazine and made my own summer vacation ad. for the band – with a twist. I wanted the typography to look promotional and slightly naive so I mixed some fonts you might not normally use together. The main font used here is Breite Egyptienne, something I scanned from a book of steel engravings and fonts. It has been redrawn as Egyptienne Wide, but I like the more analog look of the original drawing." Limited edition, hand-pulled screenprint.
DESIGN FIRM: Lure Design DESIGNERS: Jeff Matz CLIENT: Foundation
PUBLISHER: Lure Design PRIMARY FONTS: Helenic Wide, Trade Gothic Bold Condensed, Trade Gothic Bold Extended

THAT HANDMADE LOOK Black Maria Film & Video Festival is a film festival where many of the films being shown have a handmade look. "We thought letterpress would best represent that," explains Raymond Nichols. The distressed slab serif type evokes the ad hoc sensibility, while setting it against the white background keeps it from being too musty.
DESIGN FIRM: Raven Press/Designers ART DIRECTORS/DESIGNERS: Raymond Nichols, Jill Cypher CLIENT: Department of Fine Arts and Visual Communications
PUBLISHER: Raven Press at the University of Delaware PRIMARY FONTS: Extra Condensed Antique, Agency Gothic

A B C D E F G H I J K L M

88

N O P Q R S T U V W X Y Z

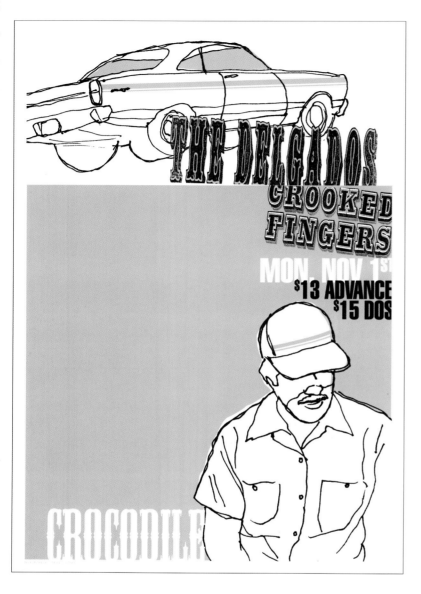

FROM THE STREET Modern Dog's head-quarters are in Seattle, WA, known for its Victorian neighborhoods. As Robynne Raye points out, the inspiration for this poster is, "Old Seattle neighborhood, which equals old woodtype." Incidentally, she adds, "the famous zoo is over one hundred years old, in the same neighborhood where the 'Artwalk' takes place." DESIGN FIRM: Modern Dog ART DIRECTOR/ DESIGNER: Robynne Raye CLIENT: Arts Council of Greenwood PRIMARY FONT: Poplar Black

CODE FOR MUSIC Why is it that contemporary music poster designers seem to gravitate towards woodtype? Perhaps it is because in addition to the flair and flourish – or maybe because of it – these stark, often decorative faces have incredible appeal. Over time, they have transcended their historical roots and become a code for contemporary music. DESIGN FIRM: Modern Dog ART DIRECTOR/ DESIGNER/ILLUSTRATOR: Michael Strassburger CLIENT: Crocodile Cafe PRIMARY FONTS: Helvetica Extra Compressed, Mesquite, old woodtypes

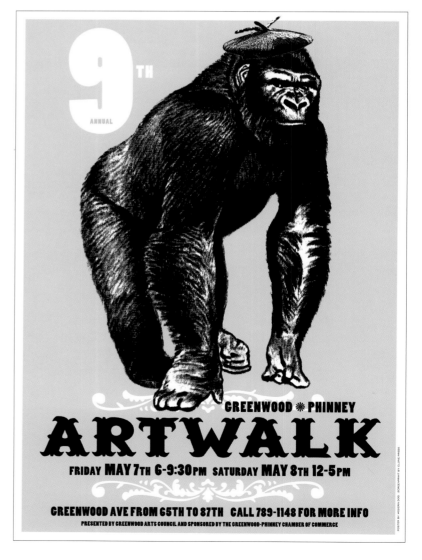

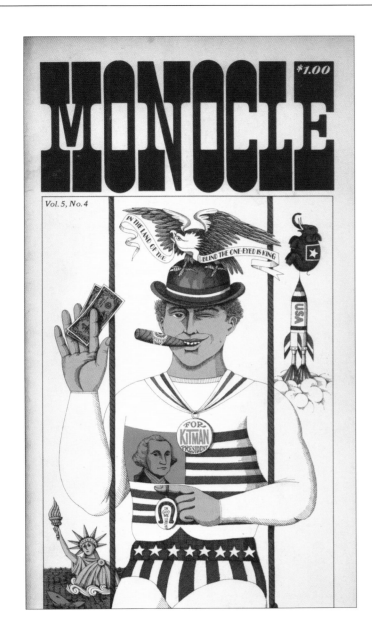

THANKS, NAPOLEON Those old slab serifs, known as Egyptian faces, were allegedly introduced to French printing culture by Napoleon following his campaign in Egypt. Apocryphal or not, the style of woodtype became very popular throughout the world, and during the early 1960s enjoyed a healthy revival, in large part thanks to *Monocle (left)*, a small magazine whose art director loved pasting together letters from nineteenth-century type books.
DESIGN FIRM: Eye Noise DESIGNER: Thomas Scott CLIENT: Figurehead
PRIMARY FONTS: Playbill, Franklin Gothic, House Script

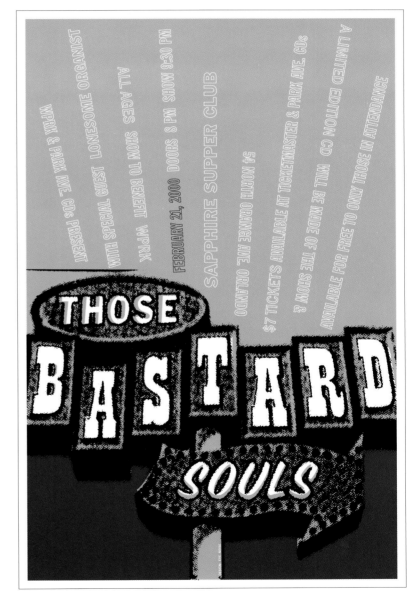

A B C D E F G H I J K L M

90

N O P Q R S T U V W X Y Z

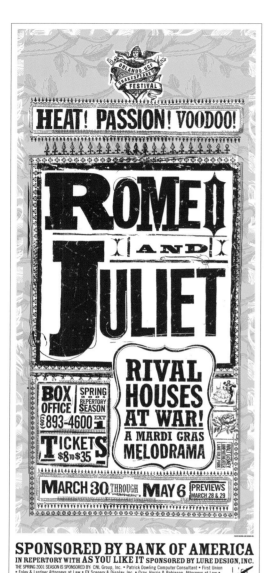

THE GOLD STANDARD The Hatch Show Print posters are the gold standard of vernacular concert and fair bills. This poster *(right)* may have been influenced by Hatch, but the University of Delaware print shop has developed its own hybrid of vintage and contemporary style.

DESIGN FIRM: Raven Press/Designers ART DIRECTORS: Courtney Bowditch, Sarah Rosenthal, Raymond Nichols DESIGNERS: Courtney Bowditch, Sarah Rosenthal CLIENT: apossibleworld.org PUBLISHER: Raven Press at the University of Delaware PRIMARY FONTS: Extra Condensed Antique, Goudy

TYPE AID The *Farm Aid 20th Anniversary* book cover was designed to visually convey the idea of a music festival that celebrates homeland farming and politics all in one image, explains Bob Delevante. "It needed something with an Americana feel without becoming overly nostalgic and to use the flag in a way that spoke to all Americans. Both Farm Aid and Hatch Show Print are institutions steeped in American tradition. The handmade feel of letterpress is a perfect match."

DESIGN FIRM: Rodale ART DIRECTOR: Ellen Nygaard DESIGNER: Bob Delevante PRIMARY FONTS: William Page, Gothic

HOMAGE TO JOB PRINTERS Since this version of Shakespeare's *Romeo and Juliet* took place during the Civil War, inspiration for this poster, notes Paul Mastriani, came from old Early American advertising, crammed with decorative typographic ornaments, woodcuts and block type. The result is a mélange of type and ornament that pays homage to the old jobbing printers and their limited means of reproduction.

DESIGN FIRM: Lure Design Inc. DESIGNER: Paul Mastriani CLIENT: Orlando-UCF Shakespeare Festival PRIMARY FONTS: Knockout, Trade Gothic

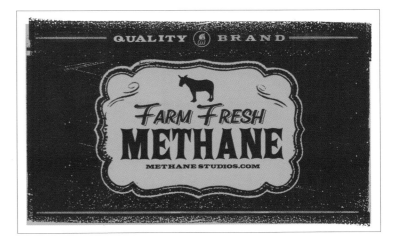

POSADA REVIVED Wit was the motivating influence here, but there are others, "My wife calls me, 'The Crap Keeper' because I tend to collect all sorts of ephemera (including old beer cans) which, coincidentally, influenced the Farm Fresh Methane poster," explains Mark McDevitt. "The pig art actually came from an old tin sign and the fonts came from various type books. The decorative elements I found in [Mexican printmaker] Guadalupe Posada's broadsheets which I scanned in and redrew on the computer, and then used a distressed texture to give it an aged look. This may be cheating a bit but it works."

DESIGN FIRM: Methane Studios DESIGNER/ILLUSTRATOR: Mark McDevitt PRIMARY FONT: Springfield Tablet

SHAKESPEARE STYLE In the late 1960s, the Morgan Press in upstate New York collected and made available many of the forgotten woodtypes. This invaluable resource was partly the basis for Paula Scher's handbill typographic language, which continues to define the New York Shakespeare Festival. DESIGN FIRM: Pentagram ART DIRECTOR: Paula Scher DESIGNERS: Ron Louie, Lisa Mazur CLIENT: The Public Theater PRIMARY FONTS: Morgan Gothic, Paulawood, Seriwood, E Ten, E Seventeen, E Twenty Five, Wood Block Condensed, Alternate Gothic No.2

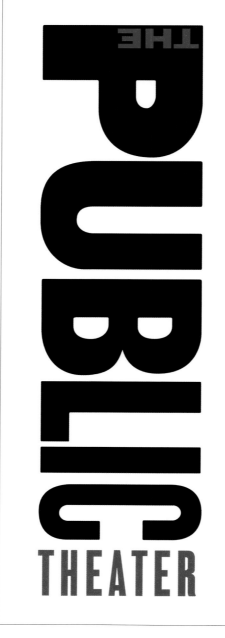

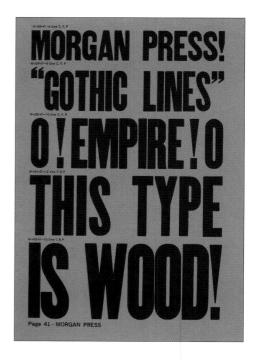

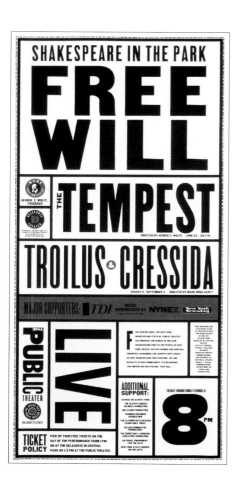

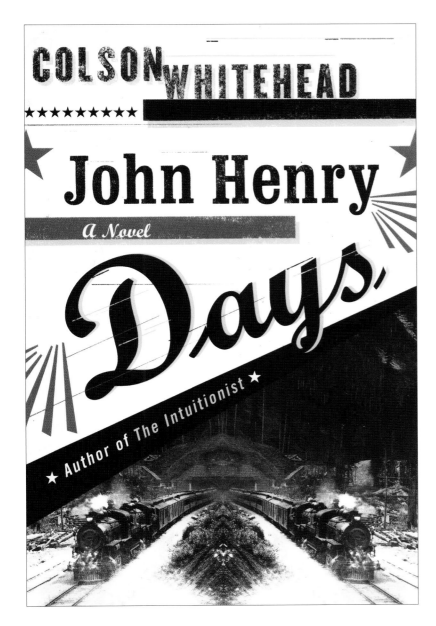

COMPOSITE HISTORY John Henry was a mythical figure in African-American history, and the type for this jacket derives from a composite of old wood and metal faces from the late nineteenth century.
DESIGN FIRM: Rodrigo Corral Design ART DIRECTOR: John Fontana
DESIGNER: Rodrigo Corral PHOTOGRAPHER: Brown Brothers PUBLISHER: Doubleday Books PRIMARY FONTS: Clarendon, Script Bold, Trade Gothic

ANTI-ART TYPOGRAPHICS
"Photomontage and Dada art" are referenced here, notes Michael Strassburger. The mixed old and new media that signaled anti-art of the 1920s remains a relevant style for the present.
DESIGN FIRM: Modern Dog ART DIRECTOR/ DESIGNER/ILLUSTRATOR: Michael Strassburger CLIENT: Seattle Fringe Feast Festival PRIMARY FONTS: Franklin Gothic, woodtype

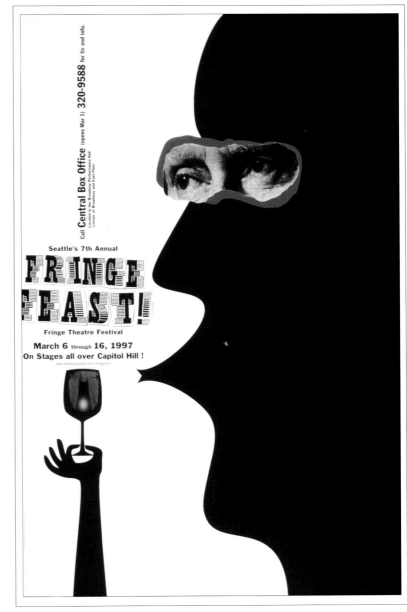

93

ABCDEFGHIJKLM NOPQRSTUVWXYZ

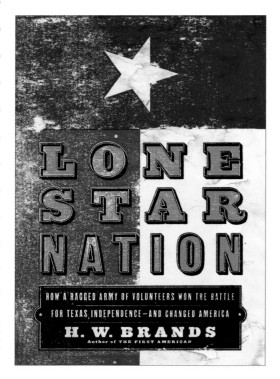

DEEP IN THE HEART OF TEXAS "Lone Star Nation tells the story of the independence of Texas, focusing on key events in the 1800s," as Rex Bonomelli explains. "Naturally, the reference for the design of this jacket came from design of that period. I specifically looked at all-type burlesque posters in order to get the feel of distinctly American type." ART DIRECTOR/DESIGNER: Rex Bonomelli PUBLISHER: Doubleday Books PRIMARY FONTS: Opti Morgan-One, HTF Ziggurat

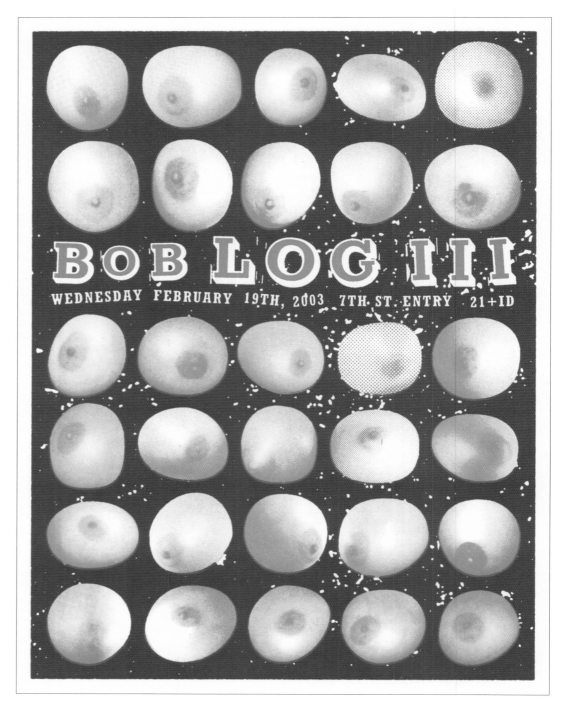

TYPE AND NIPPLES Bob Log III's blues-inspired music is pretty weird; he's a one-man band who sings through a telephone receiver hooked up to a motorcycle helmet. So, notes Dan Ibarra and Michael Byzewski, "We wanted a typeface that was kind of hokey and classic at the same time," to play off the catalog of nipples. DESIGN FIRM: Aesthetic Apparatus DESIGNERS: Dan Ibarra, Michael Byzewski CLIENT: First Avenue PRIMARY FONT: Rockwell Shadow (found sample from vintage type specimen book)

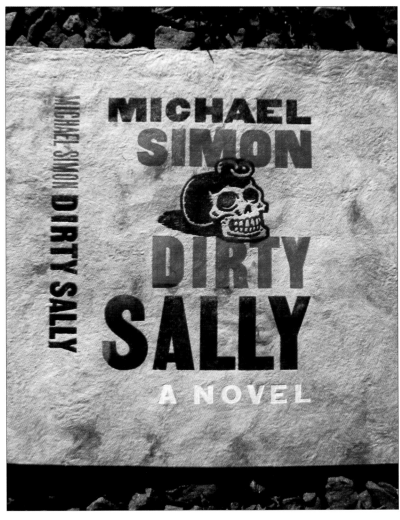

SNAKE OIL TYPE Kelly English credits, "Snake oil ads, wanted posters, outlaw tattoos and the Western flavor," for this image. The style was also prompted by the name of High Noon and its late, lamented predecessor, O'Cayz Corral.
DESIGN FIRM: Planet Propaganda ART DIRECTOR: Kevin Wade DESIGNER: Kelly English CLIENT: High Noon Saloon PRIMARY FONTS: Found type, Clarendon

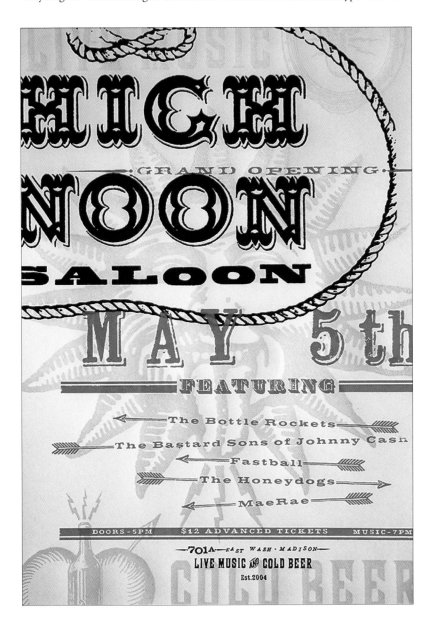

BIG, BOLD, DIRTY Ross MacDonald, an avid collector of type and printer of broadsides, based this composition appropriately enough on nineteenth-century public notices and street ballads, which works with the balladesque title of the book.
ART DIRECTOR: Paul Buckley DESIGNER/ ILLUSTRATOR: Ross MacDonald CLIENT/ PUBLISHER: Viking Penguin PRIMARY FONTS: Nineteenth-century woodtype: Gothic Bold, Gothic Bold Condensed, Gothic Bold XXX Condensed

A B C D E F G H I J K L M N O P Q R S T U V W X Y Z

[A|B|C|D|E|F|G|H|I|J|K|L|M|○|○|
96
|N|O|P|Q|R|S|T|U|V|W|X|Y|Z]

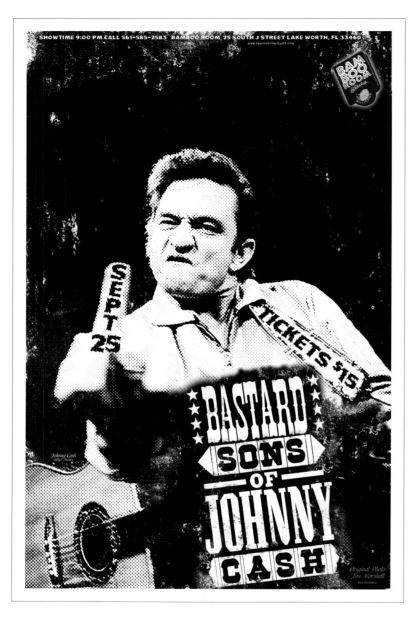

MORE CASH TYPE Mike Rivamonte says that this was, "inspired by Hatch Show Print." But, as is evident with other Cash art in this book, the slab serif appears to define the character of the singer.
DESIGNER: Mike Rivamonte PHOTOGRAPHER: Jim Marshall CLIENT: Bamboo Room PRIMARY FONT: Firecat

PURPLE PROSE "This poster was a play on type/image dominance," explains Brady Vest. "We just got a batch of big wood numbers and really wanted to use them. Actually, Modest Mouse is kind of an absurd and irreverent rock band and the poster tries to evoke that sensibility."
DESIGN FIRM: Hammerpress DESIGNER: Brady Vest CLIENT: Eleven Productions PRIMARY FONTS: Assorted ornaments, wood and lead type

SCALE IS EVERYMING

Raymond Nichols and Jill Cypher credit Hatch Show Print posters for inspiration. "We wanted the poster to look human because I think Steven [Heller] comes off like that." (Little did they know.) DESIGN FIRM: Raven Press at the University of Delaware ART DIRECTORS/ DESIGNERS: Raymond Nichols, Jill Cypher CLIENT: Department of Fine Arts and Visual Communications PUBLISHER: Raven Press at the University of Delaware PRIMARY FONT: Extra Condensed Antique

PINTER STYLE

"Since this is a book about two plays, it was important to give the typography a theater poster feel," recalls Rodrigo Corral. "Also, because Pinter is a well-known playwright, his name became the focus of the jacket. The color choices reflect his characteristically powerful dialogue. DESIGNER: Rodrigo Corral PUBLISHER: Grove Atlantic PRIMARY FONT: Champion Gothic

97

FAN-BASED EMBROIDERY "The font is where I started when I designed this piece," says Mark McDevitt, "I usually start with the illustration." The lettering comes from a couple of different hand-scrawled signs that he saw in a book about the old West, and "liked the feel and shape of the letters." He wanted to have a design that might reflect something a fan would embroider on the back of their jacket, "and the hand-painted letters were a logical choice." DESIGN FIRM: Methane Studios ART DIRECTOR/ DESIGNER/ILLUSTRATOR: Mark McDevitt PRIMARY FONT: Handlettering, based on a sign from the old West.

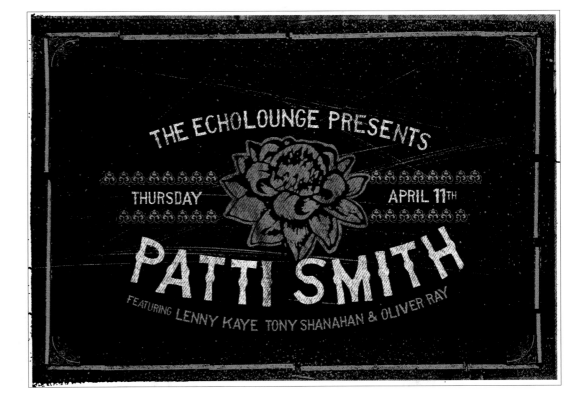

A B C D E F G H I J K L M N O P Q R S T U V W X Y Z

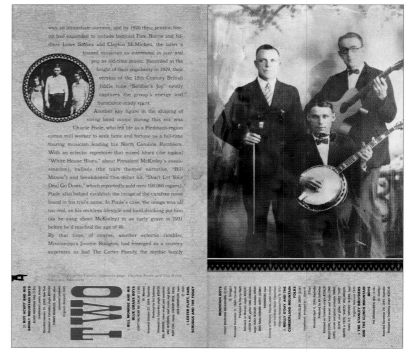

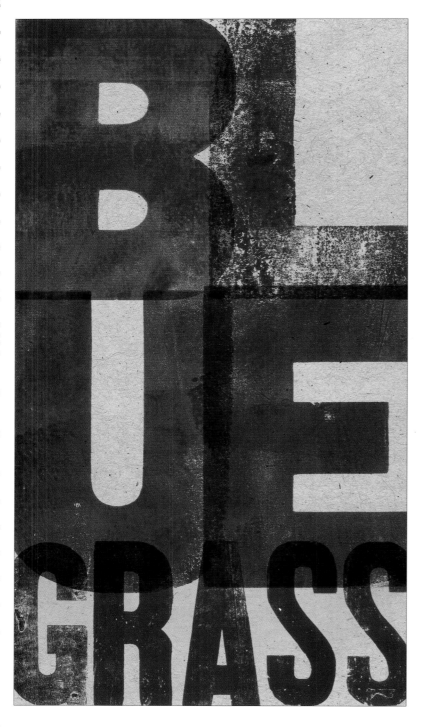

OVERPRINTING MANIA Designers love overprinting huge woodtype letters in hues that are just slightly different from one another. The raw Poster Gothics used for the cover of this booklet are taken from actual wood fonts, and the faces used in the interior are commonly available as digital versions. The trick is always to avoid prosaic pastiche while evoking the aesthetics of the age represented.
DESIGN FIRM: Skouras Design Inc. ART DIRECTORS: Josh Cheuse, Angela Skouras DESIGNERS: Angela Skouras, Mike Curry PHOTOGRAPHERS: Les Leverett/Frank Driggs Collection, David Gahr CLIENT: Sony BMG Music Entertainment PRIMARY FONTS: Woodtype, Bookman, Franklin Gothic

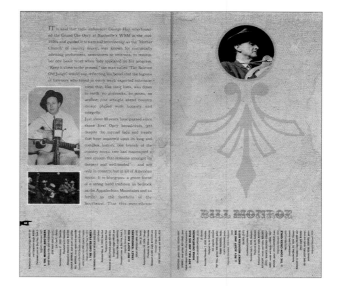

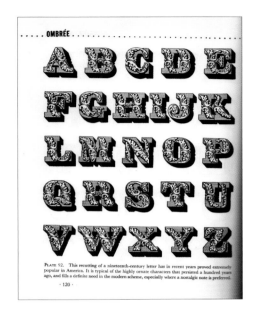

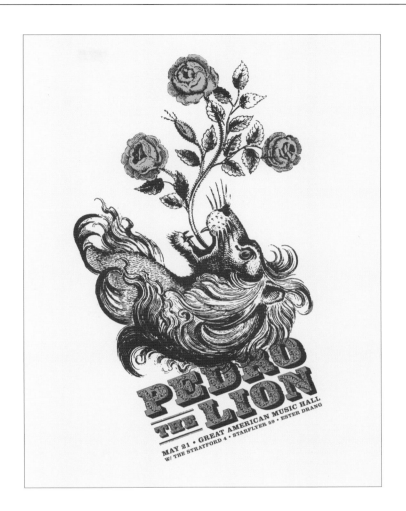

OPPOSITES ATTRACT This image was created by mixing two old woodcut images. Jason Munn says that the goal, "was to create an image combining two things that felt opposite, but when put together they looked natural." The perfect font for this poster needed to be heavy enough to support the image but ornate enough to fit like a glove. The baroquely ornamented face was eventually found in Victorian display alphabet book.
DESIGN FIRM: The Small Stakes ART DIRECTOR/DESIGNER: Jason Munn
CLIENT: Pedro the Lion PRIMARY FONT: *Lettres Ombrées Ornées*

STEAK AND CHOPS Louise Fili usually combs through old type books for faces that have little currency. "I prefer finding those letters that no one has used in ages, it is like finding buried treasure," she says. This logo for an old-style steak and chops restaurant needed to have an antique aura recalling a men's club from the mid-nineteenth century. The original was found in a type catalog, but this was completely redrawn in pen and ink from an old wood typeface.
DESIGN FIRM: Louise Fili Ltd ART DIRECTOR/DESIGNER: Louise Fili ILLUSTRATOR: Christopher Wormel CLIENT: Patroon PRIMARY FONT: Handlettering

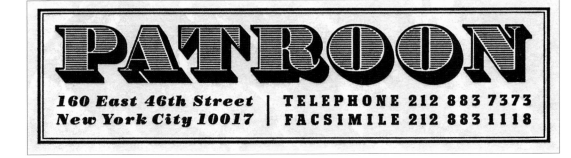

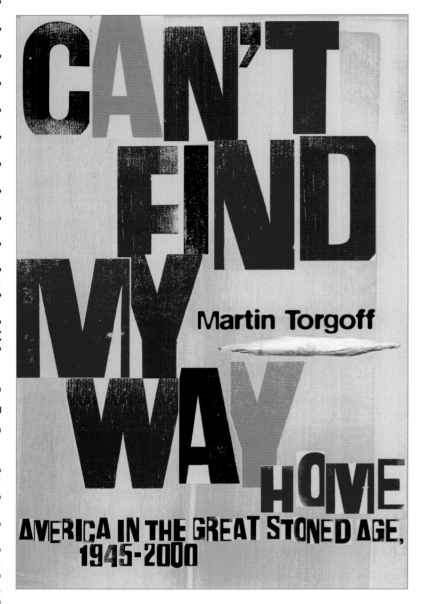

A B C D E F G H I J K L M

100

N O P Q R S T U V W X Y Z

DEAD-EYE COMIC TYPE Ross MacDonald, a collector of vintage type and cuts, used old gunpowder labels and classic circus posters for the inspiration of this self-published book of passé fare. DESIGN FIRM: Brightwork Press ART DIRECTOR/ DESIGNER/ILLUSTRATOR: Ross MacDonald CLIENT: Brightwork Press PRIMARY FONTS: Nineteenth-century wood and metal type: Egyptian Extended, Tuscan Antique Ornate, Gothic No. 3, Doric

CUT 'N' PASTE Back in the nineteenth century, most woodtype was not overprinted – the printers were more careful than that. But in this poster, carving away at the letter forms gives this poster a raw but modern look.
DESIGN FIRM: Skouras Design Inc. ART DIRECTOR: Michael Accordino DESIGNER: Angela Skouras PHOTOGRAPHER: Mike Curry PUBLISHER: Simon Schuster PRIMARY FONT: Woodtype

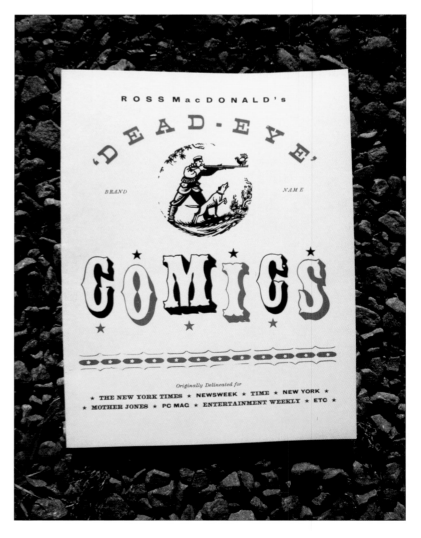

ALL YOU NEED IS... Alan Kitching notes the idea of overlapping the four letters was inspired by Robert Indiana's 'Love' painting, and the desire to create a greater type canvas to express the meaning and emotion of the word itself through touching type, textures and color.
DESIGN FIRM: The Typography Workshop ART DIRECTOR/DESIGNER/ILLUSTRATOR: Alan Kitching CLIENT: The Royal Mail PRIMARY FONT: Woodtype

YAHOO STYLE Originally created for the Double A restaurant in Santa Fe, NM, Jim Sherraden re-carved the image of the cowboy on the horse to fit the required dimension from the client. "I was familiar with all the old Western motifs there in the shop, so I designed and printed this piece (120" x 60") with those woodblocks in mind," he explains. "Big they wanted, big they got."
DESIGN FIRM: Hatch Show Print ART DIRECTOR/PRINTMAKER: Jim Sherraden PRIMARY FONTS: Woodblocks from Hatch Show Print archive. The rodeo woodblock was used as a single source for old posters, the Landola type was carved on a single block of wood along with the trailer.

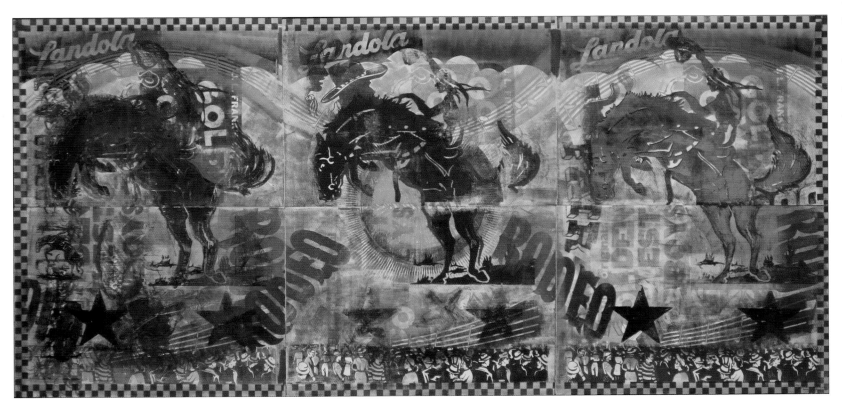

[A][B][C][D][E][F][G][H][I][J][K][L][M] ◦ ◦ ◦ ◦ 102 ◦ ◦ [N][O][P][Q][R][S][T][U][V][W][X][Y][Z]

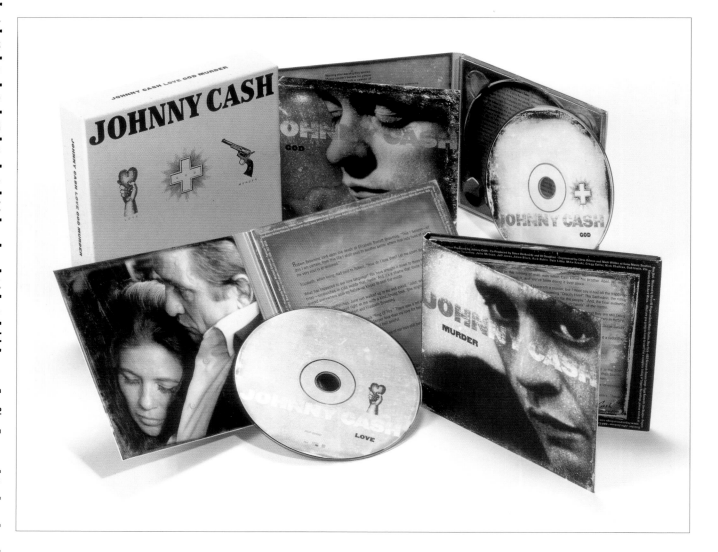

MODERN WESTERN TYPE

While the look of these Cash CDs are modern, the type is a recasting of old wood faces distorted and updated.

DESIGN FIRM: Skouras Design Inc.

ART DIRECTOR: Angela Skouras, Howard Fritzon

DESIGNERS: Angela Skouras, Mike Curry

CLIENT: Sony BMG Music Entertainment

PRIMARY FONTS: Smokler, Univers Condensed

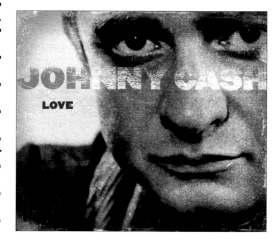

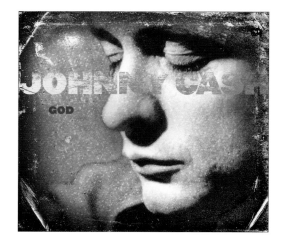

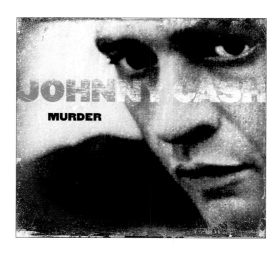

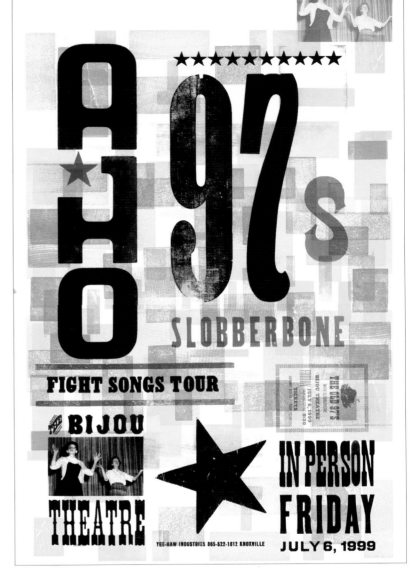

PRINTED MATTER Jordi Duró takes his cue from the countless ways type is used on packages and letters to signal the most banal messages, from fragile to printed matter. Here, the assemblage results in a lively abstraction.
DESIGN FIRM: Estudi Duró ART DIRECTOR: Jordi Duró DESIGNER: Lucrecia Olano CLIENT: Estudi Duró PRIMARY FONTS: Words found on envelopes, shipping boxes and mail labels.

PORCINE TYPE This type style comes from a turn-of-the-nineteenth-century country fair poster, while, "The image is influenced by the traditional livestock paintings, but with a modern twist," says Carrie Hamilton.
DESIGN FIRM: Empire Design Studio ART DIRECTOR: Gary Tooth DESIGNER: Carrie Hamilton PHOTOGRAPHER: Robert Dowling/Corbis CLIENT: Smithsonian Institution PUBLISHER: Smithsonian Books PRIMARY FONTS: Rosewood, Belizio, Cottonwood, DIN, Breite, Verzierte, Clarendon

RELIGIOUS FERVOR Kevin Bradley explains that the numerous layerings of type size and image for the Fight Songs Tour was done with a hint of the religious fervor found in Southern born-again tent shows.
DESIGN FIRM: Yee-Haw Industries DESIGNERS: Kevin Bradley, Kyle Blue CLIENT: Bijou Theatre PRIMARY FONTS: Various wood and lead type

A B C D E F G H I J K L M N O P Q R S T U V W X Y Z

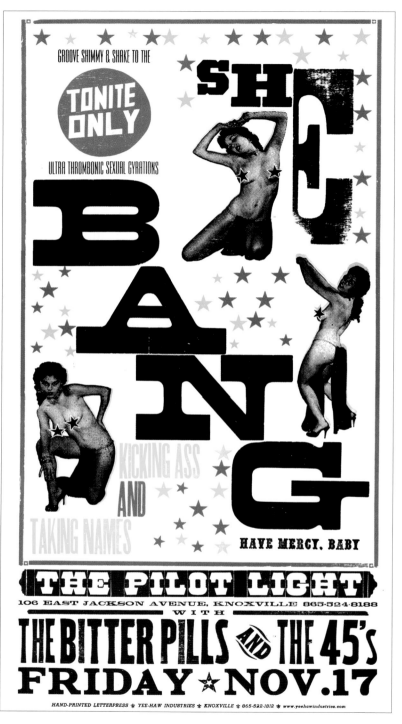

ALMOST REAL This poster was advertising a sexy girl band from Asheville that had broken up and gone into the burlesque business. The poster is part-carnival, part-burlesque, and almost as real as it would be if it had been printed in the 1950s. DESIGN FIRM: Yee-Haw Industries DESIGNER: Kevin Bradley CLIENT: The Pilot Light PRIMARY FONTS: Various woodtype

IMPRESSIONIST PRINTING Alan Kitching says, "This was the first time I created hard-edged colors and textures by hand-inking directly onto the woodtype." The *Dazed & Confused* art department then scanned textured areas into their standard logo to complement and reflect Kitching's headline type treatment. DESIGN FIRM: The Typography Workshop ART DIRECTOR/DESIGNER/ ILLUSTRATOR: Alan Kitching CLIENT: *Dazed & Confused*: Rankin Waddell, Jefferson Hack. PUBLISHER: Dazed & Confused: Rankin Waddell, Jefferson Hack PRIMARY FONTS: Various woodtype

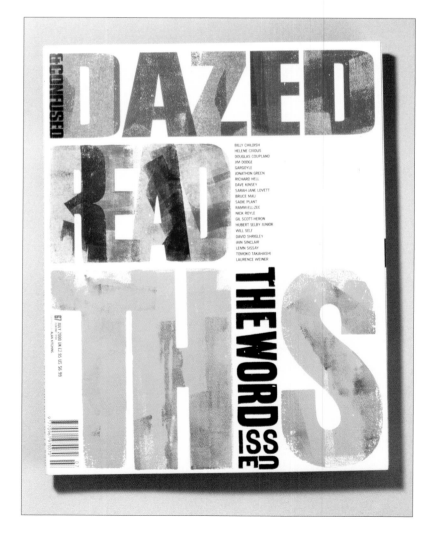

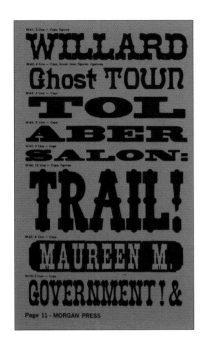

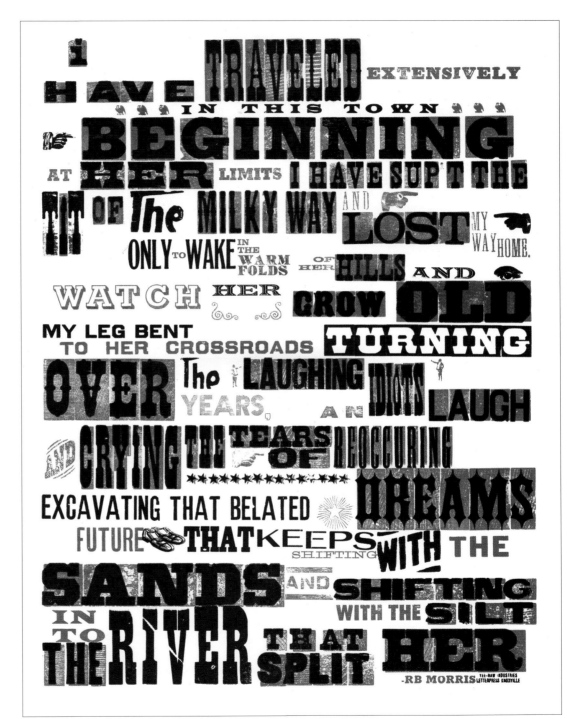

TYPE SAMPLER This was a poster for a great writer, great poet, great musician. His mantra, Kevin Bradley notes, is that "you cannot corrupt poetry, there's no money in it." This falls under the rubric "broadsides" because they are how poets in the nineteenth century displayed their work. DESIGN FIRM: Yee-Haw Industries DESIGNER: Kevin Bradley CLIENT: R. B. Morris PRIMARY FONTS: Various woodtype

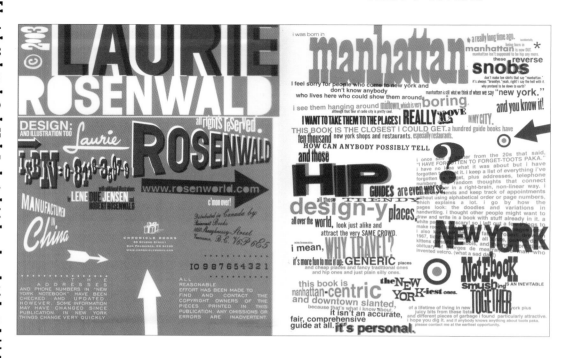

HOW TO BE A NEW YORKER (NEW YORK NOTEBOOK) Laurie Rosenwald draws much of her stylistic inspiration from Sister Corita Kent, whose handlettering was often a copy of old woodtypes. Here, every style from the 1890s to 1980s are explored.
DESIGN FIRM: Rosenworld.com ART DIRECTOR/ DESIGNER/ILLUSTRATOR: Laurie Rosenwald CLIENT: Chronicle Books PRIMARY FONTS: Various

SLEEPING WOODBLOCK Jim Sherraden reveals, "This was one of my first attempts to reinterpret the sleeping woodblock there in the shop," otherwise known as the overprinting of various fore and background images. The poster's musical notes came from old minstrel show woodblocks.
DESIGN FIRM: Hatch Show Print ART DIRECTOR/PRINTMAKER: Jim Sherraden PRIMARY FONT: 1940s woodblock, advertising Roy Acuff and His Smoky Mountain Boys.

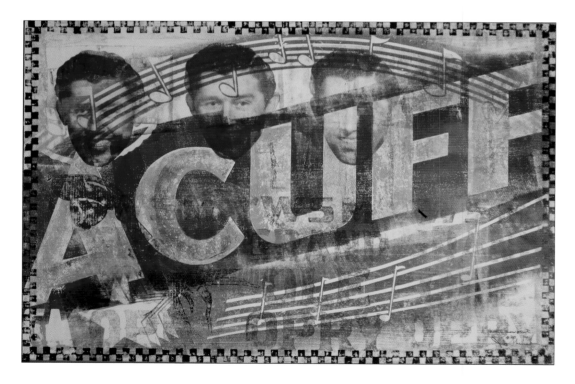

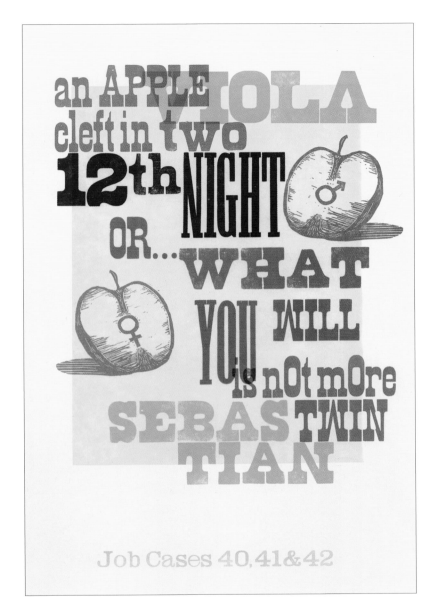

Job Cases 40, 41 & 42

BEVY OF WOOD David Wolske notes that this piece was, "Influenced by vintage type specimens and inspired by Indiana University Associate Professor, James Reidhaar," and provided a contemporary way to work with old material.
DESIGNER/ILLUSTRATOR/LETTERPRESS PRINTER: David Wolske CLIENT: Graphic Design Press, Indiana University PRIMARY FONTS: Various woodtype

HORSE ICON "We call this a constitution poster," says Kevin Bradley, "with so much copy that it is like typesetting the constitution. We were subliminally using the country icon of a horse in conjunction with a metro symbol to confuse the suburbanites who think that because we now have a condo goldrush in Knoxville, they now live in NYC." DESIGN FIRM: Yee Haw Industries DESIGNERS: Kevin Bradley, Adam Ewing CLIENT: *Metro Pulse* newspaper PRIMARY FONTS: Various woodtype and letterpress

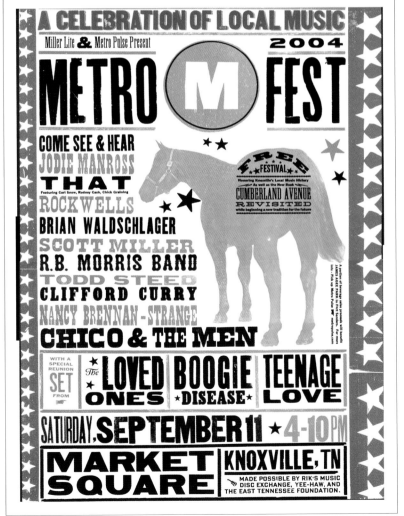

POTPOURRI OF GRAPHIC DELIGHTS The lives of musicians during the
Depression era are represented through this collection of turn-of-the-century wood and
metal faces, printed with the patina of the times.

DESIGN FIRM: Skouras Design Inc. ART DIRECTOR: Josh Cheuse, Angela Skouras
DESIGNERS: Angela Skouras, Mike Curry PHOTOGRAPHERS: Dennie Tarner, James R.
Michin III, Stephanie Chernikowski CLIENT: Sony BMG Music Entertainment
PRIMARY FONTS: Egiziano, Cheltenham

SYMMETRICAL BALANCE "The main influence behind this poster is the music of LungFish," says Jason Munn. "Very symmetrical with lyrics that are usually highly descriptive and seem to evolve with each line. That is the way I approached the poster starting with the central image (the skull) and going from there. Most of the elements came from old clip art books."
DESIGN FIRM: The Small Stakes ART DIRECTOR/DESIGNER: Jason Munn CLIENT: Lung Fish PRIMARY FONT: Broadcast

TYPE FOR FREEMEN The Magna Carta postage stamp for the Royal Mail Millennium issue in 1999, commemorates the granting of first rights to freemen of England in 1215. "The type, color and composition reflect both the forced signing of the Magna Carta at Runnymede island and the continuing global struggle for basic human rights," Alan Kitching explains.
DESIGN FIRM: The Typography Workshop ART DIRECTOR/DESIGNER/ILLUSTRATOR: Alan Kitching CLIENT: The Royal Mail PRIMARY FONT: Woodtype

LOCK AND KEY Jason Munn explains the derivation for this poster came from the title of the art show. "Many of the pieces in the show were very small (nothing over 4 inch square). I wanted the idea to come across of a 'keepsake' – being something so special to you that you keep it under lock and key." The type fits the lock.
DESIGN FIRM: The Small Stakes ART DIRECTOR/DESIGNER: Jason Munn
CLIENT: Keepsake Society PRIMARY FONT: Blackoak

TITLE: FALL OUT BOY LIMITED EDITION POSTER Mike Joyce recalls the constructivist sensibility of Herbert Matter's New Haven Railroad logo, designed in 1955, it used broad slab serifs as an architectonic typographic conceit.
DESIGN FIRM: Stereotype Design ART DIRECTOR/DESIGNER: Mike Joyce
CLIENT: Fueled by Ramen PRIMARY FONT: Helenic Extended

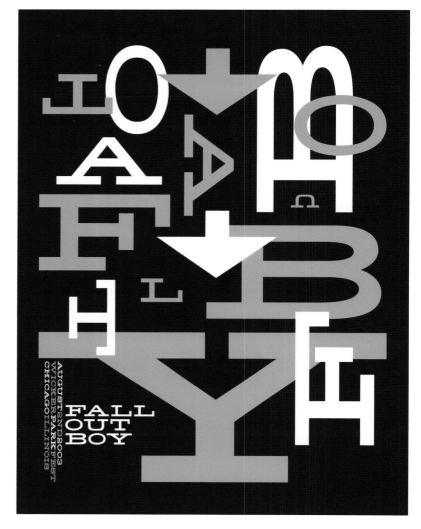

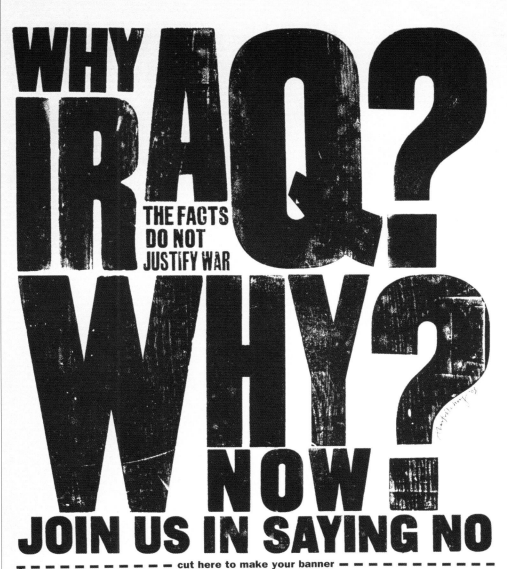

PROTEST TYPE This was a full page advertisement in the *Guardian* newspaper protesting the imminent invasion of Iraq. Designed and composed to work as both as a newspaper advertisement and a protest banner, Alan Kitching says that, "the page ad. became a personal placard for participants in the next day's UK and global anti-war rallies."

DESIGN FIRM: The Typography Workshop ART DIRECTOR/DESIGNER/ILLUSTRATOR: Alan Kitching CLIENT: Richard, Ruth and Roo Rogers PUBLISHER: *Guardian*, UK PRIMARY FONTS: Various woodtype

A B C D E F G H I J K L M

111

N O P Q R S T U V W X Y Z

Fashion & FLOU

ART DECO (OR ART MODERNE) IS ARGUABLY THE most revived of all vintage type styles, even more so than the ubiquitous slab serif woodtypes so plentiful in this volume. Despite its identifiable historical veneer, Deco has been reprised so many times that it is now often mistaken as contemporary. However, when Art Deco (the term is a contraction of the landmark 1925 Paris *Exposition Internationale des Arts Décoratifs et Industriels Modernes*, where the post-war commercial style was introduced to the world) was new, it was decidedly unprecedented. Although influenced by earlier historical graphic manifestations, such as Classicism, neo-Classicism, Mayan and Egyptian styles, when mixed together with a dollop of orthodox Modernism, the result was of its time.

THE ART DECO STYLE

RISH

SLAB BEAUTY
During the 1920s, various type manufacturers and designers produced sample or template sheets with full alphabets of quirky, though highly stylized, typefaces. They were designed to encourage sign painters and head-line designers to copy them and although many were never made into actual fonts, some were adapted as such. This nameless German specimen is something of a cross between a slab serif like Stymie and a brushstroke italic.

114

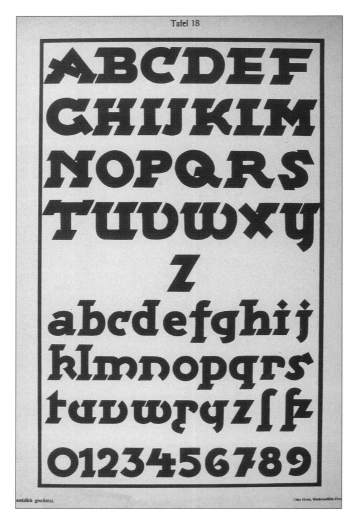

Stylized typefaces defined Art Deco exuberance during the 1920s and 1930s every bit as much as cubistic fashions, streamline furniture, setback skyscrapers, and aerodynamic automobiles. Voguish display types were the marks of modernity in advertisements for contemporary products. Type designers may not have been major players in the higher echelons of industry, but they were in the trenches of the consumer revolution.

Art Deco was launched in the post-World War I era as a pan-European fashion that migrated into Asia (Shanghai was the Deco capital of the Far East), South America, and the United States (where it was referred to as either the Skyscraper style or Streamline). While it was practiced differently in various countries where distinct national traits were injected, the truly fundamental modernistic characteristics remained constant throughout the world.

The airbrush was the principal tool giving all the graphics an emblematic smooth and sleek veneer. The basic geometry of Art Deco was rectilinear, as opposed to Art Nouveau, which was unremittingly curvilinear. The metaphoric hook was speed, with the most archetypal designs poised in forward or upward motion. There were other traits too, but the key was always modernity; Art Deco was a commercial alternative to the austere Bauhaus sensibility. Where the radical New Typography move-ment rejected ornament in favor of religiously followed asymmetry and bold, geometric gothic typefaces, Deco was known for its own kind of ornamentation. In its early iterations during the late 1920s and early 1930s, slick versions of baroque and rococo adornment were acceptable in Deco design. By the later or "high" moderne period during the late 1920s and early 1930s, most embellished conceits were radically simplified though never entirely eliminated – the lightning bolt and sunray were the most common motifs.

Deco was anathema to purist Modernists, who viewed it as merely another extravagance catering to the bourgeois classes. But really, it was a deliberate stylistic trope designed to spark increased consumerism, and, like any popular fashion, its creators' aimed to create allure, trigger desire, and encourage behavior most likely to perpetuate con-sumption. It accomplished this goal in the period between World War I and the world depression with such results that the style virtually masked the despair felt in many countries at that time. In a curious way, Deco was a bandage that covered the social wounds providing an illusion of cultural progress. It lasted more or less through the great depressions up until World War II, when it was replaced by more austere attitudes. Although Deco was ultimately seen as indulgence, its excessiveness was nonetheless celebrated as a throwback to the good old days. Certain Deco structures, such as architecture, ob-jects, and furniture, had even become part of everyday life, with typefaces integrated into art and design for at least a decade to follow Deco's initial demise.

Because it was a style born of compromise, Deco was actually more expandable and inclusive than other venerable styles. Italians infused Futurist typography with certain Deco conceits and a Mediterranean color palette; Germans mixed Expressionism with Deco sensibilities; even the Dutch mixed rigidly geometric De Stijl with Cubism for an eclectic modernistic appearance.

Posters were the most visible graphic artifacts, and magazines featuring poster-like covers spread the Deco gospel. Equally ubiquitous were the point-of-sale displays for the leading department stores, as well as sundry and food packages for premium goods. Deco would not have had an impact but for its emblematic, rectilinear typefaces, which were the glue that bound all disparate moderne conceits together.

Today's Deco typographic style, and a lot of the revivals and inspirations reproduced here, plays off the monumental aura of sleek airbrushed renderings of heroic, neo-Classical figures. Moreover, shadows are synonymous with Deco styling and most type suggesting the 1930s Machine Age features them.

Back when Deco inveigled its way into mass consciousness, stylized type had the power to influence popular perceptions, so new type designs were released with great fanfare. Type specimen sheets from the 1920s through the 1930s show enticing displays of alluring designs. Advertising artists demanded stylish faces with "Jazz Age" conceit, and with the widespread availability of print advertising during the early twentieth century, novel and novelty letter forms – some revivals of historical faces, others contemporary inventions – appealed to printers and designers alike. Scores of new typefaces and complimentary ornaments and dingbats with futuristic names like Vulcan, Modernistic, Cubist Bold, and Novel Gothic heralded Machine Age progress. Although the production of Deco types ceased in the early 1940s, the typefaces that signaled the opulent style of the Deco decade retains a certain luster today. The current revivals are used for everything from pastiche to contemporary applications having little to do with the Deco past. But even today, they all telegraph an aura of status that the original versions were designed to project.

STOREFRONT LETTERS When Nick Curtis was a child, he began a lifelong interest in typographical archaeology that is represented here. "In a way, a revivalist type designer is like a shaman," he says, "We study the bones, we say a few magic words (actually, we do some serious Bezier curve crunching, finessing and tweaking), and conjure up the talismans that allow anyone to travel to another place and another time." These letters reflect the Deco and post-war styles often found on shop windows, signs, and marquees.
DESIGNER: Nick Curtis PUBLISHER: Nick's Fonts, distributed by myfonts.com

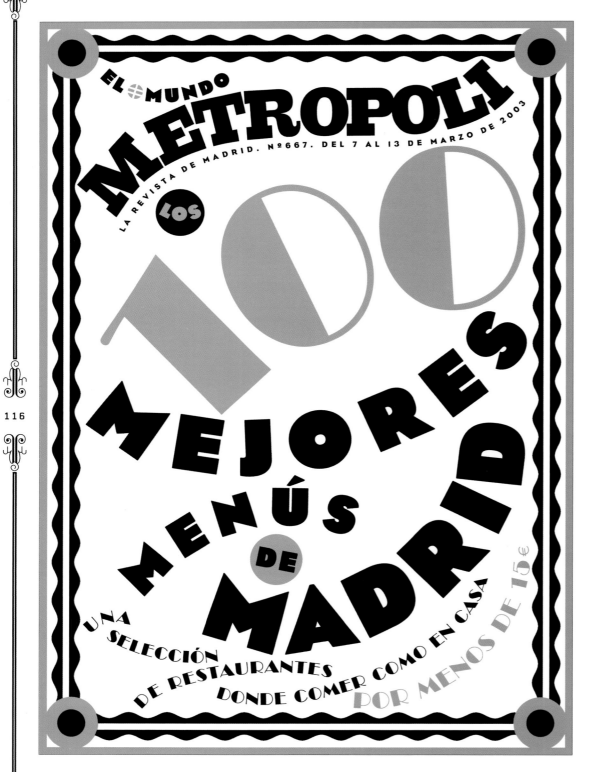

DECO SPECIMEN Art Deco was a worldwide phenomenon in the late 1920s and throughout the 1930s. This cover of *Metropoli* takes its lead from the carnivalesque type specimens that sold stylish Deco typefaces to printers.
DESIGN FIRM: Unidad Editorial S. A. ART DIRECTOR/DESIGNER: Rodrigo Sanchez CLIENT: *El Mundo Metropoli*/Unidad Editorial PRIMARY FONTS: Giza, Broadway, Eagle, Cloister

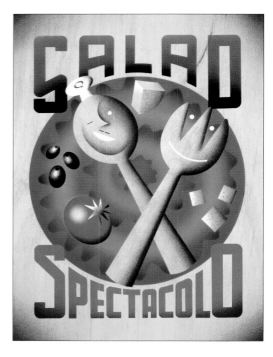

ANIMATED LETTERS Art Deco and Streamline styling evoke a period when design was mostly illustration, and most of that was done with an airbrush. The sans serif lettering with the smooth colorful surfaces is made to seem animated.
DESIGN FIRM: Tesser ART DIRECTOR: Tre Musco DESIGNER/ILLUSTRATOR: Terry Allen CLIENT: Quiznos PRIMARY FONT: New

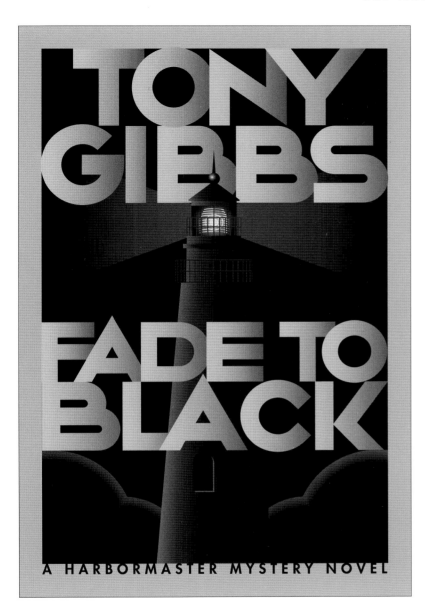

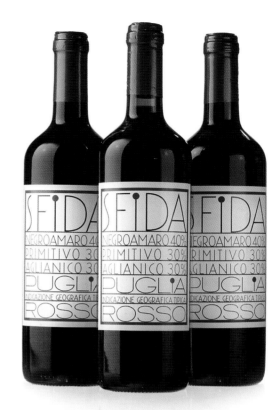

FUTURIST WINE
As is usual with Louise Fili, 1930s Italian decorative typography – a variant of commercial Futurism – was the inspiration for this design. The thin sans serifs were originally designed and exaggerated to exude a sense of modernity, but in this context it makes the wine label into a mini-poster.
DESIGN FIRM: Louise Fili Ltd ART DIRECTOR: Louise Fili DESIGNERS: Louise Fili, Mary Jane Callister CLIENT: Pink Door PRIMARY FONT: Handlettering

MYSTERY TYPE The origin of the posters of A. M. Cassandre is not a mystery, and their application in this mystery novel jacket adds a sinister character to the design. His distinctive use of airbrushed, overlapping and shadow-laden typography defined the 1930s, and Cassandre produced some of the world's most memorable advertisements.
DESIGN FIRM: Daniel Pelavin ART DIRECTOR: Rachel McClain DESIGNER/ILLUSTRATOR: Daniel Pelavin PUBLISHER: Mysterious Press PRIMARY FONTS: Custom lettering, Futura

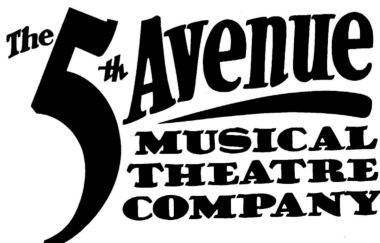

SPEEDBALL LETTERS The eclectic, spirited Art Chantry notes his inspirations as, "Old Speedball pen lettering books: Volume 17 – particularly by George Ross; and Old Movie Show cards of the 1930s." This was the age of one-off handdrawn characters that were part-calligraphy, part-typography, and part whatever came to mind.
DESIGN FIRM: X Design Co. ART DIRECTOR/DESIGNER: Art Chantry CLIENT: 5th Ave Musical Theatre Company PUBLISHER: Vintage Books PRIMARY FONT: Handlettering

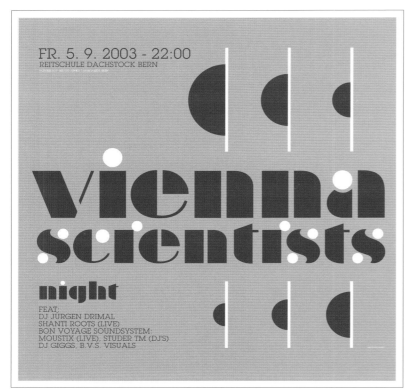

VIENNA'S SECESSION A lush stencil based on a bastardized lower-case Bodoni-style face, evokes the vibrancy of the 1920s somewhere between the Vienna Secession and orthodox Modernism.
DESIGN FIRM: Büro Destruct DESIGNER: Lopetz CLIENT: Reitschule Dachstock Bern PRIMARY FONTS: Braggadicio, Lubalin Graph

RACY TYPE This poster references the racy, expressionist images in Joseph Moncure March's banned Jazz Age poem, *The Wild Party*, and the aesthetics of the "roaring twenties". Kevin Brainard notes, "It attempts to depict the seamy underside of excess," and does so excessively.
DESIGN FIRM: Spot Design ART DIRECTOR: Drew Hodges DESIGNER/ILLUSTRATOR: Kevin Brainard CLIENT: Manhattan Theatre Club PRIMARY FONTS: Opti Morgan, untitled alphabet by Andres Vlaadern

118

ALL ABOARD The analog for this is a French train ticket, "or what we thought it should look like," injects Louise Fili. Using letter forms discovered in old Deberny & Peignot type specimen books, this 1930s design is made modern with the pastel color palette.
DESIGN FIRM: Louise Fili Ltd ART DIRECTOR: Louise Fili DESIGNERS: Louise Fili, Mary Jane Callister CLIENT: Metrazur PRIMARY FONT: Handlettering

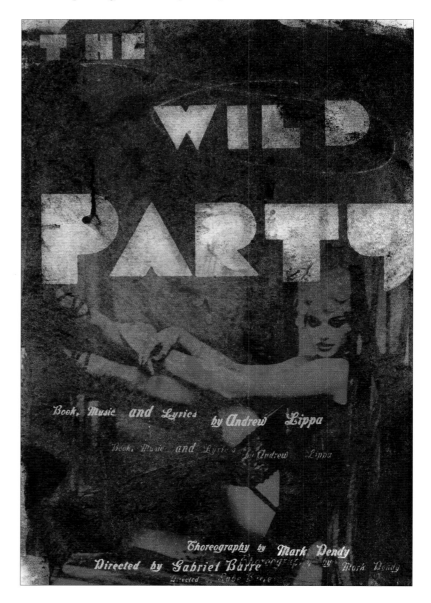

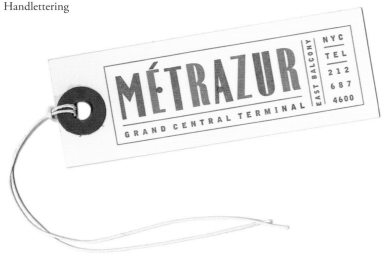

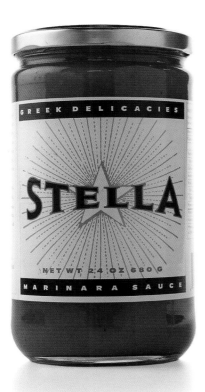

GREEK, ITALIAN, FRENCH Italian and French label design from the 1920s and 1930s are joined together in this hybrid piece of retro for a Greek food company. The types and ornaments each derive from vintage samplers.
DESIGN FIRM: Louise Fili Ltd ART DIRECTOR/
DESIGNER: Louise Fili CLIENT: Likitsakos
PRIMARY FONT: Handlettering

HAIL, JEAN CARLU! Art Deco posters by Jean Carlu and his circle are revived and reinterpreted here. The color palette may be brighter than most Deco extravaganzas but the airbrushed virtuosity retains its verisimilitude.
DESIGN FIRM: Tesser ART DIRECTOR: Tre Musco DESIGNER/ILLUSTRATOR:
Terry Allen CLIENT: Quiznos PRIMARY FONT: New

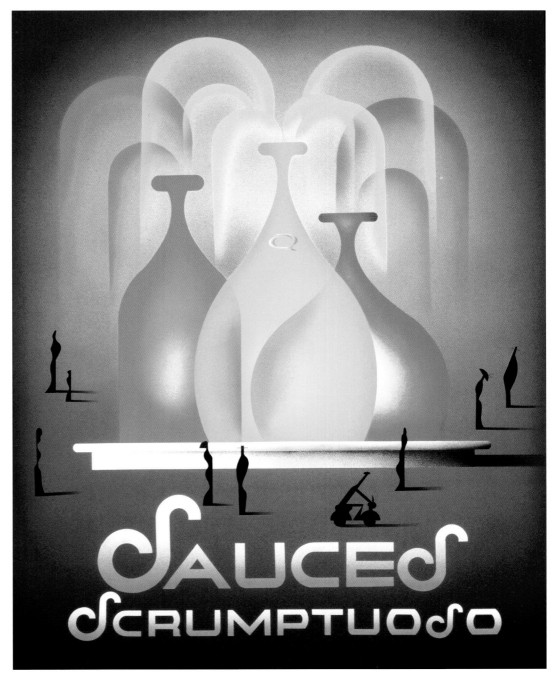

DROP SHADOW GORGEOUS Old window and sign lettering with deep drop shadows gives this reinterpretation of modernistic design its allure. The type is typical of the multi-dimensional, brightly colored styles prevalent from the 1910s to the 1930s.

DESIGN FIRM: Tesser ART DIRECTOR: Tre Musco DESIGNER/ILLUSTRATOR: Terry Allen CLIENT: Quiznos PRIMARY FONT: New

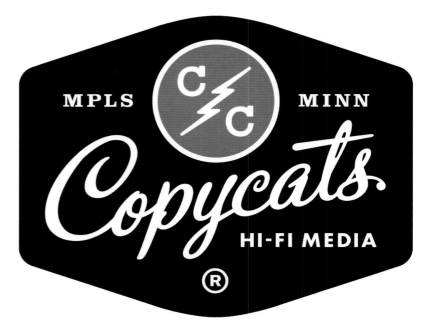

120

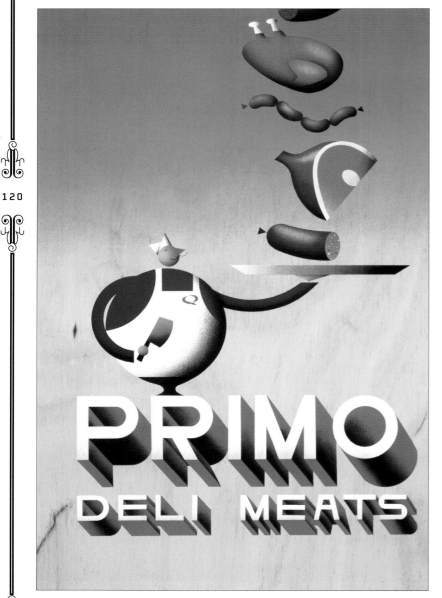

RECORD LABELS Copycats is a CD/DVD manufacturer offering design, printing and packaging services. Richard Boynton used his "trusty Lubalin Graph" in the circular mark with bolt creating a vintage manufacturing sensibility, "as a supplement to the custom script that fuses into a kind of hybrid 'record label/industrial manufacturer' vernacular."

DESIGN FIRM: Wink, Incorporated CREATIVE DIRECTORS: Richard Boynton, Scott Thares DESIGNER: Richard Boynton CLIENT: Copy Cats PRIMARY FONTS: Clarendon, Monterey

ROCK CENTER

Rockefeller Center is the sparkling architectural jewel in the Deco crown. For the long-awaited opening of its rooftop observation deck, Staci Mackenzie looked to an old Art Deco perfume bottle for inspiration, as well as iconic friezes and murals found throughout the complex.

DESIGN FIRM: Doyle Partners ART DIRECTOR: Stephen Doyle DESIGNER: Staci Mackenzie CLIENT: Tishman Speyer/Rockefeller Center

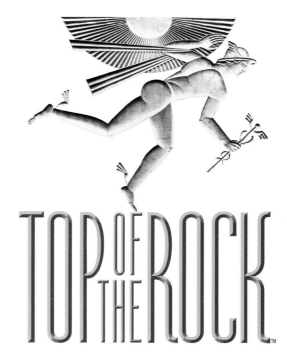

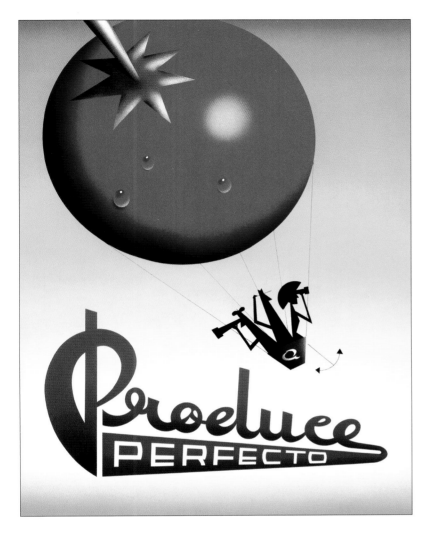

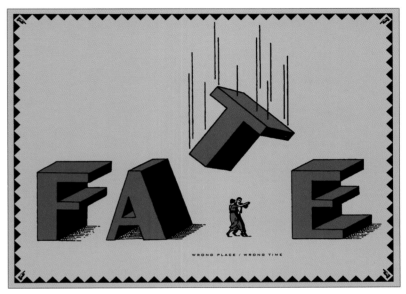

FALLING LETTERS In addition to the obvious nineteenth-century typography, Joe Scorsone and Alice Drueding pay homage to Saul Steinberg's comic typographic imagery.
DESIGN FIRM: Scorsone/Drueding ART DIRECTORS/DESIGNERS/ILLUSTRATORS: Joe Scorsone, Alice Drueding CLIENT: Scorsone/Drueding PRIMARY FONTS: Bank Gothic, nineteenth-century wood-carved alphabet by Silvestre

COMMERCIAL VERNACULAR Bold scripts have a timeless quality in the commercial vernacular, but they also denote particular times in design history. This has a 1950s look, but given the application of the airbrush, merges into pre-World War II territory as well.
DESIGN FIRM: Tesser ART DIRECTOR: Tre Musco DESIGNER/ILLUSTRATOR: Terry Allen CLIENT: Quiznos PRIMARY FONT: New

SOFT SOAP Elizabeth Morrow McKenzie lists the following as inspirations, "Deco soap labels, neon signs, and plain old Deco typefaces." The logo is a composite of the in-line and outline sans serifs of the 1920s.
DESIGN FIRM: Morrow McKenzie Design ART DIRECTOR: Elizabeth Morrow McKenzie DESIGNERS: Mette Hornung Rankin, Elizabeth Morrow McKenzie CLIENT: Lucina PRIMARY FONT: Drawn

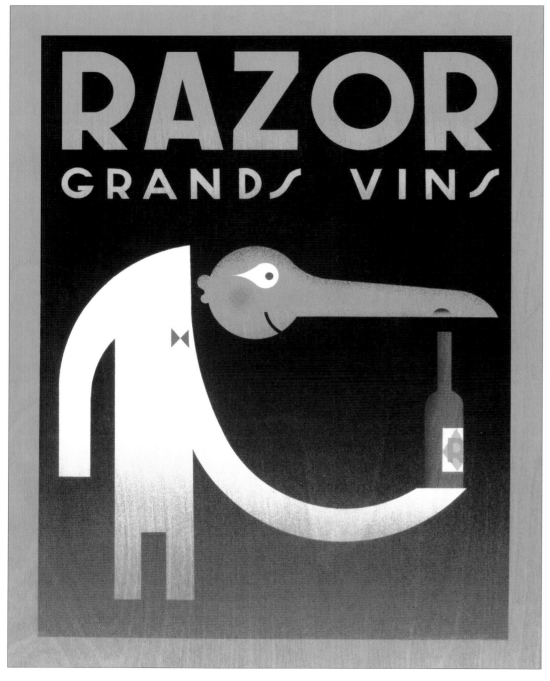

SPECTER OF CASSANDRE Once again, the specter of A. M. Cassandre's emblematic advertising posters is evoked in a hybrid of Art Deco and Art Brut sensibilities. The type is pure Cassandre, while the comic image – perhaps inspired by the Dubonnet Man – is utterly today.
ART DIRECTOR/DESIGNER/ILLUSTRATOR: Terry Allen CLIENT: Self, for promotional reasons PRIMARY FONT: Custom

SLAVISH COPY Kobalt Black was based on handlettering that appeared in European posters of the 1920s and 1930s, but was also used on sheet music covers of the era. "Kobalt" is a play on "Kabel" because Koch's Kabel typeface was, "an attempt to hasten the exuberance of this poster style while Kobalt is more accurate," says Leslie Cabarga. Ojaio is based on the letters of Danish industrial designer Gustav Jenson from the 1930s but it is not a slavish copy. "It is more of a synthesis of all such thin decorative styles of the era," he continues. "I like contrasting the thin Ojaio with the Bold Kobalt Black, and the two fonts worked well to evoke old sheet music of the book cover with an old music theme."
DESIGN FIRM: Leslie Cabarga/Flashfonts ART DIRECTOR/DESIGNER: Leslie Cabarga PUBLISHER: David R. Godine, Publishers PRIMARY FONTS: Kobalt Black, Ojaio Regular

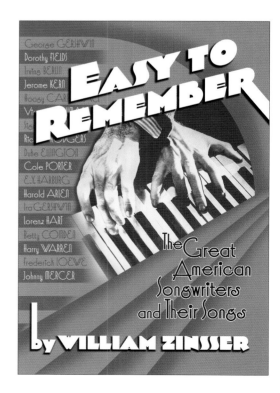

DELI TYPE Somehow, this stylish, novel sans serif was the offspring of what Elizabeth Morrow McKenzie calls, "vernacular diner and deli signage," with a vintage 1920s caste.
DESIGN FIRM: Morrow McKenzie Design ART DIRECTOR: Elizabeth Morrow McKenzie DESIGNERS: Mette Hornung Rankin, Elizabeth Morrow McKenzie PRIMARY FONT: Burin Sans

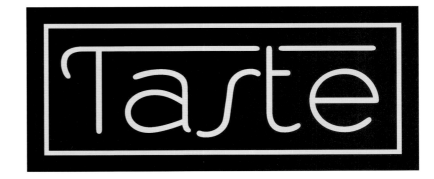

THEATRICAL TYPE Inspiration for this logotype came from the renovated Teatro Alameda that is the centerpiece of the National Center for Latino Arts and Culture. Aesthetically, the theater reflects an exuberant combination of Art Deco, Moderne and Mesoamerican motifs. The type for the logo came from a sampler of 1930s typefaces, though the name of the original font is unknown. Giles Design redrew the letter forms with very minor alterations to create a logo that is contemporary but strongly reminiscent of the Alameda's early-twentieth-century heyday. "We pared the logo type with organic shapes inspired by design elements in the Teatro's interior and rendered in spatter ink technique found in a 1938 Sanford Ink Hobby book," says Jill Giles.
DESIGN FIRM: Giles Design, Inc. ART DIRECTOR: Jill Giles DESIGNERS: Jill Giles, Cindy Greenwood, Barbara Schelling ILLUSTRATORS: Cindy Greenwood, Barbara Schelling CLIENT: The Alameda National Center for Latino Arts and Culture PRIMARY FONT: Found in a collection of 1930s typefaces

MAKING STREAMLINES Daniel Pelavin designed ITC Anna, and named it after his oldest daughter. Rooted in the Streamline and Art Deco aesthetic, it also has a futuristic air that conforms to the mural-like drawing of this cover, only this is a vision of the future as seen from the past.
DESIGN FIRM: Daniel Pelavin ART DIRECTOR: Krystyna Skaski DESIGNER/ILLUSTRATOR: Daniel Pelavin PUBLISHER: Walker & Company PRIMARY FONTS: ITC Anna, Bokar, Kabel

123

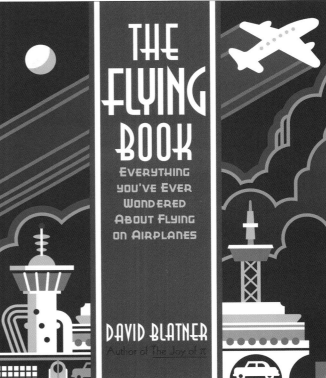

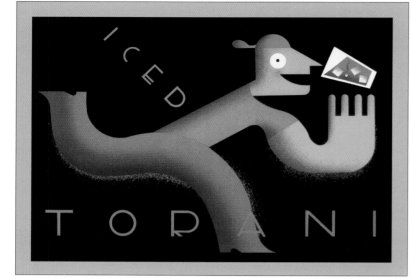

CASSANDRE REDUX French and Italian airbrushed Art Deco, in particular the Dubonnet posters by A. M. Cassandre, informs this poster's color, figure and typography. Terry Allen's distinctive pictorial distortions are uniquely his own, but the formal attributes suggest the Streamline aesthetic. While the type may be a little finer than Cassandre's would have been, the roots are unmistakable.

ART DIRECTOR/DESIGNER/ILLUSTRATOR: Terry Allen CLIENT: Self, for promotional reasons PRIMARY FONT: Custom

124

SPANISH LUXURY This decorative two-color stencil lettering was all the rage during the late 1920s to mid-1930s. It suggested progress, luxury and the machine. While researching for the book *Deco España*, Louise Fili discovered two-tone typography being used in a logo for a Spanish sundry product. Fili later adapted the idea for this fashion manufacturer's logo.

DESIGN FIRM: Louise Fili Ltd ART DIRECTOR/DESIGNER: Louise Fili CLIENT: Ilux PRIMARY FONT: Handlettering

FILM CARDS Kobalt Black was the composite of many styles of classic 1930s European poster letters. These same styles were used by film title card letterers at the Max Fleischer Studios. Leslie Carbarga used his custom-designed Kobalt Black, with alterations to several of the letters, to imitate the unique Fleischer graphic style.

DESIGN FIRM: Leslie Cabarga/Flashfonts DESIGNER/ILLUSTRATOR: Leslie Cabarga PUBLISHER: Kit Parker Films PRIMARY FONT: Kobalt Black from Flashfonts, by Leslie Cabarga

CAPTURING KABEL The airbrushed gradation of this "moderne" lettering (reminiscent of Rudolf Koch's Kabel) simply exudes a period aesthetic often found in packages and posters of the period but not influenced by an exact historical object.
DESIGN FIRM: Jon Valk Design ART DIRECTOR: Louise Fili DESIGNER: Jon Valk PHOTOGRAPHER: Popperfoto PUBLISHER: Pantheon Books
PRIMARY FONT: Handdrawn, Pennant

DACHAU REVIVAL Letter forms used in 1930s advertising were often based on architectural models, and elongated curves and ovals were common. Appropriately enough, this book cover was, says Jon Valk, "based on early-twentieth-century Viennese architecture and design, as well as the infamous *Arbeit Macht Frei* (Work Will Make You Free) gate design at Dachau that greeted the poor inmates of the Nazi concentration camps."
DESIGN FIRM: Jon Valk Design ART DIRECTOR: Kathleen Lynch DESIGNER: Jon Valk
PHOTOGRAPHER: Hulton-Deutsch Collection/ Corbis PUBLISHER: Oxford University Press
PRIMARY FONT: Custom, based on Heritage

125

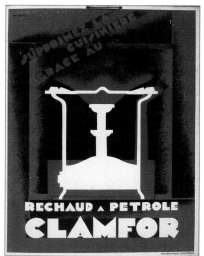

THE IMPRESSION OF SPEED Certain Italian travel and product posters from the 1920s and early 1930s used typefaces inspired by the Futurists. The type gave the impression of speed – the Futurist ethos – by using sharp sans serif forms that looked as though they were cut with a knife. This is one of Terry Allen's influences, another being the heavy and thin-lined faces so common in all design of that era.
DESIGN FIRM: Wieden + Kennedy ART DIRECTOR: James Selman DESIGNER/ILLUSTRATOR: Terry Allen
CLIENT: Nike PRIMARY FONT: New

A B C D E F G H I J K L M N O
P Q R S T U V W X Y

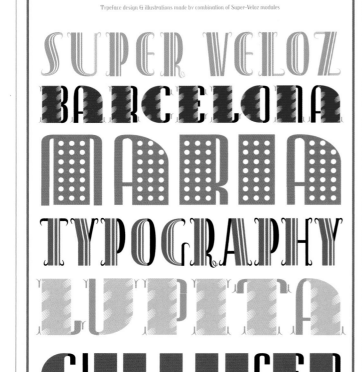

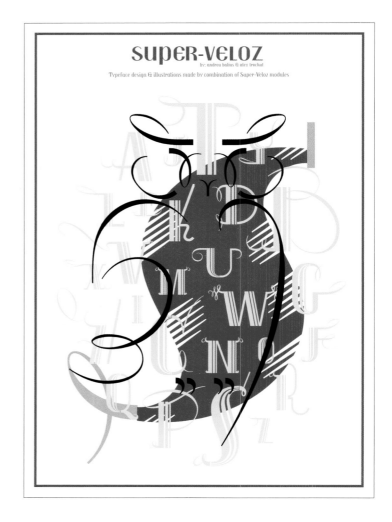

DECO DECORATION A Spanish Art Deco type specimen catalog is the prime inspiration for this digital typeface. Even the letters themselves echo the original 1930s decorative style.

DESIGN FIRM: Typerepublic.com ART DIRECTORS/DESIGNERS: Andreu Balius, Alex Trochut PUBLISHER: Typerepublic.com PRIMARY FONT: Super-Veloz

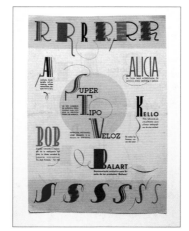

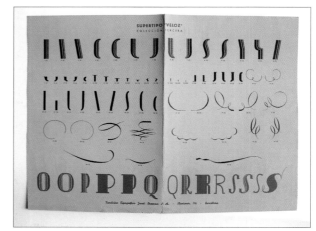

FUTURIST PAST Daniel Pelavin derives many of his basic typefaces from existing Art Deco ornaments and lettering. This face refers to Italian Futurist advertisements and the bold alphabets that appeared to be influenced by lightning bolts. It also resembles Milton Glaser's earlier alphabet called Baby Teeth.
DESIGN FIRM: Daniel Pelavin ART DIRECTOR: Mark Zisk DESIGNER/ILLUSTRATOR: Daniel Pelavin PUBLISHER: Institute of Management Accountants PRIMARY FONT: Custom lettering

SOMETIMES UNTUTORED This ska LP cover is a mélange of Deco and Deco-inspired letters. But the type is just one element of an overall cluttered and commercial aesthetic as every graphic piece works together to create a jarring disharmony suggestive of the sometimes untutored design of the 1920s and 1930s.
DESIGN FIRM: Büro Destruct DESIGNER: Lopetz CLIENT: Reitschule Dachstock Bern PUBLISHER: Kit Parker Films PRIMARY FONTS: Clarendon, Dusty Rose, Stencil, Cowboys

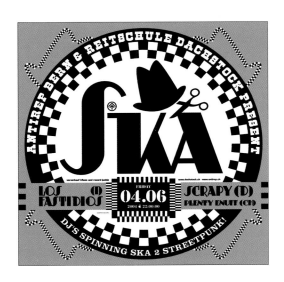

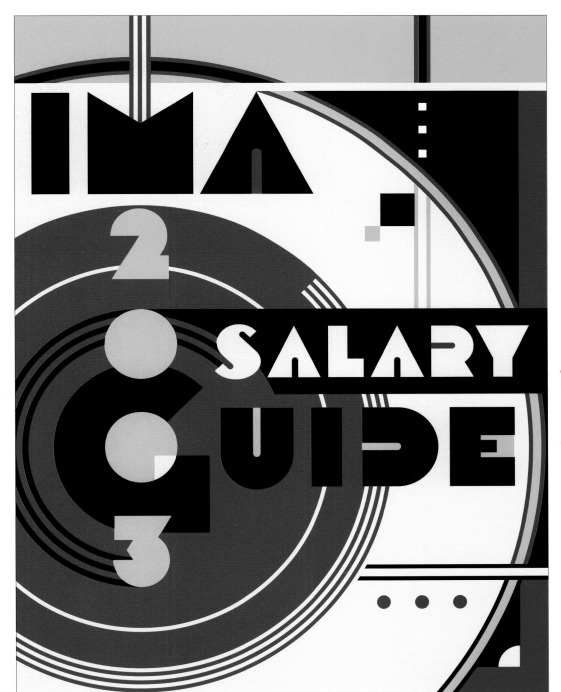

129

130

DECO STYLES For each of the eight books in the Deco series, Louise Fili designed a typeface inspired by a poster, label or package featured inside the book. The Dutch Moderne type echoed the De Stijl sensibility, while the German Modern type came from one of Lucian Bernhard's object posters. DESIGN FIRM: Louise Fili Ltd ART DIRECTOR/ DESIGNER: Louise Fili ILLUSTRATORS: Various CLIENT: Chronicle Books PRIMARY FONTS: Various

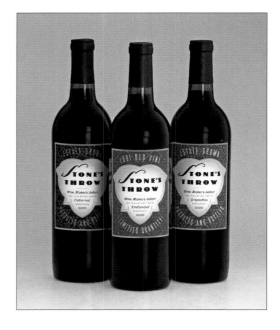

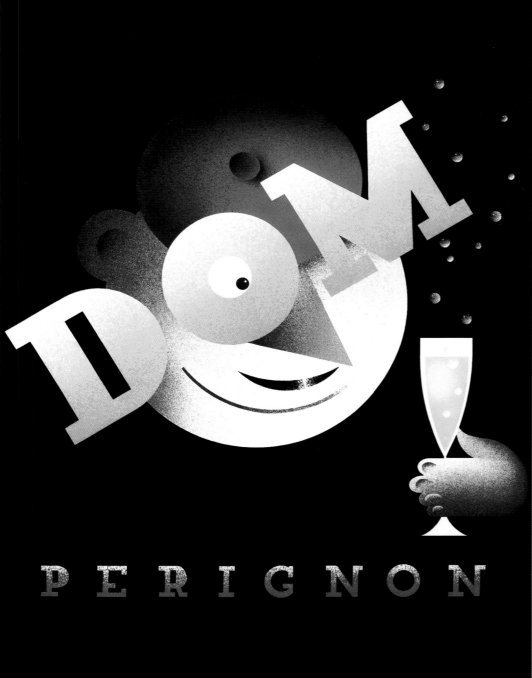

132

VINO TYPOGRAPHICO Wine labels are often the hybrid of other design schemes, such as soap, candy labels and other wine labels. This set borrows from the 1920s novelty types typically used for these kinds of products.
DESIGN FIRM: Morrow McKenzie Design
DESIGNER: Elizabeth Morrow McKenzie CLIENT: Stone's Throw PRIMARY FONT: Handdrawn

A FRENCH CLASSIC Russian designer Alexy Brodovitch, who worked in Paris in the 1930s, and years later became the legendary art director for *Harper's Bazaar* magazine in New York, designed a series of posters and advertisements for the French department store, Madelois. He used slab serif types and handlettered sans serifs. Terry Allen's poster, which advertises another French classic, reveals its unmistakable source.
ART DIRECTOR/DESIGNER/ILLUSTRATOR: Terry Allen CLIENT: Self, for promotional reasons
PRIMARY FONT: New

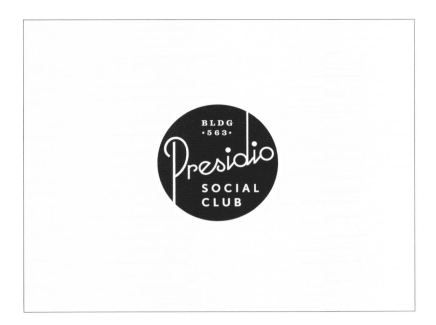

ARMY STYLE The Presidio National Park in San Francisco has a history that dates back to 1776, when Spanish soldiers and missionaries built their garrison there. It remained an army post for over two hundred years, until the mid-1990s, when it became part of the National Park system. The park has now been opened to businesses to make it financially self-sufficient, and the Presidio Restaurant has found a home in the defunct barracks. Because of the historical preservation of the site, alterations to the exterior of the building are not allowed and no commercial signage can be posted. Given these limitations, Mucca Design created an identity conveying the mood of a 1940s Army officers' club using period typography and historic color schemes. "We created illustrations of the restaurant in a style typical of letterhead design of the early 1900s and used these illustrations, along with existing vintage images of the Presidio, to create a fictional visual history of the restaurant, as if it has existed since the 1940's," says Matteo Bologna. Since the façade of the building cannot be altered, these repeated images of the restaurant become part of the visual anchor that holds the brand in place.

DESIGN FIRM: Mucca Design ART DIRECTOR: Matteo Bologna DESIGNER: Christine Celic Strohl CLIENT: Presidio Social Club PRIMARY FONTS: Custom, Geometric 706, Clarendon

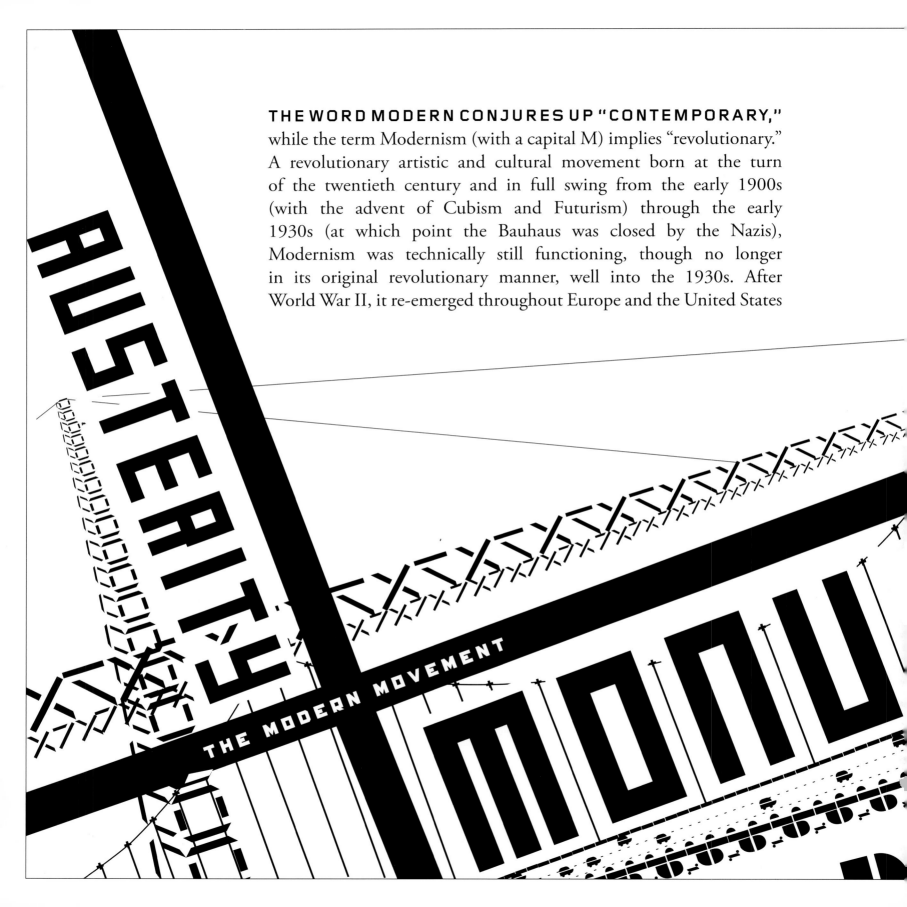

THE WORD MODERN CONJURES UP "CONTEMPORARY," while the term Modernism (with a capital M) implies "revolutionary." A revolutionary artistic and cultural movement born at the turn of the twentieth century and in full swing from the early 1900s (with the advent of Cubism and Futurism) through the early 1930s (at which point the Bauhaus was closed by the Nazis), Modernism was technically still functioning, though no longer in its original revolutionary manner, well into the 1930s. After World War II, it re-emerged throughout Europe and the United States

AUSTERITY

THE MODERN MOVEMENT

MONU

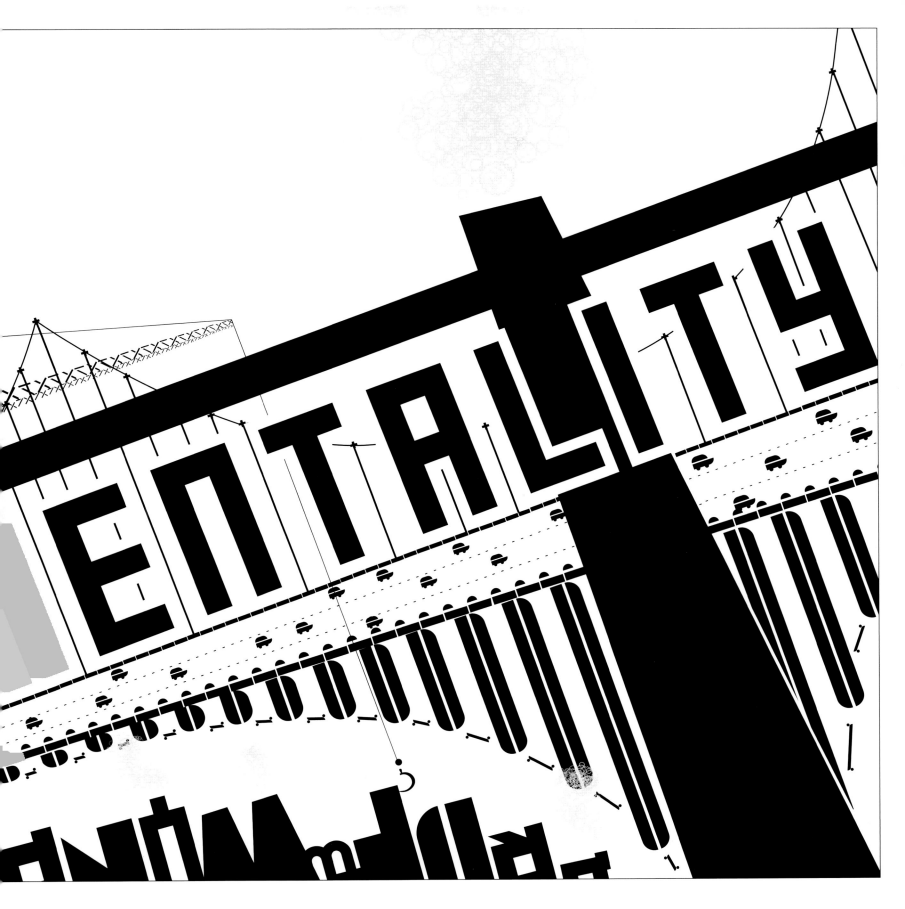

SCHMUCK BOLD
Futura was eventually was designed as a stencil and as "jewels" or schmuck, which looked very different from the original geometric typeface. These ornamental printer's jewels of circles, semicircles, curves, ovals, etc., gave designers and printers the opportunity to make designs that were constructivist and modernistic in style.

on the social, political, and even technological contexts in which they worked. The early revolutionary avant-garde stage of Constructivism was noted for geometric abstraction, while the later Productivist stage was more minimally representational. Various other art-isms founded throughout Europe had distinct design idioms that defined their ideals.

The common Modernist graphic traits of asymmetric layout, sans serif type faces, austere geometric ornament, primary color palette, photographic illustration, pictographic imagery, were not always universally employed in purist ways. Although rules for Modernist graphic design were described in books like Jan Tschichold's *The New Typography,* they were not, as Modernist legend implies, strictly adhered to. Moreover, a less orthodox form of Modernism, referred to as Art Moderne (and later Art Deco), combined Modernist ideas with decorative sensibilities that resulted in retail design for a middle-class market. Modernism, which was initially synonymous with "wild and edgy," ultimately became a code for "new and improved."

Nor was Modernism was confined to a single political ideology. Although the Fascists branded Modernism as liberal, Bolshevik, and degenerate, the physical traits were also applied to totalitarian design. The Nazis prohibition of Modernist sans serif typefaces was rescinded in the late 1930s when it suited them to use gothic faces in place of unwieldy Fraktur or blackletter types. Italian Fascists employed Modernist, modernistic or Moderne graphics because they wanted to appeal to a youthful audience, and in this sense Modernism was the visual code for the new order. Similarly, a variant of Modernism known as Streamline was common in the United States, neither as revolutionary leftwing or rightwing code but as the symbol for industrial progress. Sans serif type and airbrushed images suggested speed and forward motion. Modernism was an apolitical tool to achieve allure.

Whatever the underlying or overriding philosophies, Modernism in general was an unmistakable period style, and there was no better evocation of it than through typography. Modernist type by any other name – Futurist,

as Late (or Corporate) Modernism (also known as the Swiss or International Style) with the goal of simplifying and universalizing visual language, including graphic, product, and architectural design.

Modernism was never so resolutely monolithic that it could be stylistically pigeonholed. Despite its proponents' primary goal to strip bourgeois artists and artisans of their hegemony over form and style, different groups representing varying degrees of Modernist fervor expressed their rebellion through distinctive visual approaches. The Futurists and Dadaists, for instance, were more typographically raucous than designers associated with the more rationalist De Stijl or Bauhaus. The Russian Constructivists, while devout Modernists, were either raucous or rational depending

Constructivist, Bauhaus, or The New Typography – had common traits in all applications. So when the style was transplanted, from its original historical period to later eras, it evoked a curious sense of nostalgia for a place and time that most contemporary designers have never experienced at first hand.

Type is a good way for a designer to establish an aura, set a stage or otherwise define a particular place better than most other graphic elements. Austere and monumental Modernist type – for it is decidedly anti-ornamental and highly sculptural – leaves a recognizable trace. Of course, many of the typefaces born of Modernism, such as Futura, Metro, and Universal, are still used today with little or no direct relationship to the past. Nonetheless, they are so linked to their origins that they strongly evoke the moment of their creation (unless the design is totally antithetical to the period pastiche). Whether pastiche or not, Modernist type used in a contemporary context epitomizes progress, speed, and machines.

The various Modernist manifestations found in this chapter represent both verisimilitude and interpretation. Some are replicas of the original Bauhaus or Constructivist models, others are patchwork composites of Modernism from here and there. Indeed, this is not unlike some original Modernist objects that were themselves a hodgepodge of numerous approaches. Some are emulations of Modernist leaders – it is not uncommon to see typographers like El Lizzitsky, Moholy Nagy, or Fortunato Depero being copied, on purpose or accidentally, in contemporary work. Frequently, these homages are celebrations of the period or individual but just as often they are expedient ways of accomplishing an effect. Using historical type is a safe way of sending a message, and Modernist type is an effective means of communicating a sense of sophistication without having to reinvent the typographic wheel. Most of the examples in this chapter are not inventions, but many are clever interpretations.

BAYER
ALBERS
BAGAGGIO
DESTIJL
FUTURISMO
CONSTRUCTIVIST
PRESSIG

MODERN SCHMODERN It is ironic that "modern" is now vintage. Richard Kegler says, "Many of these faces are classics in the history of design and it seemed odd that with all of this great material, it couldn't be as accessible. I like to think our releases give designers an interactive history lesson. To use Theo Van Doesburg's De Stijl font or Josef Albers's Kombinationschrift as they had designed them is something of an academic exercise, but also an exciting opportunity to incorporate something pure and classic into a contemporary design. There is too much great 'lost' typographic art to ignore."
DESIGNERS: Richard Kegler, Denis Kegler, Michael Want, Alan Kegler CLIENT: P22

138

THEATER STYLE Ever since the late nineteenth century, theater posters more or less followed the same format of bold lettering stacked symmetrically against a solid color. These posters pay homage to that format, using turn-of-the-century ornamented letters but in an uncharacteristic manner.
DESIGN FIRM: Atelier René Knip ART DIRECTOR/DESIGNER: René Knip
CLIENT: Amsterdam Old Church PRIMARY FONT: Custom

MODERN ARCHITECTURE These days, typeface revivals are garnered from sources as varied as old candy wrappers to architectural signs. Neutraface was inspired by the 1940s–1950s Modernist architect, Richard Neutra. This geometric sans serif metal typeface was routinely specified by Neutra for use on both his commercial and residential architecture projects.
DESIGN FIRM: House Industries ART DIRECTOR: Andy Cruz DESIGNERS: Andy Cruz, Ken Barber, Christian Schwartz, Tal Leming, Richard Neutra ILLUSTRATOR: Chris Gardener CLIENT: House Industries PRIMARY FONT: Neutraface

SHADOW SHOW Jeff Kleinsmith admits that this finished poster looks nothing like his starting point of influence – the work of Russian Constructivist, Alexander Rodchenko.
DESIGN FIRM: Patent Pending Industries ART DIRECTOR/DESIGNER/ILLUSTRATOR: Jeff Kleinsmith CLIENT: The Nein PRIMARY FONT: Handdrawn lettering

THE NEW WEST There is nothing more modern than Helvetica, but this book cover manages to blend the now and then into a curiously timeless composition.
DESIGNER: Ralph Schraivogel CLIENT: Film Podium, Zurich PRIMARY FONT: Helvetica

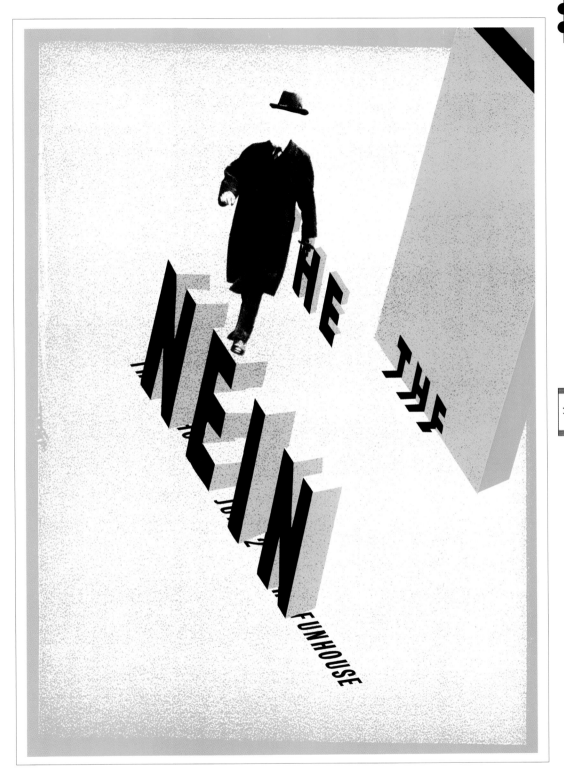

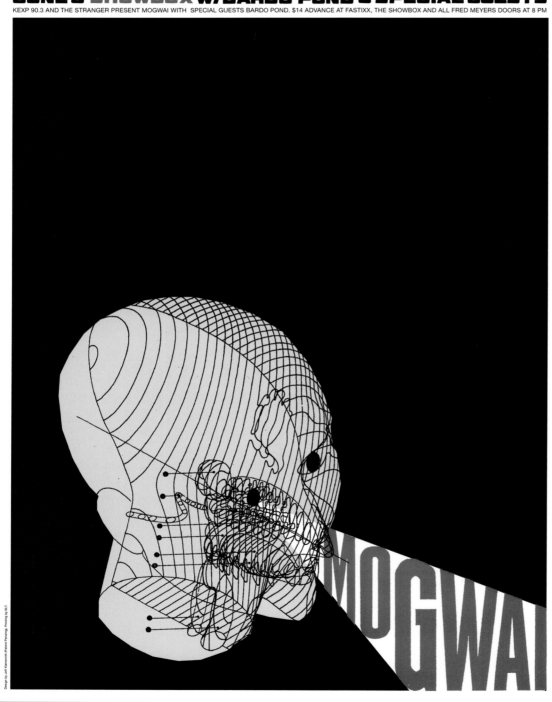

SHOUT STYLE Jeff Kleinsmith insists that he had, "No influence in mind." But the resemblance to El Lissitzky's famous shouting poster suggests some unconscious references. DESIGN FIRM: Patent Pending Industries ART DIRECTOR/DESIGNER/ ILLUSTRATOR: Jeff Kleinsmith CLIENT: Showbox PRIMARY FONTS: Enge Wotan, Dover 100 Condensed

SHOUT STYLE REDUX Laurie Rosenwald acknowledges the debt to Russian Constructivism, but more specifically to El Lissitzky's icon of early Modernism.
DESIGN FIRM: Rosenworld.com ART DIRECTOR: Chris Curry ILLUSTRATOR: Laurie Rosenwald CLIENT: *The New Yorker*/Condé Nast PRIMARY FONT: Handlettering

SHOUT STYLE REDUX AGAIN "The previous couple of years, the Bumbershoot poster had had multiple elements going on and we thought a strong central image would be a refreshing change," says Jeff Kleinsmith. "We chose Enge Wotan as the title type for its bold, clean appearance and looked nice large or small. Futura was used for the event details for its timeless appeal." And then there was El Lissitzky.
DESIGN FIRM: Patent Pending Industries ART DIRECTORS/DESIGNERS: Jeff Kleinsmith, Jesse LeDoux CLIENT: One Reel PRIMARY FONTS: Enge Wotan, Futura

141

RUSSIAN DRESSING The Stenburg brothers created a wealth of posters (top right) that inspired many Soviet graphic pastiches. Director Grant Barbeito purchased a book on the brothers' work and asked Spot Design to create a film poster using the Russian Constructivist style.
DESIGN FIRM: Spot Design ART DIRECTOR: Drew Hodges DESIGNERS: Kevin Brainard, Stella Bugbee PRIMARY FONTS: Handlettering, Industria

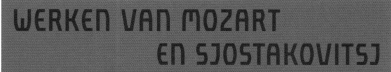

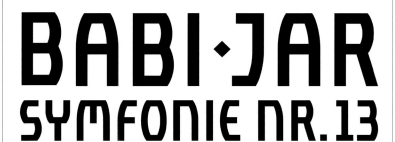

CONSTRUCTING CONSTRUCTIVISM
Jakub Stepien notes that "Russian posters and Constructvism" are the prime inspiration for this artwork. But it is not a direct appropriation, as while the type echoes the 1920s style, it is a little too fine-tuned to be directly from the era.
DESIGN FIRM: Hakobo ART DIRECTOR: Jakub Stepien CLIENT: Academy of Fine Arts in Lodz, Poland PUBLISHER: Silkscreen Center PRIMARY FONTS: Stuntman, Airwave

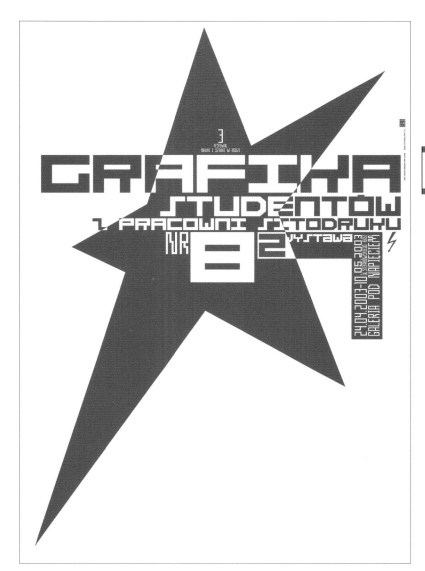

143

THE RUSSIANS WERE COMING By using red, black, and Cyrillic-styled typefaces, it is not difficult to affect the look of Constructivism. For this Babi-Jar poster, the Russian look is seamlessly integrated into a contemporary style.
DESIGN FIRM: Atelier René Knip ART DIRECTOR: René Knip DESIGNERS: Rens Martens, René Knip CLIENT: Amsterdam Royal Concertgebouw Orchestra PRIMARY FONT: Custom

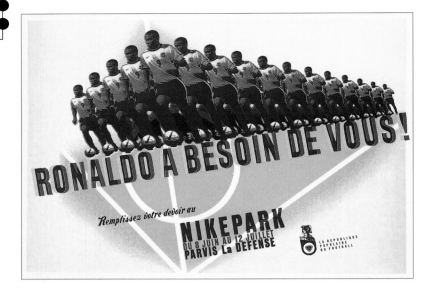

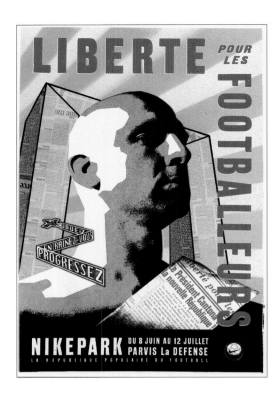

MODERNIST KICK Referenced from promotion posters from the 1930s, the asymmetrical type composition and photomontage are reminiscent of E. McKnight Kauffer's work. The woodtype used has been scanned from an old font specimen book.
DESIGN FIRM: Studio Boot ART DIRECTOR: John Norman DESIGNERS/ILLUSTRATORS: Petra Janssen, Edwin Vollebergh CLIENT: Nike PRIMARY FONT: Collins 10 Uppercase

144

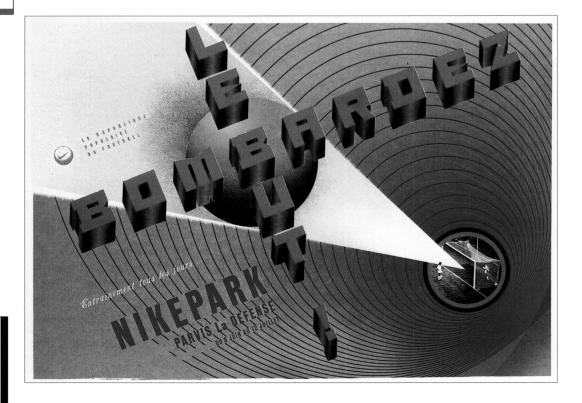

LATE DECO John Norman notes that this retro-styled image was inspired by tourist promotion posters from the 1930s (*à la* Herbert Matter). Eric Cantona, a leading soccer player, wanted to be portrayed as the president of Nike Nation, a free area in Paris during the World Cup Tournament. The type and solarized image evoke the heroic aesthetic common during the late Deco period in Europe before World War II.
DESIGN FIRM: Studio Boot ART DIRECTOR: John Norman DESIGNERS/ILLUSTRATORS: Petra Janssen, Edwin Vollebergh CLIENT: Nike PRIMARY FONT: Collins 10 Uppercase

TOURIST FONTS Like the poster above, this modernistic collage was inspired by tourist posters, but also owes a debt to the Machine Age sensibility of mixing photographs with mechanical-looking block types.
DESIGN FIRM: Studio Boot ART DIRECTOR: John Norman DESIGNERS/ILLUSTRATORS: Petra Janssen, Edwin Vollebergh CLIENT: Nike PRIMARY FONT: Handdrawn 3D block type

INDUSTRIAL CHIC The album that The Black Keys were touring with was named "Rubber Factory," after Akron's manufacturing history (and their practice space). The type was inspired by early-twentieth-century manufacturer's logos and packaging, and resembles many newspaper and trade magazine advertisements of the 1930s. "We wanted something emblematic that felt like it was from that industrial era," says Dan Ibarra, and they got it.

DESIGN FIRM: Aesthetic Apparatus
DESIGNERS: Dan Ibarra, Michael Byzewski
CLIENT: First Avenue PRIMARY FONTS: Futura Display, Backhand Script

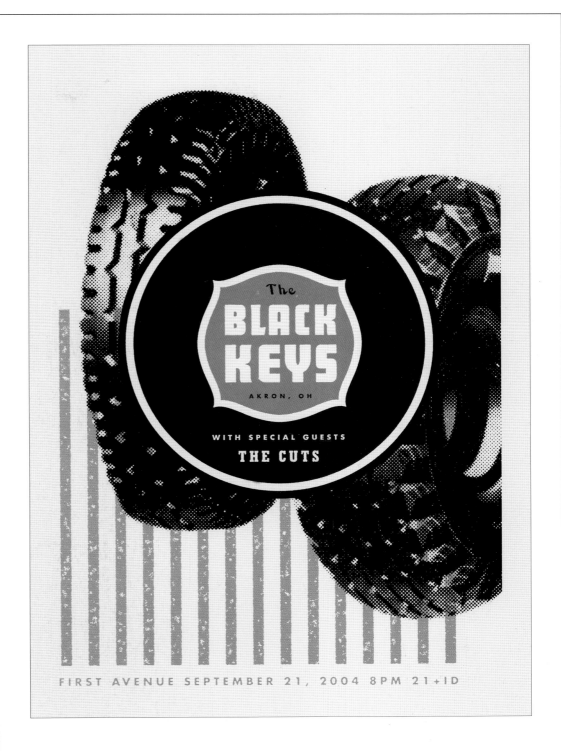

FUTURA Display

ABCDEFGHIJ
KLMNOPQR
STUVWXYZ
$1234567
890&

PLATE 76. While this type is cast as a supplement to the Futura family, it exhibits marked qualities of its own. The verticals with occasional emphasis at the top of certain letters set this off as different from the other Futuras. Designed by Paul Renner.

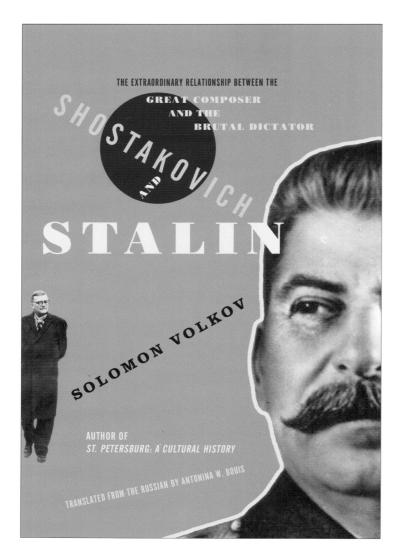

UNCLE JOE STYLE Peter Mendelsund points to the "Red Romantic" Soviet Propaganada posters *(right)* with a hint of Constructivism thrown in. Of course, Stalin was not a fan of either Constructivism or Shostakovich. DESIGN FIRM: Peter Mendelsund Design ART DIRECTOR: Carol Carson DESIGNER: Peter Mendelsund PUBLISHER: Alfred A. Knopf PRIMARY FONTS: Alt Gothic B., Poster Bodoni

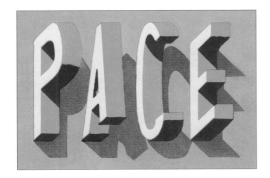

SHADOW LETTERS Louise Fili notes that her design derived from a French hand-painted alphabet from the late nineteenth century found in a sign and window painters' typeface manual.
DESIGN FIRM: Louise Fili Ltd ART DIRECTOR/DESIGNER: Louise Fili CLIENT: Beanstalk Restaurant Group PRIMARY FONT: Shadow Sign letters

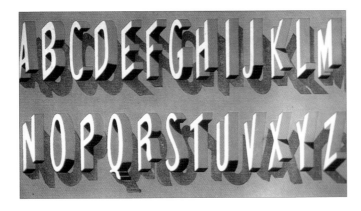

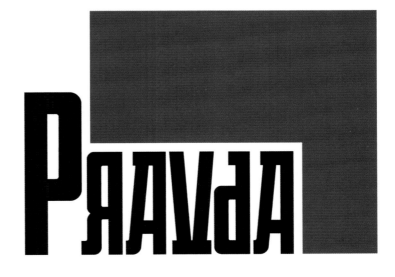

147

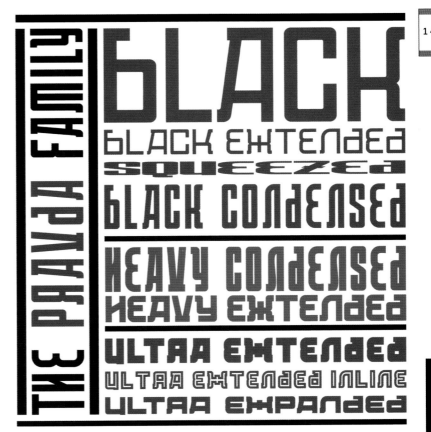

THE RUSKIES ARE COMING When Keith McNally opened Pravda, he commissioned Mucca Design to create an identity for his new underground lounge. All the design for Pravda, from the graphic system to the design of the spacious interior, was to have the look and feel of an early-twentieth-century Russian nightclub. Matteo Bologna drew upon Russian Suprematism and Constructivism and designed a typeface family in ten weights for the identity system.
DESIGN FIRM: Mucca Design ART DIRECTOR: Matteo Bologna CLIENT: Keith McNally PRIMARY FONT: Pravda

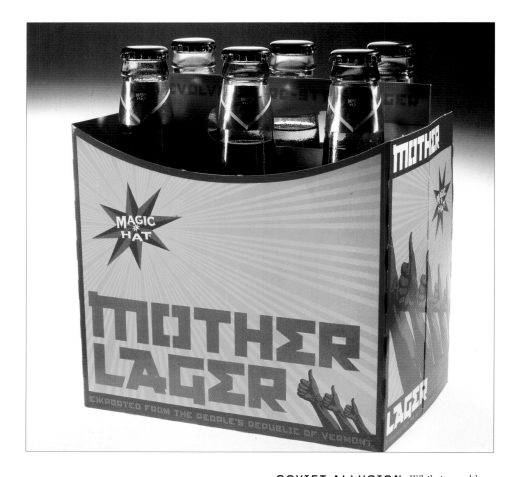

148

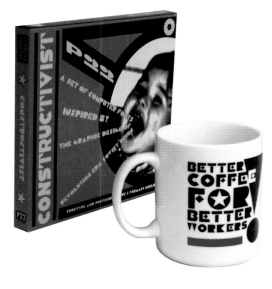

A MUG THAT SHOOK THE WORLD

The typeface designed by P22 Type Foundry for their historical line is built entirely on Soviet revolutionary posters and packaging, and are, notes Richard Kegler, a "homage to Alexander Rodchenko."
DESIGN FIRM: P22 Type Foundry ART DIRECTOR/DESIGNER: Richard Kegler CLIENT: P22 Type Foundry PRIMARY FONT: P22 Constructivist

SOVIET ALLUSION While it would have been hard in the 1950s to think Soviet design was chic, by the 1990s it had a nostalgic charm. "We wanted to play off those stark Soviet designs and propaganda pieces – the work of Alexander Rodchenko or the Stenberg Brothers' movie posters," says Peter Sunna. The newly digitized Modified Constructivist Square font provided the severity they were looking for, while giving the room to undercut the Soviet allusion with a bit of Western humor.
DESIGN FIRM: Jager Di Paola Kemp Design
ART DIRECTOR: Malcolm Buick
DESIGNER/ILLUSTRATOR: Peter Sunna
PHOTOGRAPHER: Alex Williams CLIENT: Magic Hat Beer PRIMARY FONT: Modified Constructivist Square

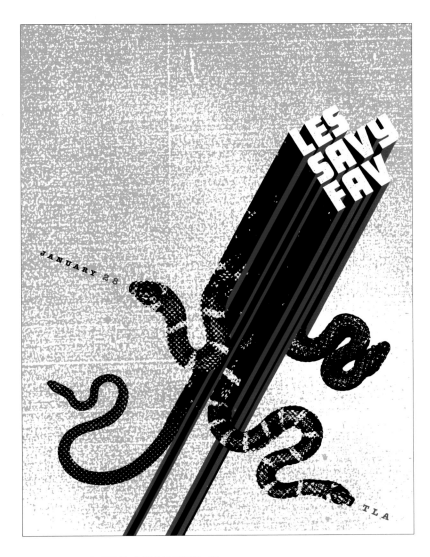

AUSTRIAN PASTICHE Leslie Cabarga has published his share of vintage type books and his collection of type ephemera is vast. All this raw material gets recycled into pastiche designs and revived and renovated typefaces. This particular exercise in replicating the past is based on Austrian designer Wihelm Wilrab 1920s-era poster for Teppichaus Repper, and reveals how easy it is to bring back the passé into fashion.
DESIGN FIRM: Leslie Cabarga/Flashfonts ART DIRECTOR/ DESIGNER: Leslie Cabarga ILLUSTRATOR: Wilhelm Wilrab PUBLISHER: David R. Godine, Publishers PRIMARY FONT: Progressiv Regular

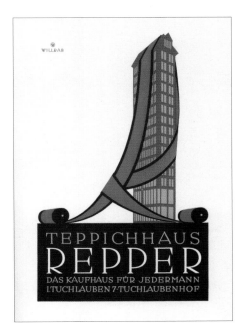

DROPPING THE SHADOWS There are various references here, largely owing to the fact that there are often multiple references even in vintage works. "This poster," notes Jason Kernevich, "was partially going for the bold look of the mid- to late-1970s movie type treatments," but the type derives from the 1930s poster and book jacket styles of big, bold, drop shadow sans serifs.
DESIGN FIRM: The Heads of State ART DIRECTORS: Jason Kernevich, Dustin Summers DESIGNER: Dustin Summers CLIENT: Theater of the Living Arts PRIMARY FONT: Stabile Extra Bold

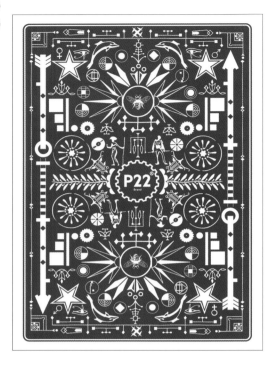

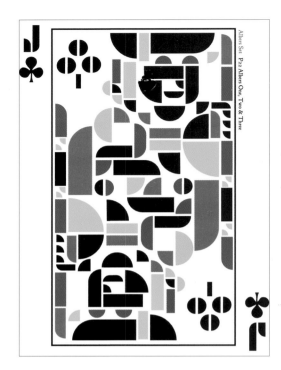

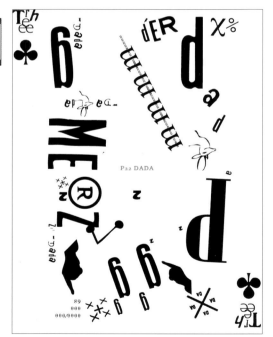

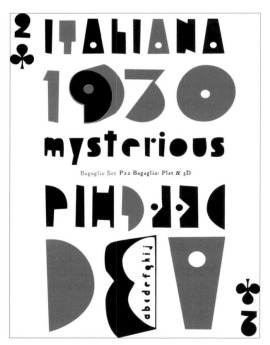

ACES WILD This deck of historical homage revives a wide range of Modernist methods, from the chaotic typographies of Dada, Futurism, and Constructivism to the rationalism of the Bauhaus and De Stijl. All the cards are interpretations of the distinct styles and icons of the respective movements, like the Merz clubs card, which looks like Kurt Schwiters might have designed it himself.
DESIGN FIRM: P22 Type Foundry ART DIRECTOR: Richard Kegler DESIGNERS: Colin Katin, R. Kegler, James Grieshaber, J. Chambers, Carima El Behariy CLIENT: P22 Type Foundry PRIMARY FONTS: P22 and International House of Fonts Collections

BERLIN STYLE Barbara Martin blends the old and new in this homage to the golden age of Weimar typography. While it wasn't designed in the 1920s, it bears the spirit of that time.
DESIGN FIRM: Black Sparrow Press ART DIRECTOR/ DESIGNER/ILLUSTRATOR: Barbara Martin PUBLISHER: Black Sparrow Press PRIMARY FONT: Futura Bold

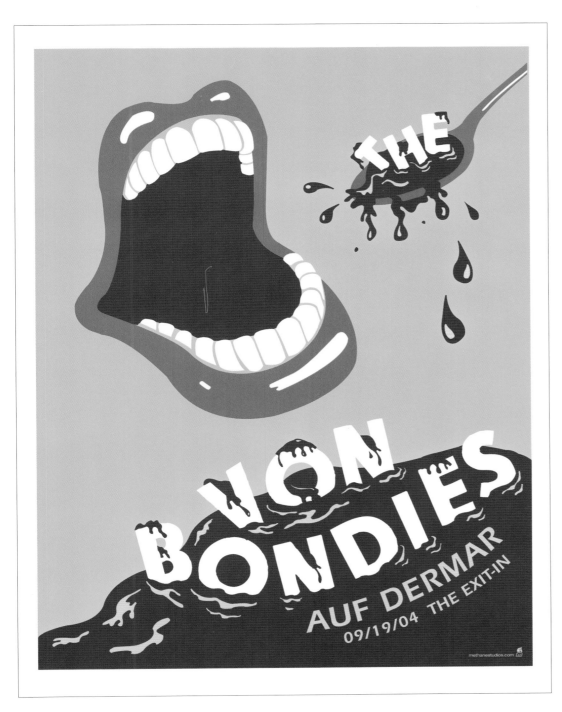

TYPE BASHING Jeff Kleinsmith says that, "this is best described as a mix between old punk rock flyers and official American propaganda posters from the 1940s." DESIGN FIRM: Patent Pending Industries ART DIRECTOR/DESIGNER/ILLUSTRATOR: Jeff Kleinsmith CLIENT: Graceland PRIMARY FONTS: Captain Nemo, Dover 100 Condensed – heavily distorted by hand

151

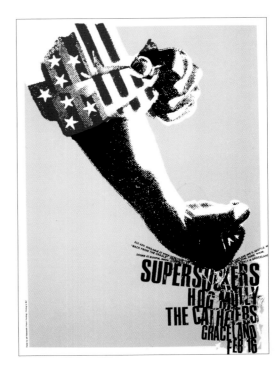

BIG LIPS One might mistakenly think the big, red, toothy lips were influenced by the Rolling Stones logo but, says Mark McDevitt, "it's really a combination of Russian and Polish poster influences with a touch of 1970s cheese." The type is a bold Mac font acessorized with a chocolate coating. "I chose this font due to its compact, bold nature plus it had a slight seventies feel to it, and I liked the shape of the 'B' and the 'S'," he adds. DESIGN FIRM: Methane Studios ART DIRECTOR/DESIGNER/ILLUSTRATOR: Mark McDevitt PRIMARY FONT: Eras ITC

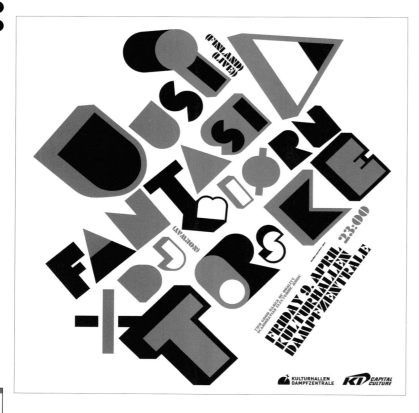

FUTURIST ANARCHY "This melange of Futurist and Constructivist lettering, with a tinge of Dada, also evokes a pop art sensibility. And let's not forget the shadows which evolve from nineteenth-century sign painting."
DESIGN FIRM: Büro Destruct DESIGNER: M. Brunner CLIENT: Kulturhallen Dampfzentrale Bern PRIMARY FONTS: Rodchenko, Crack Man

STENCIL CITY "This is my own interpretation of Constructivism," says Jakub Stepien. The black and white echoes the Russian avant-garde sensibility, but the well-proportioned stencil type is decidedly contemporary.
DESIGN FIRM: Hakobo ART DIRECTOR/DESIGNER: Jakub Stepien CLIENT: Cool Kids of Death PUBLISHER: Jakub Stepien PRIMARY FONT: Kaiser

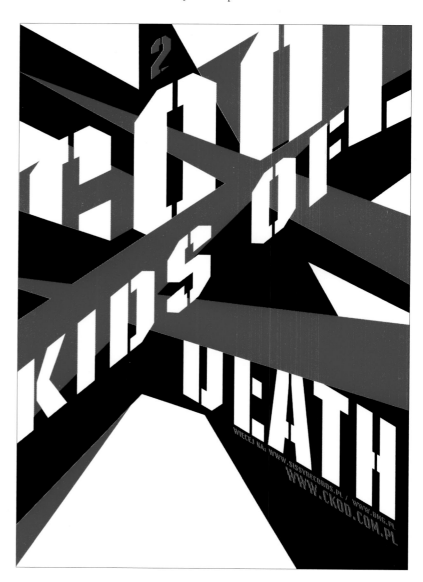

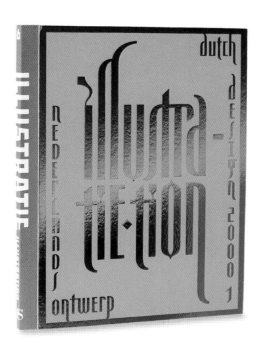
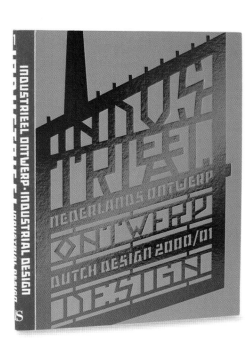

FLUORESCENT HISTORY Each of these typeface treatments suggests an historical style, from Deco to Futurism, but the use of fluorescent inks affords them an unmistakably contemporary aura.
DESIGN FIRM: Atelier René Knip ART DIRECTOR/DESIGNER: René Knip CLIENT: BNO PUBLISHER: Bis Publishers PRIMARY FONTS: Custom

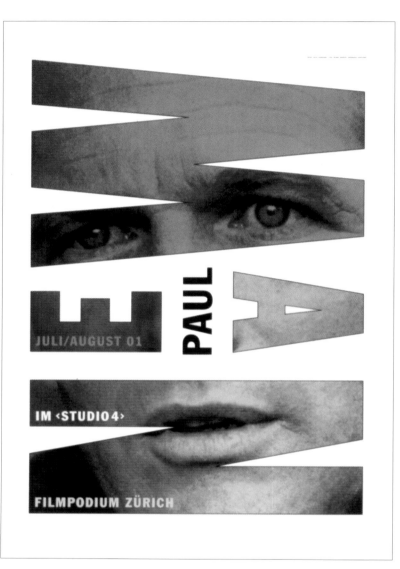

FRAGMENT STYLE Ralph Schraivogel draws from an old Modernist conceit of fragmenting images inside typographic frames. Here, a portrait of Paul Newman echoes minimalist movie posters of the 1950s.
DESIGNER: Ralph Schraivogel PHOTOGRAPHER: Unknown CLIENT: Film Podium, Zurich PRIMARY FONTS: Interstate, handlettering

MONUMENTAL LETTERS "If ever there was a Fascist font," says Peter Mendelsund, "Futura seems to fit the bill. Muscular and clean, it seems to be a face Albert Speer could have designed. Extruding the letter forms was my own little way of adding some extra monumentality to an already monumental font." Regrettably though, Futura was considered a "degenerate font" by the Nazis and subsequently prohibited by them.
DESIGN FIRM: Peter Mendelsund Design ART DIRECTOR: Carol Carson DESIGNER: Peter Mendelsund PUBLISHER: Alfred A. Knopf PRIMARY FONT: Futura

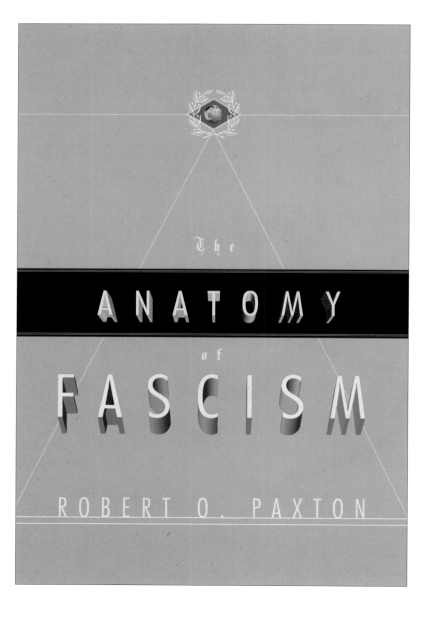

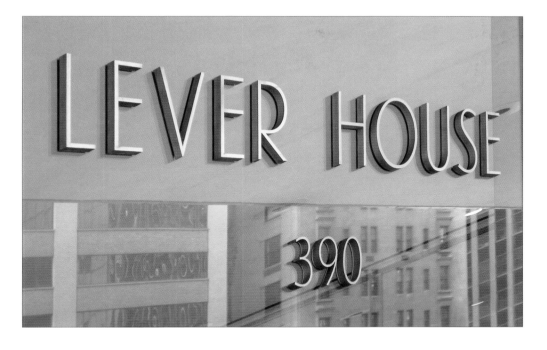

MODERN ARCHITECTURE The Lever House in New York, designed in 1954 by Gordon Bunshaft, is a classic Bauhaus-influenced building. The lettering designed for its renovated exterior references the original modernist sans serif.
DESIGN FIRM: Pentagram ART DIRECTOR: Michael Bierut DESIGNER: Tracey Cameron PHOTOGRAPHER: Peter Mauss/Esto CLIENT: RFR Realty LLC PRIMARY FONT: Lever Sans

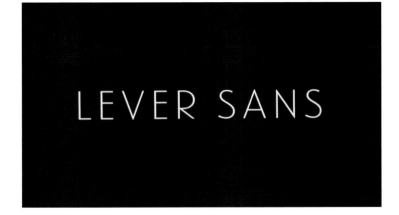

LEVER SANS

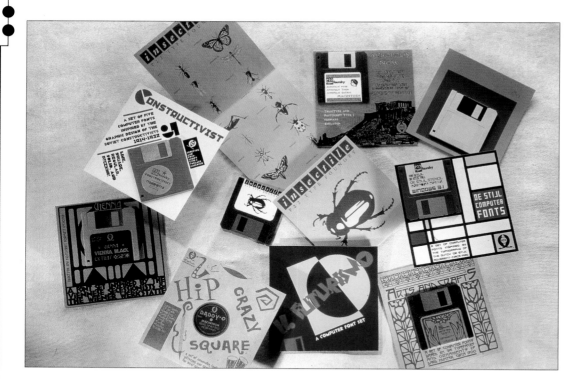

REVIVAL ORIGINALS For this eclectic series of pastiche revivals, Richard Kegler was influenced by every Modernist and non-Modernist movement of the twentieth century, from Vienna Secession to Atomic Style.
DESIGN FIRM: P22 Type Foundry ART DIRECTOR: Richard Kegler DESIGNERS: Richard Kegler, Alan Kegler, Michael Want CLIENT: P22 Type Foundry PRIMARY FONTS: P22: Insectile, Acropolis Now, Albers, Restijl, Arts and Crafts, Futurismo, Daddy-O, Vienna, Constructivist

RUSSIAN FLAIR A Russian Cyrillic air floats over this poster and while there is not a reversed "R" in the composition, the basic sensibility echoes early Constructivist typographics.
DESIGN FIRM: Atelier René Knip ART DIRECTOR: René Knip DESIGNERS: Rens Martens, René Knip CLIENT: Amsterdam Royal Concertgebouw Orchestra PRIMARY FONT: Custom

SMORGASBORD OF INFLUENCES
In addition to all of these typefaces, Denise Korn and Javier Cortés list, "Pop culture, skateboarding stickers, Las Vegas, car emblems, and vernacular signage," as the raw material for this identity.
DESIGN FIRM: Flux Restaurant Identity ART DIRECTOR: Denise Korn DESIGNER/ ILLUSTRATOR: Javier Cortés CLIENT: Flux Restaurant PUBLISHER: Brightwork Press PRIMARY FONTS: American Typewriter, Base 9, Bell Bottom, Century Schoolbook, Cooper Black, Dogma, Futura, Interstate, Solex, Suburban, Vitrina

SWISS ECLECTIC
Ralph Schraivogel has made a smorgasbord of mid- and late-modern conceits found in post-war Switzerland, such as the inspirations of Armin Hofmann and Josef Muller-Brockmann.

DESIGNER: Ralph Schraivogel CLIENT: Museum Strauhof, Zurich PRIMARY FONTS: Various

RUSSIAN NEWSPAPER
Geoff Halber says this came from, "An early-twentieth-century economic periodical," but whether he knows it or not, it also references Eastern European and Russian avant-garde newspapers from the early 1910s.

DESIGN FIRM: Planet Propaganda DESIGNER: Geoff Halber CLIENT: Broom Street Theater PRIMARY FONTS: Found type

FUTURIST LETTERING Rodrigo Sanchez's cover design for *El Mundo Metropoli* magazine could easily have appeared as a Spanish Deco poster back in the 1920s. The type, while contemporary, has that Deco/Futuristic allure. DESIGN FIRM: Unidad Editorial S.A. ART DIRECTOR/DESIGNER: Rodrigo Sanchez CLIENT: *El Mundo Metropoli* PUBLISHER: Unidad Editorial PRIMARY FONTS: Giza, Eagle

158

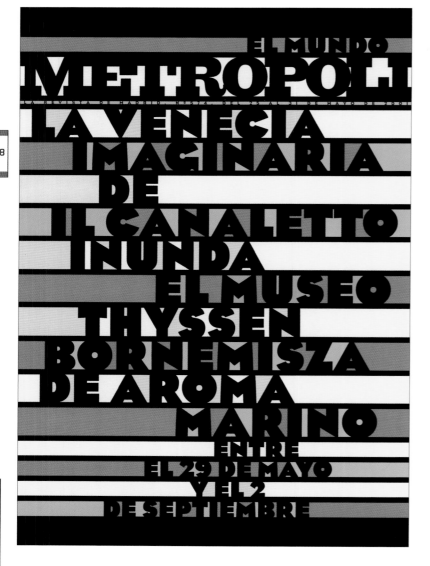

MODERNISM TODAY Influenced by Dada and Bauhaus designers such as Lester Beall and Paul Rand who used bold, often slab serif letter forms in concert with certain abstract color fields to evoke their brand of Modernism, Rex Bonomelli echoes this now-heroic Modernist sensibility in this poster for a Broadway show. DESIGN FIRM: SpotCo ART DIRECTOR: Drew Hodges DESIGNER: Rex Bonomelli CLIENT: The producers of *Copenhagen* PRIMARY FONT: Antique Bold Condensed

SENECA
ON THE
SHORTNESS
OF LIFE
LIFE IS LONG
IF YOU
KNOW HOW
TO USE IT
PENGUIN
BOOKS
GREAT IDEAS

LETTER IMPRESSIONS "I wanted to suggest Roman monumentality without using Trajan," says Phil Baines, referring to the lettering that changed the written world. "The Romans used sans serifs as well as the better-known serifed square capitals that opened the door to other less obvious possibilities. Although not a humanist sans serif, the font URW Grotesk, designed by Hermann Zapf, is considerably softer in feel than the harsh neo-grotesques like Helvetica or Univers, and its weight balanced well with the standard QuarkXPress outline tool."
DESIGN FIRM: Phil Baines for Penguin Books ART DIRECTORS: David Pearson, Jim Stoddart DESIGNER: Phil Baines PUBLISHER: Penguin Books PRIMARY FONT: URW Grotesk

159

GEARS AND LETTERS This Machine Age-styled logo *(below)* is reminiscent of many such trademarks of the late 1920s and 1930s. But Elizabeth Morrow McKenzie took it directly from a poster for the progressive labor union, the Wobblies.
DESIGN FIRM: Morrow McKenzie Design DESIGNER: Elizabeth Morrow McKenzie
CLIENT: Wild Alchemy PRIMARY FONT: Newport Condensed (redrawn)

CLEANING STYLE For this breakthrough cleaning packaging *(above)*, Sharon Werner explains, "The logotype is based on Tourist Gothic, a font we found in an old type book. The overall look of the label and the illustrations were inspired by cleaning products and ads from the 1930s *True Romance* and *True Stories* magazines."
DESIGN FIRM: Werner Design Werks, Inc. ART DIRECTOR: Sharon Werner DESIGNERS: Sharon Werner, Sarah Nelson CLIENT: Clean & Co. LLC. PRIMARY FONTS: Clarendon, Franklin Gothic, Futura, News Gothic, Trade Gothic, logotype is based on the font Tourist Gothic.

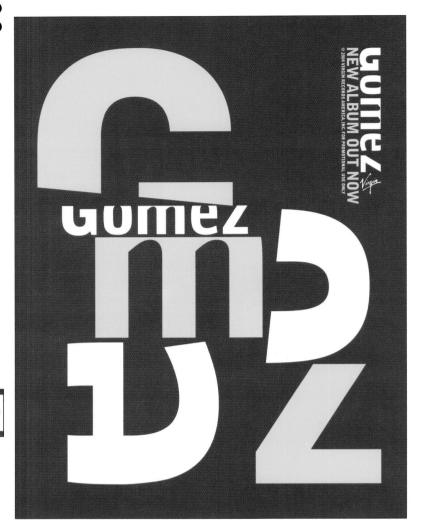

VERVE REVISITED Art Chantry and Jamie Sheehan delved deep into their collections of *Hi-Fidelity* magazine (1951), old Verve jazz record covers, and 1950s Seattle jazz posters. The result is this homage to American Modernism.
DESIGN FIRM: Art Chantry Design Co. DESIGNERS: Art Chantry, Jamie Sheehan PHOTOGRAPHER: Erwin Von Dessauer CLIENT: Verve Records
PRIMARY FONTS: Handlettering, Franklin Gothic

CROPPED TYPES Mike Joyce happily credits the look of his album to Reid Miles, the esteemed creator of typographic album covers for Blue Note Records in the 1950s and 1960s.
DESIGN FIRM: Stereotype Design ART DIRECTOR/DESIGNER: Mike Joyce
CLIENT: Virgin Records PRIMARY FONT: Bell Gothic

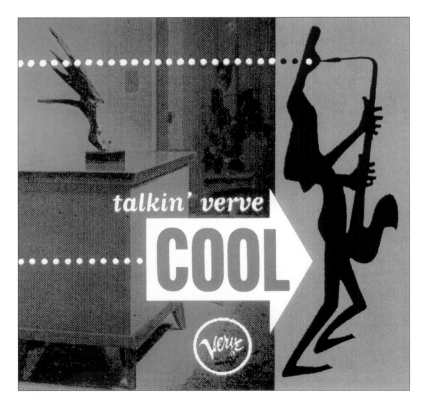

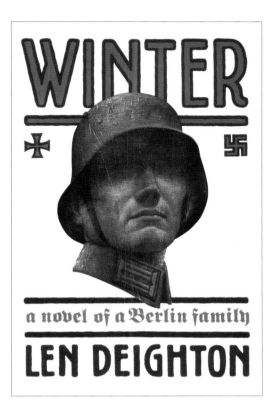

PROPAGANDA STYLE Jon Valk's book cover draws directly from World War II German propaganda posters. The bold typography is a hybrid of these and earlier advertising placards, but the Romantic Nazi illustration style is torn right from the pages of history.
DESIGN FIRM: Jon Valk Design ART DIRECTORS: Sara Eisenman, Chip Kidd DESIGNER: John Valk ILLUSTRATOR: John Rush CLIENT/PUBLISHER: Alfred A. Knopf PRIMARY FONT: Handdrawn based on Berliner Grotesk

the **I**nsanity of normality

realism as **sickness**: toward understanding **human** destructiveness

a r n **o** g r u e n

161

"O" FOR BAGEL Modernism meets typography parlant (letters that speak directly to the look or function of the message), for what is a bagel if not an "O"? Here, in a futuristic manner, the "O"s fill the "O".
DESIGN FIRM: Milton Glaser, Inc. ART DIRECTOR/DESIGNER: Milton Glaser CLIENT: Bruegger's Bagels PRIMARY FONT: Brueggers

BAYER'S LEGACY Herbert Bayer designed Universal in 1925, the lower-case alphabet used for all Bauhaus printing (at least for a while). In the pre-digital days, Carin Goldberg gave new life to an old cut of the face for this book jacket.
DESIGN FIRM: Carin Goldberg Design DESIGNER: Carin Goldberg PUBLISHER: Grove Press PRIMARY FONT: Universal

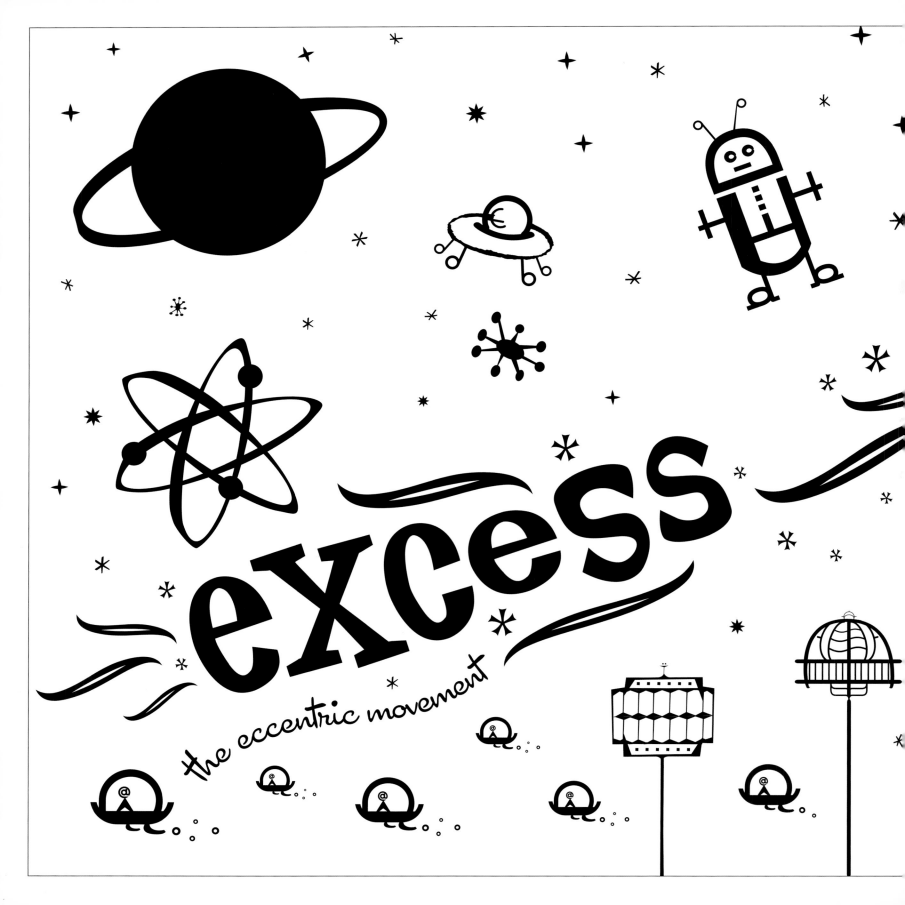

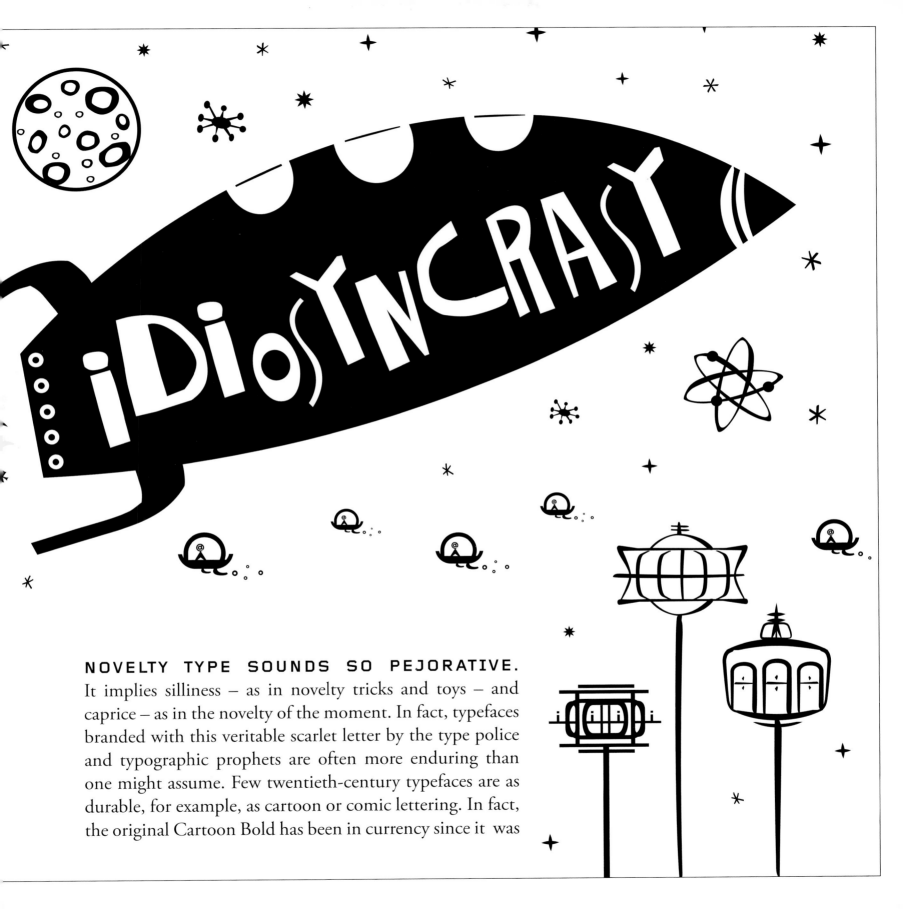

IDIOSYNCRASY

NOVELTY TYPE SOUNDS SO PEJORATIVE.
It implies silliness – as in novelty tricks and toys – and caprice – as in the novelty of the moment. In fact, typefaces branded with this veritable scarlet letter by the type police and typographic prophets are often more enduring than one might assume. Few twentieth-century typefaces are as durable, for example, as cartoon or comic lettering. In fact, the original Cartoon Bold has been in currency since it was

·ARTISTIK· ·BAUER & CO., STUTTGART & H. BERTHOLD, BERLIN.

ACCIDENTAL OCCIDENTAL

Western type designers often took inspiration from the mysterious Orient. Although type styles like this art nouveau-ish novelty that is not based on a specific Japanese or Chinese character set, it exudes the exoticness of one of those beautiful alphabetic systems. These faces, however, were used to promote everything from perfumes to war bonds, depending on the designer's need and proclivity.

164

designed by Howard Trafton in 1936. Though viewed by serious typographers as graceless and even goofy, this so-called novelty face not only functions in a fundamental comic context but in sophisticated designs as well.

Novelty is thus a relative term with dubious distinctions. Of course it means "new." So, any typeface that veers from the classical rightness of form when initially introduced to the marketplace must be considered a novelty, for it is new. Only time and continued usage determines whether or not a typeface has legs. Why a particular quirky typeface is embraced or not, and whether it then becomes popular or discarded, is usually based on the vicissitudes of taste – subjective criteria that can sometimes appear quite infuriatingly random. Nonetheless, the rationale behind creating such faces is often rooted in an overarching hope for viability (that many people will like and buy it).

When the impresario Charles Peignot, proprietor of the Paris-based Deberny & Peignot Type Foundry, released the Art Deco poster master A. M. Cassandre's Bifur in 1929, it was their desire (and anticipation, given Cassandre's fame) that it would become a popular and hugely profitable advertising face by virtue of widespread use throughout Europe, and even in the more conservative United States. Bifur's novelty derived from its freshness and uniqueness, its dark and light contrasts, ornamental peculiarities, and quirky streamline details. It was a serious face with wit – it was also cool by 1930s

standards. By virtue of its ubiquity in Art Moderne Paris, it became one of the main typefaces that defined the stylistic era. So it began as novelty, then became just novel, and ultimately it turned into an icon of design history. It's not as commonly used today as when it was introduced, but not entirely passé either (indeed it was recently digitized and updated by at least one digital type foundry).

There are also scores of what can be called pure novelty faces, types intentionally designed to be funny and to serve perhaps a momentary or transitory commercial need, such as to sell a particular product or idea. Some of these are purposefully slapstick and were never intended to look exquisite on a page or screen. Rather, they were designed more to jostle the senses and trigger a laugh or at least a snicker, as that would be more likely to ensure a memorable message.

Among the most popular in its day, Chop Suey and the variant Bamboo (designers unknown), are among the more "classic" novelties introduced around the turn of the twentieth century. While the face may be frowned upon today as a racially derogatory typographic stereotype, it originally was meant as a kind of "typographic parlant," akin to architecture parlant – a structure that serves a basic function yet also conveys a secondary, semiotic meaning (as in a hot dog stand shaped like a hot dog). In this case, Chop Suey, which tries to suggest Chinese brush lettering, can be used typographically to convey anything Chinese. Unless one is truly perverse, Chop Suey or Bamboo would never be used as a text face or headline for a serious magazine or newspaper. However, from the 1930s through the 1960s (when sensitivity to racial and ethnic difference became *de rigeur*) it was used on every ephemeral item, from Chinese food menus to sheet music and advertisements, to suggest the Oriental sensibility. Chop Suey has even been used on neon signs for Chinese restaurants promoting, well, chop suey.

Another archetypal novelty is Ice Cube, usually a Gothic bold or outline face that is covered with frozen snowcaps. How many times has this been used on ice machines or on machines where cold drinks are sold? Ice Cube, like its opposite, Fire (with flames emerging from the

letters), has been part of novelty catalogs for years. There is also Banana (letters in the shape of the phallic yellow fruit), which had limited use but is still ripe in some typographic realms. And then there is the venerable favorite, Log Cabin, a.k.a. Rustic, designed in the mid-nineteenth century but continually used even in some highly contemporary layouts. Carnivals and fairs were another key source for novelties, and a large array of "parlant-able" fonts filled the signs, banners, and handbills common to this entertainment medium.

Of course, the faces discussed above are but the tip of the novelty font-berg. Even going back to the turn of the century, for every serious text or headline face, two or three novelties were released with limited time spans. In the late 1980s, with the advent of the desktop computer and font-making software, designers, unhampered by the rigors of true type designing, produced dozens, scores, even hundreds of ephemeral faces, simply because they could. Some were deliberately based on existing novelties from the late nineteenth and early twentieth centuries, but others, particularly the grunge ones, were made from whole cloth (or fresh pixels).

The majority of the excessive and idiosyncratic styles populating this chapter have roots in the great classic specimens, but thanks to digitization, even these are frequently manipulated to look more askew. Still, the historical foundation is usually obvious. And no matter how hard a designer tries to transform Ice Cube or Log Cabin into something respectable, it is hard to make ice or logs – or bananas for that matter – anything more than what they actually are.

Kitchenette

HAMBURGER MENU

QUEEN ROSIE

SQUARE MEAL

MILWAUKEE

CHICKEN BASKET

DRY CLEANERS

165

HOLIDAY RANCH

GUEST CHECK

BLUE PLATE SPECIALS Commercial establishments use types but they are also the inspiration for them. Stuart Sandler borrows from luncheonette and dinner signs for this menu of quirky novelties. He says, "There is no such thing as bad taste when it comes to display typography, after all it has been chosen by the end user like a beauty pageant winner." Given his restaurant theme he adds, "Display typography is very much like food in that the further you explore the options, the larger your appetite for the gourmet stuff becomes."
DESIGNER: Stuart Sandler CLIENT: Font Diner

Plate 44—Uncommon effects for your accounts.

DOO-WOP LETTERS What would a performance poster for *Kat and the Kings* – the subject of this 1950s era doo-wop musical – look like? Decidedly, it would recall the common showcards produced by job printers for all manner of concerts and fairs. While this is a little more sophisticated (note the "A" and "T" in Kat – they overlap like the originals would never do) it is pretty true to the original inspiration. DESIGN FIRM: Spot Design ART DIRECTOR: Drew Hodges DESIGNER/ILLUSTRATOR: Kevin Brainard CLIENT: *Kat and the Kings* PRIMARY FONTS: Various woodtype (scanned), Modified Brush Scripts

NUTRITIONAL TYPE This is one of many illustrations created for a weekly nutritional column written by Jane Clarke for *The Mail on Sunday* newspaper supplement, *YOU magazine.* "The jar containing honey is similar to the jars that could be found in our pantry in the sixties," says Bo Lundberg. ART DIRECTOR: Linda Boyle DESIGNERS: Carin Goldberg, Bo Lundberg CLIENT: *YOU magazine, The Mail On Sunday,* UK PRIMARY FONTS: Parade, Neville Script

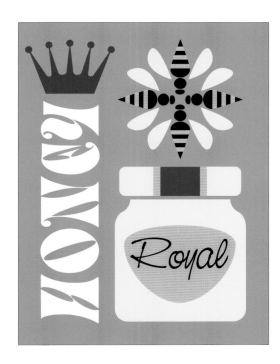

LOOK UP IN THE SKY A Superman comic book page from 1934 was the first, only, and most appropriate inspiration for this book cover about writers on comics. While colorfully witty, the evil specter of the atomic blast still sends shivers up the spine. ART DIRECTOR/DESIGNER: Archie Ferguson ILLUSTRATOR: Mark Zigarelli CLIENT/PUBLISHER: Pantheon Books PRIMARY FONTS: Akzidenz Bold Condensed, Comic Strip, Blue Print

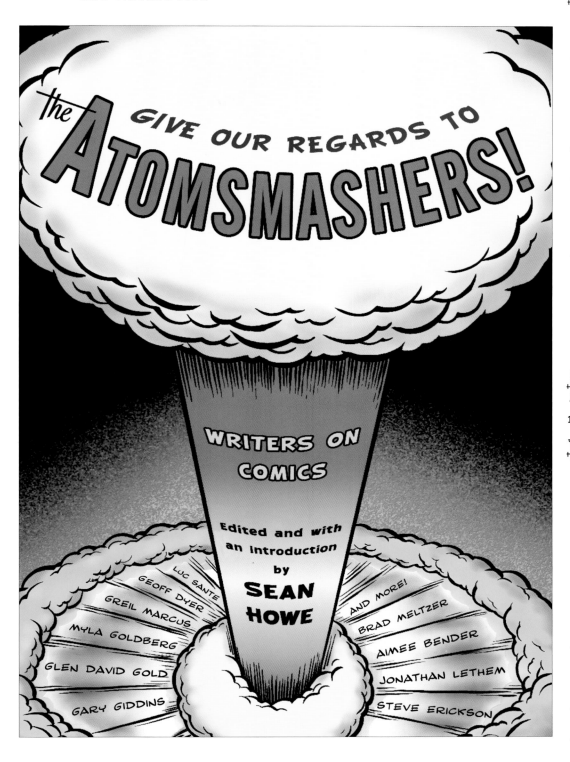

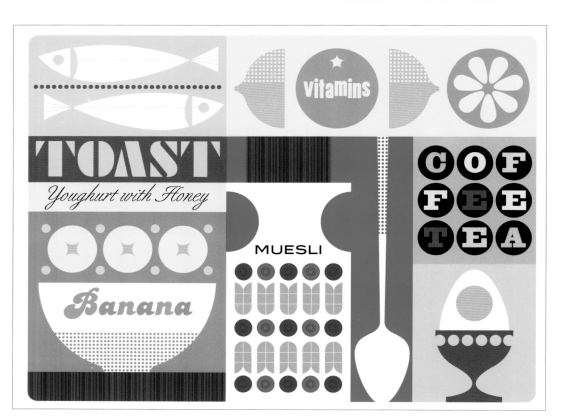

FROM THE SUMMER HOUSE Bo Lundberg created a whole range of glassware for Joseph Joseph and it wasn't until he had produced several pieces that he realized that it was inspired by objects, patterns and colors from his parents 1960s-era summer house. The lettering and overall design suggests the colorful pop culture aesthetic of that time. DESIGN FIRM: Bo Lundberg DESIGNERS: Bo Lundberg, Antony Joseph ILLUSTRATOR: Bo Lundberg CLIENT: Joseph Joseph, UK PRIMARY FONTS: Allure Script, Egiziano, Blair, Futura Black, Candid

168

HAPPY SCRIPT When Alex Steinweiss, the inventor of modern record cover design, created his signature "Steinweiss Scrawl" (*above*) he did so because type was too expensive. Ironically, the Scrawl became a Photo-Lettering, Inc. typeface in the end. Art Chantry was inspired by this happy script (which he uses almost verbatim) for this invitation, as well as old sleeves for Decca 45rpm records.
DESIGN FIRM: Art Chantry Design Co. ART DIRECTOR/DESIGNER: Art Chantry CLIENT/PUBLISHER: Norton Records PRIMARY FONTS: Handlettering, Franklin Gothic

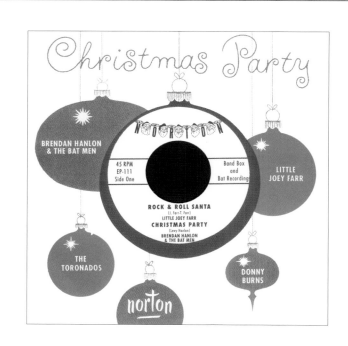

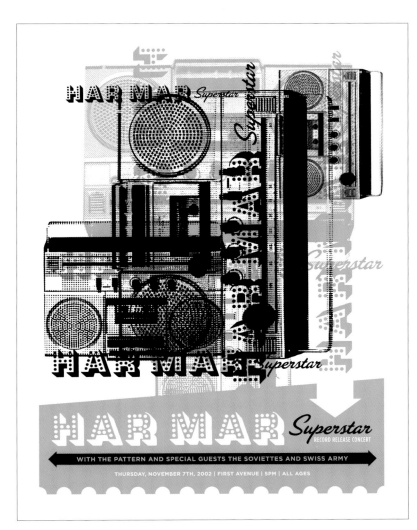

HOT WHEELS Anyone who grew up with Mattel Hot Wheel and ¹⁄₂₅th scale Model Kit packaging would remember this pseudo-hippy type. House Industries also got their spark from *Car Craft* and *Hot Rod* magazines, drag car lettering, Roach T-shirts, and as Andy Cruz notes, "all the cool lettering that was done before people got lazy and started to use fonts." DESIGN FIRM: House Industries ART DIRECTOR: Andy Cruz DESIGNERS/ILLUSTRATORS: Andy Cruz, Allen Mercer, Ken Barber CLIENT/ PUBLISHER: Custom Papers Group PRIMARY FONT: Handlettering

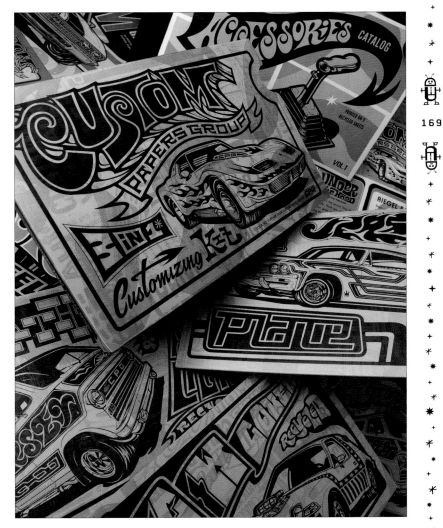

FROM THE MALL Har Mar Superstar, a.k.a. Sean Tilman, grew up in Saint Paul, Minnesota. And in Saint Paul there is an old mall called the "Har Mar" mall. The typefaces on this poster are directly influenced by the old "Har Mar Theater." DESIGN FIRM: Aesthetic Apparatus DESIGNERS: Michael Byzewski, Dan Ibarra CLIENT: First Avenue PRIMARY FONT: Tonight

FAUX WOOD Jeffrey Everett says that the spark for this came when walking around small towns in New Hampshire and "seeing all these funky, unfinished signs everywhere." The vernacular faux wood appealed to him and since he also wanted to do a play on the word "block," what better way than to go against the grain.
DESIGN FIRM: El Jefe Design ART DIRECTOR/DESIGNER/ILLUSTRATOR: Jeffrey Everett CLIENT: Animation Block Party PUBLISHER: Printed by Jak Printing PRIMARY FONTS: Handmade (title), Knockout (subtitle)

170

STICKY STUFF James Victore enjoys toying with form and content. For this self-promotional masking tape, he takes a form that is not known as a showcase of graphic design and printed his name in a typeface not often used for its elegance or beauty. Rustic was designed as a novelty face in the nineteenth century and has become, along with Icicle (snow-capped Gothic) and Bamboo (letters that look, well, like bamboo,) as an icon of "type parlant" or type that speaks its meaning.
DESIGNER/ILLUSTRATOR: James Victore CLIENT: Self PRIMARY FONT: Log Cabin a.k.a. Rustic

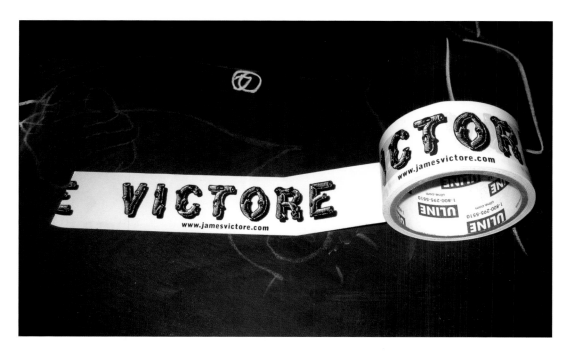

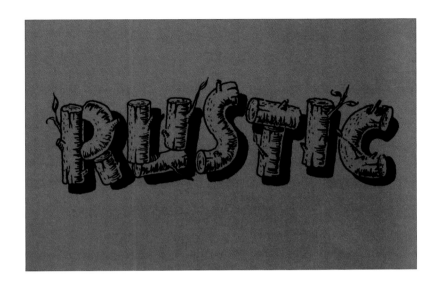

RUSTY RUSTIC Studio Boot were inspired by American tourist promotion brochures and posters from the 1930s. The Rustic typeface, used throughout the late nineteenth century, had a full-fledged revival when Americans roamed the parks and forests in their motorcars.
DESIGN FIRM: Studio Boot ART DIRECTORS/DESIGNERS: Petra Janssen, Edwin Vollebergh CLIENT: Nike PRIMARY FONT: Handdrawn 3D block type

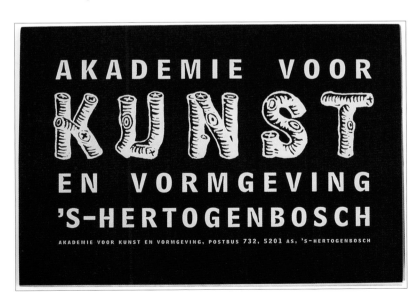

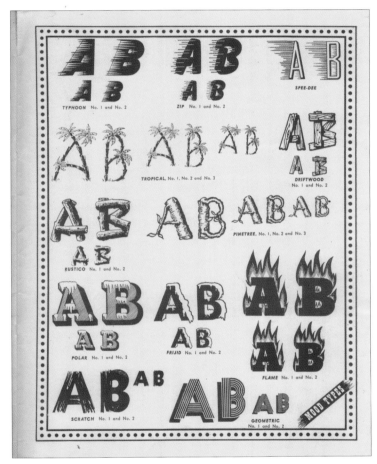

171

STENCIL STYLE

For centuries, cutting out and painting over the negative spaces of letters has produced a distinct form of typography – the stencil. It usually suggests ad hoc or untutored activity. *Rent* is a musical that takes place in a tenement building in NYC, and stenciled lettering is reminiscent of the "Post No Bills" signs that appear on such buildings and walls.
DESIGN FIRM: Spot Design ART DIRECTOR: Drew Hodges DESIGNER: Naomi Mizusaki CLIENT: The Producing Office/Rob Weisbach PRIMARY FONT: Stencil

172

"Extraordinary . . . Not just a welcome addition to a crowded shelf, but one of the best books ever done on the spellbinding intensity of cinema."
—David Thomson, *THE NEW REPUBLIC*

SCREAMING GOTHIC It is difficult not to vicerally feel this murderous typography screaming from the terrified Janet Leigh, in her classic shower scene in the thriller film *Psycho*.
DESIGN FIRM: Farrar, Straus and Givoux ART DIRECTOR/DESIGNER: Lynn Buckley PHOTOGRAPHER: Cover photograph of Janet Leigh in *Psycho* courtesy of Paramount/The Kobal Collection PUBLISHER: Farrar, Straus and Givoux PRIMARY FONT: Cut paper type

SIGN PAINTINGS Pablo A. Medina explains, "The photograph was taken in 1996 in North Bergen, NJ. The sign painter Leonardo started painting signs in Cuba and had been taught by his father who was also a sign painter. His inspiration for this sign came from a general love of letter forms, flourishes, color, and symmetry."
DESIGN FIRM: Cubanica DESIGNER/PHOTOGRAPHER: Pablo A. Medina PRIMARY FONT: Image is a photograph of a window in the Latin American Cafeteria Restaurant, the windows are hand-painted by Leonardo.

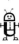

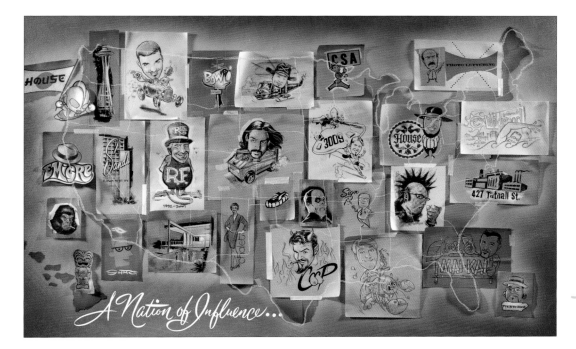

MAP ART Andy Cruz says that it is pretty obvious where this came from – the tradition of illustrated tourist travel maps, but with a new twist.
DESIGN FIRM: House Industries ART DIRECTOR: Andy Cruz DESIGNERS: Andy Cruz, Ken Barber, Chris Gardener ILLUSTRATORS: Chris Gardener CLIENT: House Industries PUBLISHER: House Industries PRIMARY FONTS: Handlettering/House fonts

SIXTIES COOL Tiki, Showcar, Stripe, and Rat Fink are all emblems of West Coast 1960s pop culture still reprised in nostalgic ways today. The Rat Fink lettering was devised by Big Daddy Ed Roth, the greatest hot rod painter of the era.
DESIGN FIRM: House Industries ART DIRECTOR: Andy Cruz DESIGNERS: Andy Cruz, Ken Barber ILLUSTRATORS: Andy Cruz, Ken Barber, Allen Mercer, Chris Gardener, Jeremy Dean, Adam Cruz CLIENT/PUBLISHER: House Industries PRIMARY FONTS: House Fonts, custom lettering

BENGUIAT IN THE RAW In the early 2000s, House Industries assumed rights to the great Photo-Lettering novelty types. Ed Benguiat was one of their chief type designers and this lettering is his handwrought poster characters from the golden age of Photo-Lettering.
DESIGN FIRM: House Industries ART DIRECTORS: Andy Cruz, Ken Barber, Ed Benguiat DESIGNERS: Tal Leming, Andy Cruz, Ken Barber ILLUSTRATORS: Ken Barber, Chris Gardener CLIENT: House Industries PRIMARY FONTS: House "Ed" fonts

the ED BENGUIAT FONTS BY HOUSE INDUSTRIES

173

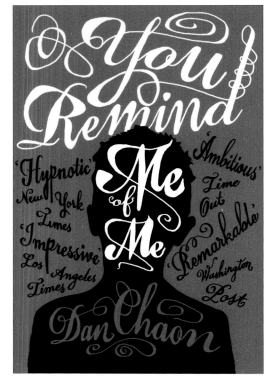

DRUG INSPIRED Vittorio Costarella claims that the Beatles' "Yellow Submarine" and 1960s rock posters are the basis for this composition, but the lettering, while free and wheeling, does not have the same intensity as most legibly-challenged psychedelic type. DESIGN FIRM: Modern Dog ART DIRECTOR/ DESIGNER/ILLUSTRATOR: Vittorio Costarella CLIENT: House of Blues PRIMARY FONT: Handlettering

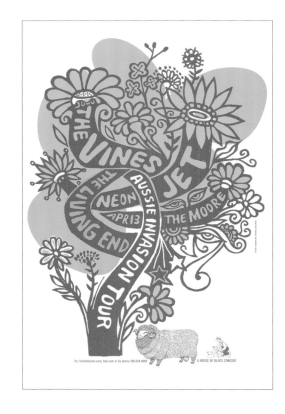

WORMY WORMY The central image, says Jesse LeDoux, is "a warmish critter, so I figured it fitting that the handmade type be wormy as well. I chose Trade Gothic for the show details, as it's rather simple and would not compete with the main illustration and band name type." DESIGN FIRM: Patent Pending Industries ART DIRECTORS: Jesse LeDoux, Jeff Kleinsmith DESIGNER/ ILLUSTRATOR: Jesse LeDoux CLIENT: The Showbox PRIMARY FONTS: Handmade, Trade Gothic

174 TATTOO YOU
Jonathan Gray looks to many sources for his handdrawn letters, but this book jacket is taken directly from vintage tattoos. DESIGN FIRM: Gray318 ART DIRECTOR: Sara Marafini at John Murray Publishers DESIGNER/ ILLUSTRATOR: Jonathan Gray PUBLISHER: John Murray Publishers PRIMARY FONT: Handdrawn

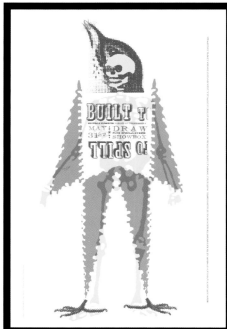
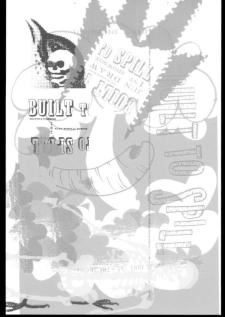
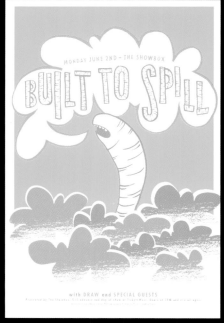

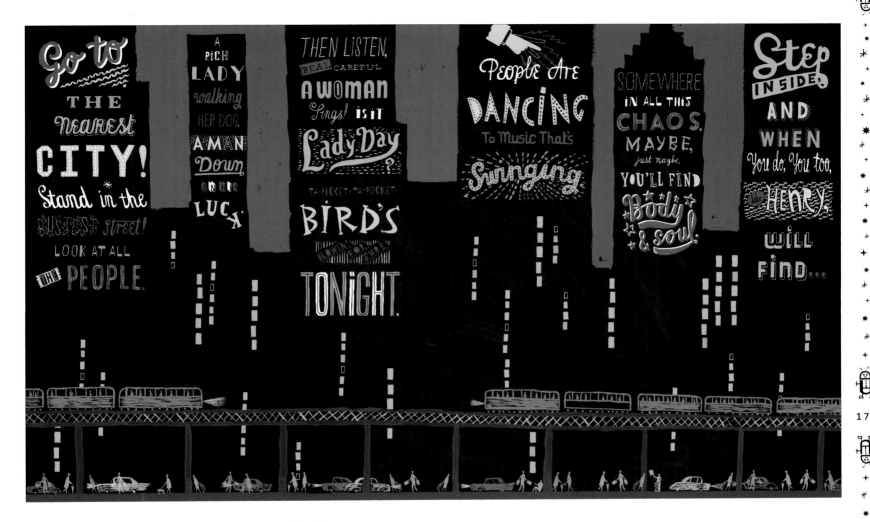

REDRAWING FACES Jonny Hannah is a sponge for all the neon street signs taken from Walker Evans and, as he notes, "umpteen Taschen and Chronicle books." He is also owes a debt to the handlettering by David Stone Martin (record albums) and Ben Shahn (book covers).

ART DIRECTOR: Deirdre McDermott ILLUSTRATOR: Jonny Hannah
PUBLISHER: Walker Books PRIMARY FONTS: Various

AMATEUR HAMS This invitation, for a presentation about ham radio, was typographically inspired by the QSL (or souvenir contact) cards collected in the book *Hello World – A Life in Ham Radio*. Some cards were designed by design amateurs with curiously exotic typefaces, while others were produced by printing companies dedicated to the QSL.

DESIGN FIRM: Spur ILLUSTRATOR: David Plunkert CLIENT: Spur Propaganda Gallery
PRIMARY FONTS: XIX Olympiad Alphabet, Cooper Black, Century Schoolbook

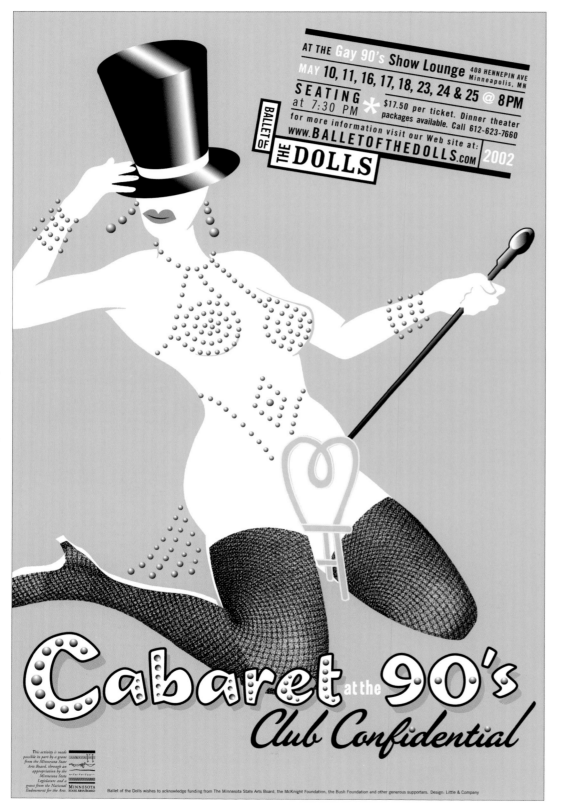

PRINTED EPHEMERA Jonny Hannah is an illustrator who illustrates mainly with type. In this case, the variegated and discordant letter forms are taken from a classic book on old letters, *Printed Ephemera* by John Lewis.
ART DIRECTOR: Darren Wall ILLUSTRATOR: Jonny Hannah PUBLISHER: Simon & Schuster PRIMARY FONTS: Various

BARS AND GRILLS For all their kitsch, the old Las Vegas typographies have been the inspiration for many sophisticated designers. This poster image was profoundly influenced by Las Vegas bar and lounge flyers and matchbook covers of the 1950s and 1960s, many of which have been reproduced in books celebrating vernacular pop.
DESIGN FIRM: Little & Company CREATIVE DIRECTOR: Monica Little DESIGNER/ILLUSTRATOR: Michael Lizama CLIENT: Ballet of the Dolls PRIMARY FONTS: Trade Gothic, Las Vegas

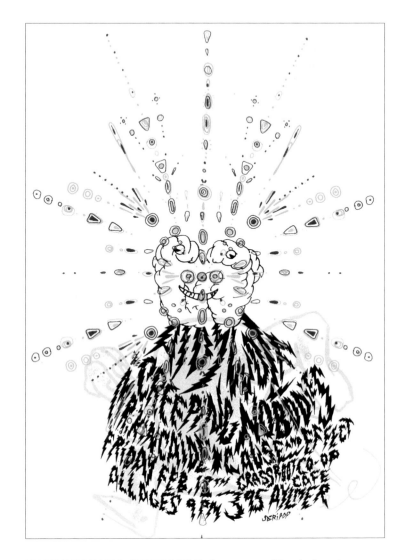

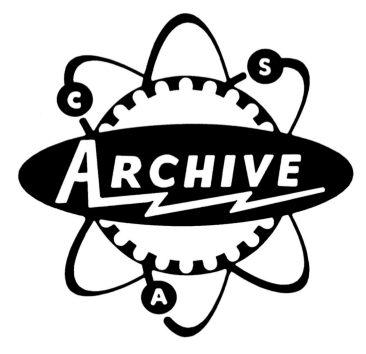

MELTING POT DESIGN Different eras from the late 1930s to the early 1960s are represented through graphics in the CSA archive. Erik Johnson cites Andy Warhol (again), but also motel signs, atomic paranoia, hippy art, and novelty cartoons. The Lightning lettering is among the talking types that designers love to hate, yet always use when it comes down to making a conceptual typographic statement.
DESIGN FIRM: CSA ART DIRECTOR: Charles S. Anderson DESIGNER: Erik Johnson PRIMARY FONT: Handlettering

TYPOGRAPHIC NOODLING Seripop says, "For the lettering on this, we were just going with the lightning bolt lettering often used in comic books and pizza signs."
DESIGN FIRM: Seripop ART DIRECTOR/DESIGNER/ILLUSTRATOR: Seripop CLIENT: AIDS Wolf PUBLISHER: Seripop PRIMARY FONT: Handlettered

WHATEVER FITS "The jazz world of 1930s New York and great old hot rod ads are what turns me on," says Jonny Hannah. So for this advertisement for his own cottage business, he traced and copied whatever he could find.
ILLUSTRATOR: Jonny Hannah CLIENT: Self
PRIMARY FONTS: Various handlettering

HOME MOVIES Mitten letters were used in the 1940s and 1950s by amateur filmmakers to create home movie titles. For this small restaurant/theater, they exuded a period look and the idea of watching a movie in a small room.
DESIGN FIRM: Louise Fili Ltd ART DIRECTOR/ DESIGNER: Louise Fili PHOTOGRAPHER: William Duke CLIENT: Screening Room PRIMARY FONT: Mitten Plaster Letters

SPLASH PANEL TYPE Darren Cox employs a classic comic strip motif *(above)* along with splash panel lettering to approximate the look of a photographic *fumetto*, or photo novel. The idea somehow never gets old.
DESIGN FIRM: SpotCo ART DIRECTOR: Drew Hodges DESIGNER: Darren Cox CLIENT: THINKFilm PRIMARY FONT: Custom

Ed Script

PHOTO LETTERING Edward Benguiat is one of the major type designers of the late twentieth century – with Benguait and Souvenir among his most popular faces. This is based on his little-known Felecia from the original Photo-Lettering, Inc. catalog.

DESIGN FIRM: House Industries ART DIRECTORS/DESIGNERS: Ed Benguiat, Ken Barber ILLUSTRATOR: Ken Barber CLIENT: House Industries PRIMARY FONT: Handlettering, that eventually became the Ed Script font.

Vegas Castaway

THE HEART OF VEGAS For this distinctive lettering, Ken Barber found the holy grail in the form of Ad-Arts original Castaways Vegas pylon sign from 1965. The rest was improvisation.
DESIGN FIRM: House Industries ART DIRECTOR: Andy Cruz
DESIGNER: Ken Barber CLIENT: House Industries PRIMARY
FONT: Castaway

SIGNS GALORE Most of the faces in the Sign Painter collection are based on the effects obtained by that most trusted of all commercial arts tools, the Speedball pen.
DESIGN FIRM: House Industries ART DIRECTORS: Andy Cruz, Al Barber
DESIGNERS: Andy Cruz, Ken Barber ILLUSTRATOR: Adam Cruz CLIENT: House Industries PRIMARY FONTS: House Sign Painter fonts, custom lettering

HIPPY ART AND MORE Charles S. Anderson must be a believer in, "what comes around, goes around" design, evidenced by these logos for Oblivious, which directly and indirectly riff off, "Andy Warhol, cereal boxes, motel signs, atomic paranoia, hippy art and cartoons," he says.
DESIGN FIRM: CSA ART DIRECTOR: Charles S. Anderson DESIGNERS: Sheraton Green, Jovaney Hollingsworth PRIMARY FONT: Handlettering

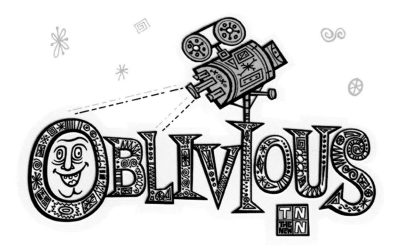

FROM MR. WARHOL Andy Warhol left a big thumbprint on post-war American art, but he also influenced a recent generation of illustrators and letterers too. His earlier work as a commercial artist, producing book jackets and advertisements, involved scrawled swash lettering, much like the script in this poster. Michael Strassburger acknowledges his debt to Warhol, who eventually gave up illustrative writing for Brillo packages.
DESIGN FIRM: Modern Dog ART DIRECTOR/DESIGNER/ILLUSTRATOR: Michael Strassburger CLIENT: House of Blues PRIMARY FONT: Handlettering

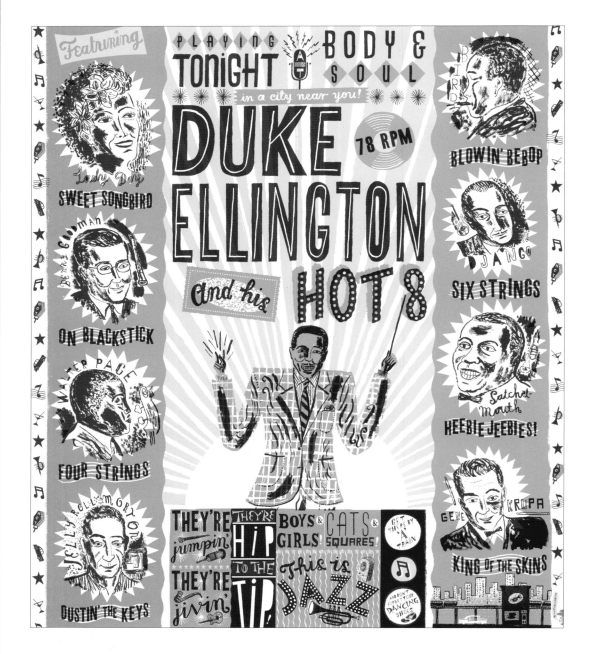

182

NEON AND MORE Jonny Hannah has a long history of redrawing historical faces to make them look hand-crafted. He borrows from various sources such as book covers *(below)*, but always, by virtue of his quirky styling, makes them his own.
ART DIRECTOR: Deirdre McDermott
ILLUSTRATOR: Jonny Hannah
PUBLISHER: Walker Books PRIMARY
FONTS: Various eclectic handlettering

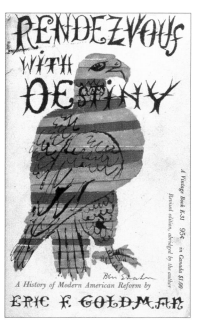

MODEST MOUSE SHOW POSTER Ed Fotheringham admires letters drawn by hand with a touch of flair. Much of his work echoes the early lettering of Andy Warhol, but here he delves into a more diverse bag of lettering inspirations from advertisements, matchbooks, and packages.
DESIGN FIRM: Patent Pending Industries DESIGNER/ILLUSTRATOR: Ed Fotheringham CLIENT: The Showbox PRIMARY FONTS: Various handlettering

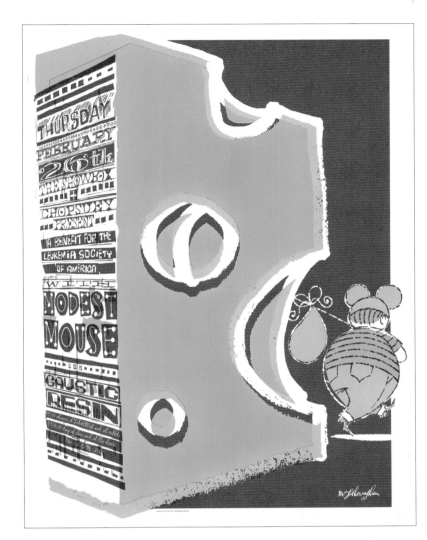

House Industries

SIGNS OF THE TIMES House Industries digs deep into pop culture's past and for the Sign Painter series they sifted through many "Signs of the Times" periodicals and various hand-painted signage reference books and catalogs.
DESIGN FIRM: House Industries ART DIRECTORS: Andy Cruz, Al Barber
DESIGNER: Ken Barber ILLUSTRATOR: Adam Cruz CLIENT: House Industries
PRIMARY FONT: House Sign Painter fonts

ANTHROPOMORPHIC ALPHABET
The fifteenth-century Bembo typeface, commissioned in Venice by Aldus Manutius and cut by Francesco Griffo, remains one of the world's most popular typefaces to this day. It serves here as the inspiration for the charming transformation of letters into caged creatures.
DESIGN FIRM: www.devicq.com DESIGNER/
ILLUSTRATOR: Roberto de Vicq de Cumptich
PUBLISHER: Henry Hout PRIMARY FONT: Bembo

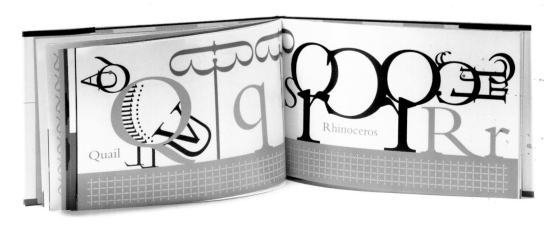

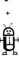

BRUSH AND PEN "The ornamented display face combines the brush-formed letters of a sign painter with the pen-formed flourishes of calligraphy," says Ray Fenwick. DESIGN FIRM: Co. & Co. DESIGNER/ ILLUSTRATOR: Ray Fenwick PUBLISHER: The Coast Weekly PRIMARY FONT: Handdrawn

MALARSTWO Novelty faces come in all shapes and contortions and the models are handlettering on packages and typography parlant (faces that look like objects). This derives from a combination of sources and are used to tickle the funny bone. DESIGN FIRM: Hakobo ART DIRECTOR: Jakub Stepien CLIENT: Radek Zielowka PRIMARY FONT: Custom

HORROR STYLE Along with circus posters, there are few stylistic mannerisms more well-known than 1950s monster movies. Thomas Scott re-created all the crass mannerisms of this stylistic genre to lend this poster its comically horrific allure.
DESIGN FIRM: Eye Noise DESIGNER/ILLUSTRATOR: Thomas Scott PUBLISHER: Figurehead PRIMARY FONTS: Handlettering (Cramps logo), Balloon Extra Bold, News Gothic Condensed

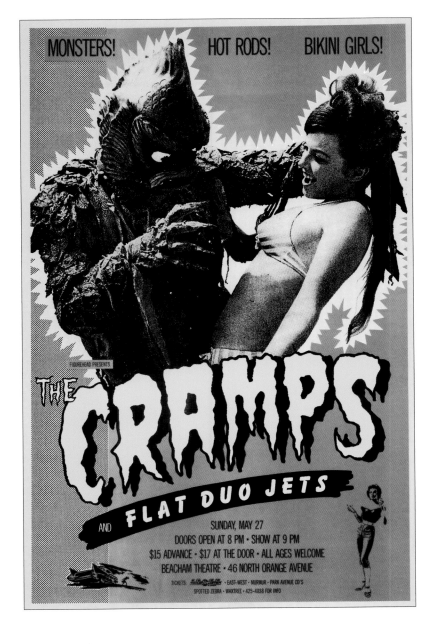

STARS AND STRIPES David Plunkert's collaged poster, featuring the blank-eyed former U.S. Attorney General, John Ashcroft, owes its debt to the vintage street posters printed by Globe Poster in Baltimore, MD.
DESIGN FIRM: Spur DESIGNER: David Plunkert CLIENT: Theatre Project PRIMARY FONTS: Stars & Stripes, Old Glory, Salute (from special effects and topical alphabets/Dover)

185

SMOKIN' IT UP Mark McDevitt has, "a thing for handlettered type created from smoke," especially the examples of which go back to 1960s and 1970s reggae album covers. "What is it anyway with reggae and smoke?" he asks, noting further that, "It was fun to illustrate and helps in keeping the design fun and whimsical much like the band's music, which is not a reggae act." The rest of the type is Vag Rounded, which he chose because it is simple and rounded like the type in the smoke, and does not detract from the main title.

DESIGN FIRM: Methane Studios DESIGNER/ILLUSTRATOR: Mark McDevitt
PRIMARY FONT: Handlettering

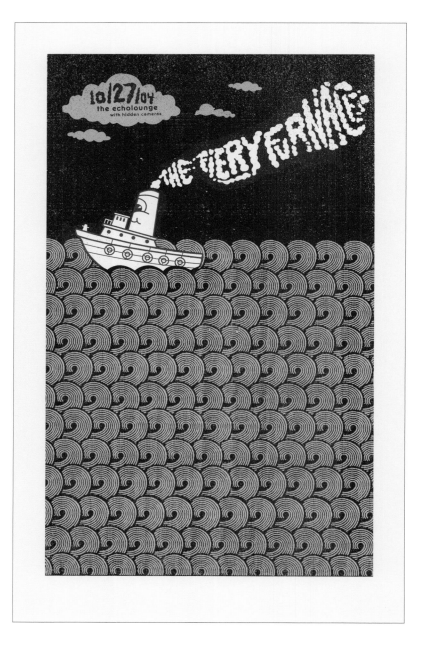

TYPOGRAPHIC OYSTER For Modern Dog, the pop culture world is their typographic oyster, and Cracker Jack toys and cereal box art are their typographic dessert. Robynne Raye reinterpreted these ephemeral artifacts to make the type and image components of this comically rendered, warm and fuzzy design for an exhibition.

DESIGN FIRM: Modern Dog DESIGNER/ILLUSTRATOR: Robynne Raye
CLIENT: Tacoma Art Museum PRIMARY FONTS: Handlettering, Antique Olive

PURPOSEFUL MISTAKES

The Frostone brochure looks a lot like a printer's make-ready press sheet that has been accidentally overprinted with multiple layers of type, image, and color. But it is also clear that some very serious 1950s-era novelty typefaces were used in the making of this piece, to give it the air of an industrial catalog.

DESIGN FIRM: CSA ART DIRECTOR: Charles S. Anderson DESIGNER: Jason Schulte CLIENT: French Paper Company PRIMARY FONT: Handlettering

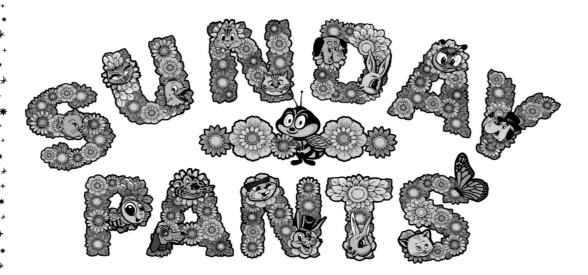

FLORID TYPE Charles S. Anderson is jaundicely smitten with the graphic kitsch that made America one of the oddest agglomerations of graphic bad taste in the world. Here, he makes the best of the most florid of lettering tricks.
DESIGN FIRM: CSA ART DIRECTOR: Charles S. Anderson DESIGNER: Jovaney Hollingsworth PRIMARY FONT: Handlettering

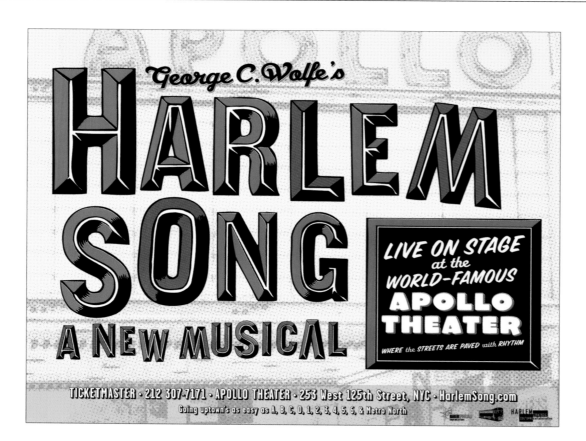

MARQUEE TYPE This beveled typeface, based on the three-dimensional letters used on theater marquees, was also used in jazz and gospel posters from the 1950s and 1960s (*above*).
DESIGN FIRM: SpotCo ART DIRECTOR: Drew Hodges DESIGNER: Gail Anderson PRIMARY FONT: Tejaratchi Caps

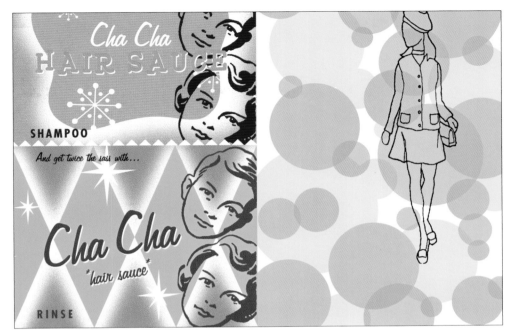

CHA CHA BROCHURE The words "Cha Cha" conjure up those Eisenhower, post-war years when Modernism fought with eclecticism for design dominance. Martha Graettinger opted for the latter with this dissonant mishmash of nostalgic pop culture from novelty type specimens. DESIGN FIRM: Planet Propaganda ART DIRECTOR: Kevin Wade DESIGNER: Martha Graettinger CLIENT: Cha Cha Haircut Lounge PRIMARY FONTS: Found type from 1950s and 1960s sources

BIBLIOGRAPHY

GLOSSARY

CLARENDON
A typeface with strokes of almost even weights, characterized by heavy, breaketed serifs.

COLD TYPE
Any method of typesetting which outputs onto sensitized paper or film.

DIDONE
Typefaces having an abrupt contrast between thin and thick strokes (formerly called "Modern.")

DIGITAL
A technology which replaced photographic font negatives from the late 1960s. Today, all types are set digitally via the computer.

DISPLAY TYPE
Type used for headlines and titles.

EGYPTIAN
A typeface similar to Clarendon without the brackets to the serifs.

FONT OR FOUNT
Originally this described the quality of type of a given size for a job. It is not a term for typefaces but in contemporary usage, it represents a style or family of types.

GARALDE
Typefaces in which the axis of the curves is inclue to the left. Formerly called "Old Face" and "Old Style."

GEOMETRIC
Grotesque typefaces constructed of geometric shapes, like circles and squares.

190

Ades, Dawn.
Photomontage (London: Thames and Hudson, 1986).

American Type Founders Company.
Specimen Book and Catalogue 1923 (Jersey City: American Type Founders Company, 1923).

Annenberg, Maurice.
Type Foundries of American and their Catalogs (New Castle: Oak Knoll Press, 1994).

Baines, Phil.
Penguin by Design: A Cover Story 1935–2005 (London: Penguin Books, 2006).

Barron, Stephanie, and Maurice Tuchman, eds.
The Avant-Garde in Russia 1910-1930. (Cambridge, MT and London: The MIT Press, 1981).

Blackwell, Lewis.
20th Century Type. (New York: Rizzoli, 1992).

Blackwell, Lewis, and David Carson.
The End of Print (San Francisco: Chronicle Books, 1995).

Broos, Kees, and Paul Hefting.
Dutch Graphic Design: A Century. (Cambridge, MT: The MIT Press, 1993).

Bruce's New York Type-Foundry.
Specimens of Printing Types (New York: George Bruce's Son & Co., 1882).

Carlyle, Paul and Guy Oring.
Letters and Lettering (New York and London: McGraw Hill Book Company, Inc., date unknown).

Carter, Rob.
American Typography Today (New York: Van Nostrand Reinhold Company, 1989).

Chwast, Seymour, Steven Heller, ed.
Seymour Chwast: The Left-Handed Designer (New York: Harry N. Abrams, 1985).

Crimlis, Roger and Alwyn W. Turner.
Cult Rock Posters; Ten Years of Classic Posters from the Punk, New Wave and Glam Era (New York: Billboard Books, 2006).

DeNoon, Christopher.
Posters of the WPA 1935–1943 (Los Angeles: The Wheatley Press, 1987).

Dickerman, Leah, ed.
Building the Collective: Soviet Graphic Design 1917–1937 Selections from the Merrill C. Berman Collection (New York: Princeton Architectural Press, 1996).

Eason, Ron and Sarah Rookledge.
Rookledge's International Directory of Type Designers (New York: Sarabande Press, 1994).

Foster, John.
New Masters of Poster Design: Poster Design for the Next Century (Gloucester: Rockport Publishers, 2006).

Freeman, Judi.
The Dada & Surrealist Word-Image (Cambridge, MT and London: The MIT Press, 1989).

Friedman, Dan.
Dan Friedman: Radical Modernism (New Haven and London: Yale University Press, 1994).

Friedman, Mildred, ed.
Graphic Design in America: A Visual Language History (Minneapolis and New York: The Walker Art Center and Harry N. Abrams, 1989).

Glaser, Milton.
Milton Glaser Graphic Design (Woodstock: The Overlook Press, 1973).

Glauber, Barbara, ed.
Lift and Separate: Graphic Design and the Vernacular (New York: The Herb Lubalin Study Center of Design and Typography, 1993).

Gottschall, Edward M.
Typographic Communications Today (Cambridge, MA: The MIT Press, 1989).

Greiman, April.
Hybrid Imagery: The Fusion of Technology and Graphic Design Publications (New York: Watson-Guptill Publications, 1990).

Heller, Steven, and Julie Lasky.
Borrowed Design: The Use and Abuse of Historical Form (New York: Van Nostrand Reinhold Company, 1993).

Heller, Steven, and Anne Fink.
Covers & Jackets (Glen Cove: PBC International Inc., 1993).

Heller, Steven and Louise Fili.
Deco Type: Stylish Alphabets of the '20s and '30s (San Francisco: Chronicle Books, 1997).

Heller, Steven and Louise Fili.
Design Connoisseur; An Eclectic Collection of Imagery and Type (New York: Allworth Press, 2000).

Heller, Steven and Elinor Pettit.
Graphic Design Timeline: A Century of Design Milestones (New York: Allworth Press, 2000).

Heller, Steven and Seymour Chwast.
Graphic Style: From Victorian to Post-Modern (New York: Harry N. Abrams, 1988).

Heyman, Therese Thau.
Posters: American Style (New York: Harry N. Abrams, Inc., 1998).

Hutchings, R.S.
A Manual of Decorated Typefaces (London: Cory, Adams, Mackay Ltd., 1965).

Jaspert, W. Pincus, W. Turner Berry, A.F. Johnson.
Encyclopedia of Type Faces (London: Blandford Press, 1953).

Kabutoya, Hajime.
New Typographics (Tokyo: PIE Books, 2005).

Kelly, Rob Roy.
American Wood Type 1828–1900: Notes on the Evolution of Decorated and Large Types (New York: Da Capo Press, Inc., 1969).

Kohler, Eric.
In the Groove: Vintage Record Graphics 1940–1960 (San Francisco: Chronicle Books, 1999).

Lasky, Julie.
Some People Can't Surf: The Graphic Design of Art Chantry (San Francisco: Chronicle Books, 2001).

Lavin, Maud, ed. Deborah Rothschild, Ellen Lupton and Darra Goldstein.
Graphic Design in the Modern Age: Selections from the Merrill C. Berman Collection (New Haven and London: Yale University Press, 1998).

Lawson, Alexander.
The Anatomy of a Typeface (London: Jamish Hamilton, Ltd., 1990).

Le Coultre, Martijn and Alston W. Purvis.
A Century of Posters (Hampshire, UK: Lund Humphries, 2002).

Lewis, John.
Printed Ephemera: The Changing Uses of Type and Letterforms in English and American Printing (Woodbridge, UK: The Antique Collectors Club, 1990).

Lewis, John.
Typography Design and Practice (London: Barrie & Jenkins, 1977).

McLean, Rauri.
Jan Tschichold: Typographer (London: Lund Humphries, 1975).

McKnight-Trontz, Jennifer and Alex Steinweiss.
For the Record: The Life and Work of Alex Steinweiss (New York: Princeton Architectural Press, 2000).

Meggs, Philip B.
A History of Graphic Design (Hoboken: John Wiley and Sons: 1998).

Meggs, Philip B.
Type and Image (New York: Van Nostrand Reinhold Company, 1989).

Meggs, Philip and Rob Carter.
Typographic Specimens: The Great Typefaces (New York: Van Nostrand Reinhold Company, 1993).

Mouron, Henri.
A. M. Cassandre (New York: Rizzoli International Publications, 1985).

Poyner, Rick.
Typographica (New York: Princeton Architectural Press, 2002).

Purvis, Alston W. and Martijn F. Le Coultre.
Graphic Design 20th Century (New York: Princeton Architectural Press, 2003).

Purvis, Alston W.
H. N. Werkman (New Haven: Yale University Press, 2004).

Remington, R. Roger.
American Modernism: Graphic Design, 1920 to 1960 (New Haven: Yale University Press, 2003).

Rothenstein, Julian and Mel Gooding.
ABZ: More Alphabets and Other Signs (San Francisco: Chronicle Books, 2003).

Rothenstein, Julian and Mel Gooding.
130 Alphabets and Other Signs (London: Redstone Press, 1991).

Sherraden, Jim, Elek Horvath and Paul Kingsbury.
Hatch Show Print: The History of a Great American Poster Shop (San Francisco: Chronicle Books, 2001).

Snyder, Gertrude and Alan Peckolick.
Herb Lubalin: Art Director, Graphic Designer and Typographer (New York: American Showcase Inc., 1985).

Spencer, Herbert.
Pioneers of Modern Typography (New York: Hastings House, 1969).

Spencer, Herbert, ed.
The Liberated Page. (San Francisco: Bedford Press, 1987).

Thompson, Bradbury.
Bradbury Thompson: The Art of Graphic Design (New Haven and London: Yale University Press, 1988).

Thorgerson, Storm and Aubrey Powell.
100 Best Album Covers: The Stories Behind the Sleeves (London, New York, Sydney: DK Publishing, Inc., 1999).

Tracy, Walter.
Letters of Credit: A View of Type Design (London: Gordon Fraser, 1986).

Type Directors Club.
Typography Twenty Six; The Annual of the Type Directors Club (New York: Harper Design International, 2005).

Updike, Daniel Berkeley.
Printing Types, Their History, Forms, and Use: A Study in Survivals (Cambridge, MT: Harvard University Press, 1962).

Varnedoe, Kirk and Adam Gopnik.
High and Low: Modern Art Popular Culture (New York: The Museum of Modern Art, 1990).

Vanderlans, Rudy and Zuzana Licko with Mary E. Gray.
Emigre: Graphic Design into the Digital Realm New York: Van Nostrand Reinhold Company, 1993.

Wallis, Lawrence W.
Modern Encyclopedia of Typefaces (London: Lund Humphries, 1990).

Wozencroft, Jon and Neville Brody.
The Graphic Language of Neville Brody (New York: Rizzoli, 1988).

ARTICLES

Blauvelt, Andrew.
'Desperately Seeking David.' *Emigre #38* (1996).

Bruinsma, Max.
'Studio Dumbar: Enigma Variations.' *Eye #19*, Vol. 5 (1995).

Burdick, Anne.
'Decoding the Monster.' *Emigre #23* (1992).

Greiman, April.
Design Quarterly #133 (Cambridge, MA and London: MIT Press for Walker Art Center, 1986).

McCoy, Katherine.
'The Evolution of American Typography.' *Design Quarterly #148* (MIT Press for Walker Art Center, 1990).

Vanderlans, Rudy.
'A Telephone Conversation between Rudy Vanderlans and David Carson.' *Emigre #27* (1993).

Weingart, Wolfgang.
'Graphic Design in Switzerland.' *Emigre #14* (1990).

Weingart, Wolfgang
'How Can One Make Swiss Typography? Theoretical and practical typographic results from the teaching period 1968–1973 at the School of Design, Basel.' *Octavo* 87.4. (London: 1987).

GLYPHIC
Typefaces that are chiseled i.e. Trajan rather than calligraphic.

GRAPHIC
Typefaces whose characters suggest they have been drawn with a brush or other tool.

GROTESQUE
Linear typefaces with nineteenth-century origins, that have a squareness of curve.

HOT METAL
Type from a mechanical composition system using molten hot lead cast from brass matrices. (Linotype machines set galleys of text type in this manner).

HUMANIST
Typefaces in which the cross storke of the lower case "e" is oblique (this was formerly known as "Venetian.")

LINEALE
Typefaces without serifs, or in other words, sans serifs.

MATRIX
A brass or copper image of a character from which the metal type is cast.

NEO-GROTESQUE
Derived from Grotesque typefaces, the ends of the curved strokes are usually oblique.

THE NEW TYPOGRAPHY
Modernist type designs based on asymmetrical composition usually associated with the early-twentieth-century avant-gardes (Bauhaus, Constructivism, De Stijl) and codified by Jan Tschichold in his book, The New Typography *(1928.)*

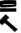

OLD FACE/OLD STYLE
Types from c. 1465–1725 characterized by calligraphic characteristics.

PUNCH
A short metal bar onto the end of which a character is "cut" by hand (by punch-cutters) at the actual size of the required type.

ROMAN CAPITALS
Engraved faces derived from the Trajan column in Rome.

ROMAN
A type style which can mean one of three things: upright as opposed to italic, the normal weight as opposed to the bold, or a serif face as opposed to a sans serif.

SLAB SERIF
Typefaces with heavy, square serifs (often found in woodtypes).

SERIF
The accretion at the end of the stems of Roman letters originating from the stone-carving practice.

TEXT TYPE
Type used for reading galleys.

TRANSITIONAL
Typefaces in which the axis of the curves is vertical or intrudes slightly to the left (influenced by the letter forms of the copperplate engraver).

TYPEFACE
Refers to the printed character left on the paper by the printing surface ("face") of the physical ("type").

WEBSITES

Aesthetic Apparatus
www.aestheticapparatus.com

AIGA Voice
voice.aiga.org

Alexander Isley Design
www.alexanderisley.com

Allen, Terry
www.terry@terryallen.com

Archive Type
www.archivetype.com

Art Chantry Design Co.
www.artchantry.com

Asterisk Studio
www.asterikstudio.com

Atelier René Knip
atelierreneknip.nl

Bloch, Anthony
www.anthonybloch.com

Bonsma, Dirk
www.magnolia.ch

Brainard, Kevin
www.portfolios.com/pleasure

Büro Destruct
www.burodestruct.net

Carin Goldberg Design
www.caringoldberg.com

Chen Design Associates
www.chendesign.com

Corral, Rodrigo
www.rodrigocorral.com

Charles S. Anderson Design
www.csadesign.com

Cubanica
cubanica.com

The Decoder Ring
www.thedecoderring.com

Delevante, Bob
www.relaystation.tv

De Vicq de Cumptich, Roberto
www.devicq.com

Doyle Partners
www.doylepartners.com

Empire Design
www.empiredesign.com

Eye Noise
www.eyenoise.net

Fenwick, Ray
www.coandco.ca/ray

f2 Design
www.f2-design.com

Font Diner
www.fontdiner.com

GIG ART
www.gigart.com

Gig Posters
www.gigposters.com

Giles Design, Inc.
www.gilesdesign.com

Glaser, Milton
www.miltonglaser.com

Gray, Jonathan
www.gray318.com

Hakobo
www.hakobo.art.pl

www.hammerpress.net
Hammerpress

Hannah, Jonny
www.heartagency.com

Hatch Show Print
www.countrymusichalloffame.com

The Heads of States
www.theheadsofstate.com

Heller, Steven
www.hellerbooks.com

HendersonBromsteadArt
www.hendersonbromsteadart.com

House Industries
www.houseind.com

Isle of Printing
www.isleofprinting.com

Jami Design
www.jamidesign.com

JDK
www.jdk.com

Joslin Lake Design Co.
www.joslinlakedesign.com

korn design
www.korndesign.com

Louise Fili Ltd
www.louisefili.com

Lundberg, Bo
www.bolundberg.com

Lure Design Inc.
www.luredesigninc.com

MacDonald, Ross
www.ross-macdonald.com

Mendulsund, Peter
www.mendelsund.com

Methane Studios
www.methanestudios.com

MK12
media2.mk12.com

Modern Dog
www.moderndog.com

Morrow McKenzie, Elizabeth
www.morrowmckenzie.com

Mucca Design
www.muccadesign.com

My Fonts
www.myfonts.com

Nichols, Ray
www.materialculture.udel.edu

Nick's Fonts
www.nicksfonts.com

P22 Type Foundry
www.p22.com

Patent Pending Industries
www.patentpendingindustries.com

Pelavin, Daniel
www.pelavin.com

Planet Propaganda, Inc.
www.planetpropaganda.com

El Revolver
www.elrevolver.com

Rivamonte, Mike
www.guitar-bones.com

Rosenwald, Laurie
www.rosenworld.com

Seripop
seripop.com

Skouras Design Inc.
www.skourasdesign.com

The Small Stakes
www.thesmallstakes.com

SpotCo
www.spotnyc.com

Spur Design
www.spurdesign.com

Stereotype
www.stereotype-design.com

Studio Boot
www.studioboot.nl

Tank
www.tankdesign.com

Uncle Charlie
www.unclecharlieart.com

Werner Design Werks, Inc.
www.wdw.com

Wilson, Gabriele
www.gabrielewilson.com

Wink, Incorporated
www.wink-mpls.com

Wooden Type Fonts
www.woodentypefonts.com

Yee-Haw Industries
www.yeehawindustries.com

Feb 27/08